To Glenn.

Happy Birthday

All my love

Lynda

X Feb 2023.

The History of the
London Underground Map

The History of the London Underground Map

Caroline Roope

PEN & SWORD
TRANSPORT

First published in Great Britain in 2022 and reprinted in 2022 by
Pen & Sword Transport
An imprint of
Pen & Sword Books Ltd
Yorkshire – Philadelphia

Copyright © Caroline Roope 2022

ISBN 978 1 39900 681 1

The right of Caroline Roope to be identified as Author of this work has been asserted by her in accordance with the Copyright, Designs and Patents Act 1988.

A CIP catalogue record for this book is
available from the British Library.

All rights reserved. No part of this book may be reproduced or transmitted in any form or by any means, electronic or mechanical including photocopying, recording or by any information storage and retrieval system, without permission from the Publisher in writing.

Typeset by Mac Style
Printed in the UK by CPI Group (UK) Ltd, Croydon, CR0 4YY.

Pen & Sword Books Limited incorporates the imprints of Atlas, Archaeology, Aviation, Discovery, Family History, Fiction, History, Maritime, Military, Military Classics, Politics, Select, Transport, True Crime, Air World, Frontline Publishing, Leo Cooper, Remember When, Seaforth Publishing, The Praetorian Press, Wharncliffe Local History, Wharncliffe Transport, Wharncliffe True Crime and White Owl.

For a complete list of Pen & Sword titles please contact

PEN & SWORD BOOKS LIMITED
47 Church Street, Barnsley, South Yorkshire, S70 2AS, England
E-mail: enquiries@pen-and-sword.co.uk
Website: www.pen-and-sword.co.uk

Or

PEN AND SWORD BOOKS
1950 Lawrence Rd, Havertown, PA 19083, USA
E-mail: Uspen-and-sword@casematepublishers.com
Website: www.penandswordbooks.com

Contents

Acknowledgements		vii
Map or Diagram?		ivii
Preface		ix
Introduction		xi
Chapter 1	A Flirtation With the Underworld	1
Chapter 2	An Unlikely Hero	5
Chapter 3	Money Makes the Train Go Round	10
Chapter 4	Things Get Smutty	17
Chapter 5	Mind the Map	22
Chapter 6	The Underground Goes Overground (and Falls Off the Map)	26
Chapter 7	Notice to Quit	29
Chapter 8	The Twopenny Tube	35
Chapter 9	Concerning Mr C. T. Yerkes	41
Chapter 10	The Monster and the Metropolitan	46
Chapter 11	Bullseyes, Bars and Circles	53
Chapter 12	By Paying Us Your Pennies	59
Chapter 13	A Verdant Realm	63
Chapter 14	Brave New World	70
Chapter 15	All Change (Please)	80
Chapter 16	A New Design for an Old Map	89

vi The History of the London Underground Map

Chapter 17	Say It With a Poster	95
Chapter 18	Design For Life or Design For Strife?	104
Chapter 19	Blitz	108
Chapter 20	Life After Pick	122
Chapter 21	Harry's War	136
Chapter 22	A Thermos Flask Reunites 'Ald' and 'Gate'	140
Chapter 23	Beyond Beck	149
Chapter 24	Fares Fair in Love and War	158
Chapter 25	Out of the Ashes	166
Chapter 26	Breaking Beck's Rules	177
Notes		184
Bibliography		196
Index		201

Acknowledgements

I would like to thank all the authors whose previous work on this subject not only sparked my interest in the history of London Underground and its design heritage but made it possible for me to write this book. Some of these wonderful writers I have quoted within the text, and I am grateful to all those who happily granted permission for me to do so, and in many cases offered words of encouragement and support as well. Particular thanks must go to Maxwell Roberts who not only willingly gave permission for me to quote him at length in the final chapter but was also happy to offer feedback and point me in the right direction – a true navigational expert. Special thanks also to Mark Noad, Mark Ovenden and Jug Cerovic who didn't mind my 'out of the blue' emails requesting information, quotes, or permission to print their versions of the map – it is much appreciated. Thanks are also due to London Transport Museum for permission to use several images from their fabulous archive collection. Without the hard work they have put in to digitising their collection and publishing it online, this book would have been impossible to write during the long year of Covid closures and lockdowns. To London Underground itself – the genius of engineering beneath our feet – and all those who have worked on or for you, past and present, you will always have a special place in my heart.

And finally, a heartfelt thanks to all my friends and family who have supported me throughout the writing of this book – I couldn't have done it without you.

Map or Diagram?

The current London Underground Journey Planner and its predecessors are overwhelmingly referred to as the 'Tube Map' or 'Underground Map' by the travelling public and society at large. Beck's famous design is a diagram and not, strictly speaking, a map – this issue is discussed in greater detail in chapter 26 – so, to distinguish it from its less-famous contemporaries, it is referred to in the text with a capital D, e.g. 'the Diagram'.

Preface

There is something slightly *Alice in Wonderland* about the London Underground. Perhaps it's the sense of disappearing into a deep, dark netherworld and eventually popping up, blinking in the daylight, somewhere completely different, with no real sense of how you got there. Or perhaps it's the distortion of time; the contraction of a journey length from hours into minutes with little to no idea how fast you are travelling or the distance that lies in-between. But for all the discombobulation of the experience – and let us not forget that not all the underground is actually underground – there is an innate satisfaction in the successful completion of a journey. It's a city effectively navigated, and a destination finally reached. And if you're travelling to a part of the capital that you're unfamiliar with, there's the anticipation of what awaits you at street level – a different landscape, new spaces, fresh faces – a little unexplored corner of the metropolis; individual and unique but undisputedly part of something far larger … that is, of course, if you can work out which station exit you need to arrive in the right place.

I spent several years commuting into London from various locations in the home counties – firstly for university, during which I had the excitement of a journey on the driverless Docklands Light Railway (DLR) every week – and later for my career in heritage and museums, which involved a journey on the altogether less exciting and perpetually overcrowded Northern and Central lines. Despite my relative ignorance about the workings of this great leviathan of engineering, I always knew I was travelling in the midst of something special, and that I had made it in life. I was a London commuter, and I wore my jaded traveller badge with pride. I didn't even need a map. Even in the early days of courting the underground, my father's encyclopaedic knowledge of London above and below ground meant I had access to a living, breathing Tube map at the end of the telephone. And before long I was on good terms with the network myself. As I travelled its length and breadth, I got to know its

x The History of the London Underground Map

quirks; its likes and dislikes. Where to stand on platforms to get the best chance of getting on; how far down the steps I'd need to be if a train came into the station and I wanted to get on with a certain amount of panache and dignity, rather than scrabbling down the steps two at a time and leaping through the closing doors, red-faced and heaving.

But as is the case with many relationships, things went a little sour. Familiarity started to breed contempt. I can't pinpoint exactly when I fell out of love with the underground but it was around the time I was heavily pregnant with my first child, and the bus suddenly seemed like a more civilised option. I suppose that eventually, as with many things we do every day on repeat, the underground became anathema to me. So, I was unfaithful with the 521 bendy bus from Waterloo Bridge to Holborn.

I no longer commute into London. In fact, I rarely make it into the city now from my garret in Hampshire. But time and distance are the perfect conditions for breeding nostalgia, and while I haven't fully forgiven the underground for sucking a certain amount of joy out of me in my twenties, I now wish I'd paid it a bit more attention when I had the opportunity. For if you look carefully, and treat it with a certain degree of reverence, it will happily reveal its stories to you – and the one that resonates the strongest for me is its visual heritage. From its ubiquitous roundel to its iconic Diagram, the underground speaks to the traveller like no other transit network. Little wonder that we cherish its iconography, emblazoning it on t-shirts, mugs, board games and duvet sets. Not only can the famous 'Tube map' help us to navigate the underground, but it also makes a good design for a cushion cover and a pair of socks – handy if you're lost and you're able to remove your shoes for a quick route check.

We take for granted that such navigational tools are at our disposal – I know this, because I did too. But behind every brilliant light-bulb of an idea often lies a much humbler story. I hope you enjoy reading about it as much as I have enjoyed writing about it.

Caroline Roope
August 2021

Introduction

London's Lifeblood

To travel the London Underground is to travel through over 150 years of engineering and design history. From the Art Deco lines of Arnos Grove to the oxblood tiled Arts and Crafts facades of Edgware Road and Russell Square – all the greatest artistic movements and feats of engineering are encapsulated in London's most iconic transport system. A living, breathing and, most importantly, functioning heritage site, the 'Tube' is a nineteenth-century invention reshaped and refashioned for a twenty-first-century consumer.

When the first section, the Metropolitan Railway, opened in January 1863, London was a bustling and cosmopolitan city of over three million people. The previous twenty-five years had seen a transport revolution, and the capital already had nine mainline terminus stations receiving trains from every direction. The underground defined London as a hub of progressive engineering might. It opened up new opportunities for growth and development in an age of visionary design and construction; the irrepressible confidence that so defines the Victorian era carrying it along on a wave of civic pride. And yet, it sounded like a terrible idea. *The Times* famously described it as an 'insult to common sense' in 1862; although in true journalistic style the same newspaper heralded it as 'the great engineering triumph of the day' less than a year later.

The idea that a steam train could travel under our feet was utterly preposterous to the average mid-century Victorian, yet the vision quickly became a necessity. Overcrowding on the roads – some contemporary accounts suggest it took longer to get across central London than it did to travel into the capital from Brighton – and a lack of mainline stations in the centre of the city meant the experimental plan became a tangible reality. (Please note, I refer to the city not the City in this book even though some examples may refer specifically to the square mile in the

xii The History of the London Underground Map

heart of the capital that is known as the City of London.[1]) Excavation for the Metropolitan Railway began in 1860 and despite several construction accidents and the displacement of thousands of London's poor, the line was hailed a success, attracting 30,000 passengers on its first day.

Having started with seven stations on the Metropolitan Railway, the underground now serves 272[2] stations across Greater London connecting with London Overground, the DLR, Crossrail, the tram network and suburban services. Its development has, at times, been frustrating. A haphazard, piecemeal approach to planning and management; financial and political pressures; war and periods of austerity are all written in its story. Yet its ability to endure in periods of uncertainty and upheaval is testament to its overriding success. Despite its many failings, it prevails – a network of veins supplying the beating heart of London with a constant flow of people.

This complex and fascinating piece of infrastructure now transports one billion passengers a year, all navigating themselves across the capital with the modern tools of a successful transport system. (This number dropped significantly during the Coronavirus pandemic to 296 million during 2020 and 2021.) Signage, maps, and most recently smartphone apps, all play their part; and along with recognisable design and styling elements, they provide the consistency that travellers look for to assist them in getting from A to B. The branding used on the modern underground – the typefaces used on signage, the unmistakable blue and red 'roundel' and Harry Beck's iconic map – play an integral part in moving people around the network. This coherent approach to styling is very much a twentieth-century phenomena, brought about by the unification of the underground; a process which began in 1902. Prior to this, the underground was operated by rival companies, controlling different lines: the City and South London Railway, the Central London Railway, the Metropolitan, the District and the Underground Electric Railways Company of London. The result was a branding nightmare. Architecture ranged from small wooden stations to high Victorian gothic edifices. Timetables contained sketches and illustrations that, although aesthetically pleasing, often had nothing to do with the business of transporting passengers, and maps were produced to show only an operator's individual line. All this made the business of getting *anywhere* within London a confusing and, at times, baffling undertaking.

Introduction xiii

Early attempts to convey diagrammatically the single unified system in the early twentieth century were not a success. The first maps produced encapsulate the challenges of representation; issues of scaling were evident from the outset, as well as the omission of several lines and stations. The result was an unhelpful clash of diagram versus map – often portraying geographically incorrect information – crammed into one display. It took over twenty years and an enormous amount of ingenuity to solve the map 'problem'. But solved it was, in 1933, thanks to the brilliance of engineering draughtsman, Henry 'Harry' Beck.

But let us briefly journey back several stops to where the underground began – to its disordered beginnings in a cluttered and over-populated metropolis – before modernity tidied everything up into the neat, integrated system depicted on Beck's Diagram. Because to understand the chaotic origins of the underground, is to understand why it took seventy years of transport mapping evolution to arrive at a satisfying solution.

Chapter 1

A Flirtation With the Underworld

On a dank and dreary Tuesday in November 1861, Adolphe Joseph Boueneau put down his chisel and hammer and took off his apron and boots. Dressing himself in his best coat and top hat, he made his way purposefully to Marlborough Street Magistrates Court. The court, now an upmarket hotel, would thirty-four years later become famous for Oscar Wilde's Queensbury case, and for playing host to Christine Keeler as the Profumo affair was made public; but on this particular day, Boueneau was going to court to protect his little corner of the empire – his home and masonry business at 48-49 Warren Street, Bloomsbury, London.

Unfortunately for Boueneau, the Metropolitan Railway Company (the Met) had made the rather inconvenient decision to excavate the ground at the rear of his property, where his masonry showroom was situated, in order to create what was to become the world's first underground railway. Construction had begun in October 1859 using the cut and cover method, which meant digging up the New Road (now the A501) and laying the railway in a shallow cutting, which was then bricked up and roofed over. To the dismay of Mr Boueneau, whose very livelihood depended on his works of art remaining upright, the movement of the ground where the company was carrying out its work meant the 'front walls [of his gallery] had been cracked, there were openings in the walls, and they had gone quite out of the perpendicular',[1] not to mention the loss of a 'large stock of mantel-pieces, a vase of the value of £800, being a fine antique, and other works of art.'[2] Boueneau was in court to ensure justice was served on the bothersome railway company, whose actions had resulted in a not inconsiderable amount of damage – for which he was claiming £41 and his costs (£41 having a value of just under £5,000 today).

Suspicions of the revolutionary new transport scheme ran deep, and it was treated with a large degree of scepticism by the public; no doubt fuelled to some extent by the popular press who had been following the progress

2 The History of the London Underground Map

of the railway since its inception. Reports of various accidents and mishaps encountered along the way which were of 'a very grave nature'[3] did not instil confidence in a public whose only point of reference to underground tunnelling was Sir Marc Isambard Brunel's largely unsuccessful Thames Tunnel. Built between Rotherhithe and Wapping to link the expanding docks on either side of the river, work on the tunnel began in 1825 and was completed in 1841. While undoubtedly an example of cutting-edge technology due to the innovative use of Brunel's tunnelling 'shield', the tunnel fell short of realising its original aims. It was never opened for commercial traffic – the financing ran out before the slopes were constructed that would have allowed for horse-drawn wagons – and so it remained a pedestrian thoroughfare until it was eventually taken over by the East London Railway in 1869. From the time of its opening to its eventual appropriation for a railway line, the Thames Tunnel attracted a fairly undesirable clientele, despite its beauty and architectural merits. It quickly became a seedy tourist bazaar by day, and the haunt of prostitutes and pick-pockets by night; an 'arched corridor'[4] extending into 'everlasting midnight ... gloomier than a street of upper London'.[5] Perhaps it was the suffering endured in its construction that gave it an air of melancholic unease. Or perhaps the notion that the subterranean space was somehow hellish and unnatural – 'a flirtation with the Underworld'[6] – meant that the Thames Tunnel project was doomed from the start. Whatever the reason, Victorian Londoners distrusted what lay beneath their feet and those who chose to meddle with it.

Such primordial fears may or may not have troubled our friend Mr Boueneau during his day in court with the Met. What we do know is that in the true spirit of Victorian pluck and arrogance, the company's defence attorney Mr Holloway argued that 'Mr Boueneau had contributed to the falling of the land by placing such a heavy weight of buildings on the land as he had.'[7] He also contended that 'Mr Boueneau had no right, by the 7th George IV., chap. 142, sect. 140, to place the buildings where they were, within 50 feet of the side road. By the Act it was proved to be a nuisance.'[8] It is unclear whether it was pointed out to the company that Mr Boueneau's buildings had only become a nuisance at the point it had decided to construct an underground railway outside his back door. The magistrate, a Mr Tyrwhitt, did eventually award costs to Mr Boueneau, as well as a measly claim of £4 14s.

The audaciousness and single-minded determination of the Met, a glimpse of which they displayed that day in court, would eventually carry their scheme through to its completion in 1863. Mr Boueneau's story ends in Marlborough Street Magistrates' Court. No doubt his experience left a bitter aftertaste and several statues without heads and limbs. But at least he was left with a home to defend. Countless others would not be so fortunate. As the new railway cut its way through the city, 'boring straight ways into the heart of it with a fine contempt for natural obstacles'[9] (and man-made obstacles for that matter) it was the London poor who would feel the sting of displacement.

Slum clearance was a necessary part of the underground's development, but its primary purpose was to rid the city streets of traffic. The London drawn by Frederick Engels in *The Condition of the Working Class in 1844* is one of 'endless lines of vehicles', 'hundreds and thousands of all classes' all traipsing the 'immense tangle of streets' and 'thousands of alleys and courts' with their 'nameless misery'. Engels' inability to quantify the masses in any meaningful way is understandable given that the population had risen from just under one million at the first census in 1801 to more than two-and-a-half million fifty years later. The growth of both the city and the amount of people within it in the first half of the nineteenth century was bewildering; not only to Engels but to its inhabitants who 'were themselves struck with awe, admiration or anxiety at the city which seemed without any apparent warning to have grown to such magnitude and complexity.'[10] London had become a spectrum of stovepipe-hatted industrialists and children in rags, great wealth and abject poverty, bold self-belief and hopeless despair.

Victorian rush hour started practically in the middle of the night as horse-drawn carts, wagons and costermongers' barrows made their way into the central markets. By dawn, the approaches to areas such as Covent Garden Market were regularly filled with goods carts, as well as long lines of men and women carrying fruit in from the market gardens in Fulham.[11] The working classes would eventually be joined, perhaps an hour or so later, by the office workers and clerks. These were the original commuters – although the term itself didn't exist until much later – walking as though they were one homogenous mass: 'pouring into the city, or directing their steps towards Chancery-lane and the Inns of Court. Middle-aged men ... plod steadily along ... knowing by sight

4 The History of the London Underground Map

almost everybody they meet or overtake, for they have seen them every morning (Sunday excepted) during the last twenty years, but speaking to no one.'[12] The Victorian commuter, with his sombre expression, black cloak and morning newspaper tucked up under one arm; seems eerily familiar...

By the 1840s, omnibuses had well and truly joined the throng and were now fighting for road space with all the aforementioned modes of transport, as well as hackney carriages, private carriages, stagecoaches and even livestock. As Charles Dickens neatly surmised, 'gigs, cabs, omnibuses, and saddle-horses The streets are thronged with a vast concourse of people, gay and shabby, rich and poor, idle and industrious.'[13] With Dickens' colourful depictions and Gustav Dore's sketch of the cheek-by-jowl congestion on Ludgate Hill (see images), it isn't hard to see how the bustling capital of the British Empire had been a victim of its own success – grinding itself to an exhausted halt by the strength of its own ambitions.

To compound matters, the new railways were disgorging yet more people at the mainline termini on the fringes of the financial capitals of London and Westminster. These stations had been built on outlying land that could be purchased cheaply, such as at London Bridge (1836), meaning that travellers to the city would have to complete their journey by road. This added further congestion to the streets – some of which were not fit for purpose, having been built in the Middle Ages, long before omnibuses and carriages were in use. At the height of 'railway mania' in the 1840s, a Royal Commission was established to consider the issue of railways entering the hallowed City and Westminster environs. It resulted, somewhat unhelpfully, in a designated railway-free zone across the central area. Only one terminus had crossed the sacred demarcation line of the 'square mile' – Fenchurch Street – and none of the lines from the south ran over the Thames. Pressure from the railway companies, who could see the financial benefit of a connection into the business centre, was growing.

What London needed was an innovative solution. What it got was a dogged, radical-thinking solicitor called Charles Pearson.

Chapter 2

An Unlikely Hero

The only remaining image of Charles Pearson shows a beleaguered-looking man, pen in hand, ready to put the world to rights. One can almost sense his displeasure in being asked to pose for a photograph when he could be making a nuisance of himself in some other capacity – perhaps arguing for universal suffrage or the plight of the poor, or disputing the Catholic-bashing inscription on Christopher Wren's Monument to the Great Fire of London. If Victorians were familiar with eyerolling, it is encapsulated in Pearson's portrait.

He may have been, in the less than flattering description offered up by the *Oxford Dictionary of National Biography*, a 'gadfly'[1] but his constant advocacy of the causes he felt passionate about ensured that things got done. And it was this dogged determination and visionary thinking that he brought to the table when he presented his first idea for an underground railway in 1839. Admittedly, Pearson was probably a little overzealous with his initial suggestion – a railway drawn by atmospheric pressure, connecting an enormous semi-underground station at Farringdon with stations all over England. Trains would be propelled by a piston, which would be sucked along by stationary pumping engines, creating a vacuum. It was, perhaps, a little fanciful but as the designer of Crystal Palace, Joseph Paxton would, some ten years later, propose a similar vacuum-powered scheme for the underground, including an epically proportioned glass arcade, it suggests that Pearson wasn't a million miles off the mark. After all, who wouldn't be excited by the thought of a smokeless railway…

Unfortunately, London wasn't quite ready for something as fantastical as a railway line housed in glass or under the ground. Not least because the idea of tunnelling under some of the most expensive swathes of land in the country, and the most expensive properties, was a railway speculator's idea of hell. Tunnelling under the Thames, as Brunel did, was one thing, but tunnelling under the estates of the Earl of Cadogan and the Duke of Westminster was highly unappealing. And not without good reason. As

6 The History of the London Underground Map

Mr Boueneau discovered, there was a very real threat of subsidence, and therefore a very real threat of hefty compensation claims from the landed gentry. There was also the small matter of the technology, or lack thereof. And a distinct lack of interest in the scheme, or money to finance it. The idea was an unmitigated flop.

Not to be put off, Pearson regrouped and reverted to Plan B – an underground line joining the London termini. In 1851 the Great Northern Railway (GNR) had reached London but had stopped short of the New Road (now Euston Road) – which had been designated the northern most point of the embargoed no-go area. The terminus was at Maiden Lane – a temporary arrangement due to the fact that the GNR was tied up in a land acquisition case with a smallpox hospital. However, in 1854 the GNR finally moved up to the New Road with the opening of King's Cross east of Euston. The Midland Railway would follow suit in 1868 with the opening of St Pancras, which sat between Euston and King's Cross.

It occurred to Pearson that incorporating the New Road stations into his proposal might get it, literally, over the line. If the railway went beneath the New Road, connecting the stations already there, and then bent south towards the city where it would terminate in an underground complex with two stations – one for long-distance traffic and one for local traffic – then it would surely be considered. Not wanting to leave anything to chance, this time he was canny enough to go armed with a set of statistics proving the amount of people coming into the city of London.[2] Pearson appointed traffic takers to count the number of people entering and leaving between 8.00am and 8.00pm on all the major routes into and out of the city. [3] His evidence established that omnibuses accounted for 44,000 passengers. On the railways, 27,000 people arrived at Fenchurch Street and London Bridge, but only 4,200 were coming in at King's Cross, Euston and Paddington. Some 26,000 used private carriages or hackney cabs but even all these numbers combined couldn't eclipse the 200,000 who were walking into the city. [4] Pearson had shown beyond doubt that

> the overcrowding of the city is caused, first by the natural increase of the population and area of the surrounding district; secondly, by the influx of provincial passengers by the great railways North of

An Unlikely Hero 7

London, and the obstruction experienced in the streets by omnibuses and cabs coming from their distant stations, to bring the provincial travellers to and from the heart of the city.[5]

But his denouement was 'the vast increase of what I may term the migratory population, the population of the city who now oscillate between the country and the city, who leave the city of London every afternoon and return to it every morning.'[6] Pearson reasoned that people were already making the journey into and out of the city – they just needed to do it in some other capacity that didn't require travelling on the roads. And he didn't overlook the poor either; expressing their predicament with the kind of brevity that had probably earned him his role as city solicitor: 'A poor man is chained to the spot. He has not leisure to walk and he has not money to ride a distance to his work.'[7] Pearson – wearing his social reformer hat – knew how dire the plight of the poorer classes had become; those who lived cheek by jowl in the filth of the metropolis's many slums. These were the 'sickly' and 'half starved' beggarly persons portrayed by Engels in *The Condition of the Working Class in 1844*. Pearson's vision to alleviate congestion wasn't the real driving force of his proposal. At the heart of his campaigning lay a genuine desire to improve the dismal and squalid conditions in which the poor and slum-dwelling classes routinely lived. This he hoped could be achieved by housing workers in the less-polluted suburban districts already being built along the route of the GNR, away from the ills of the metropolis. He also suggested they be offered cheap fares to make their daily train journey to work.

Pearson deposited his City Terminus Bill in Parliament in 1852, hoping this time his scheme would pass muster.

Sadly, it did not.

His logic was sound on paper, but like all good ideas, vision was only going to take him so far. What he really needed was financial backing. And for that he needed businessmen.

As luck would have it, a more commercially minded venture was also being proposed at the same time by a consortium of businessmen. In 1853, this entirely separate underground scheme – originally known as the Bayswater, Paddington and Holborn Bridge Railway – had done the unthinkable and managed to obtain royal assent. This scheme would run beneath the New Road from Paddington to King's Cross and then drop

8 The History of the London Underground Map

south towards the city, but instead of the sprawling terminus complex proposed by Pearson, this line would terminate at a modest station at Farringdon. At Paddington, the line would connect with the Great Western Railway (GWR) mainline, which secured investment from the company running that line (the GWR) as well as the use of its rolling stock on the new underground line. The other connection would be at King's Cross to the GNR mainline. The GNR refused to invest in the scheme but would be charged to use the tracks that would carry its trains through to the city.

A surveyor was appointed; John Hargreaves Stevens, a colleague of Pearson's. John Fowler (later Sir John) was appointed as chief engineer. The scheme, into which Pearson's proposal had become subsumed and now known as the Metropolitan Railway, was presented to the Parliamentary Select Committee in 1854. The committee looked very closely at the issues posed by steam engines in tunnels, prompting Fowler to produce no less than Marc Brunel's son, Isambard Kingdom Brunel, as an expert witness. Brunel declared, in rather blasé terms that 'I thought the impression had been exploded long since that railway tunnels require much ventilation.' [8] He then went on to baffle the assembled committee by adding, 'If you are going a very short journey you need not take your dinner with you, or your corn for your horse.'[9]

Despite (or possibly because of) Brunel's total lack of concern, the Parliamentary Select Committee on Metropolitan Communications eventually recommended that 'the different metropolitan Railway Termini should be connected by railway with each other, with the docks, the river and the Post Office, so as to take all through traffic off the streets' [10] and commended 'Mr Charles Pearson's plan for a railway from Farringdon Street, communicating with the Great Northern station [which would become King's Cross] and the Metropolitan Railway.'[11]

All well and good – except the committee neglected to offer any further insight as to how the scheme might be realised, only that it should be 'carried out by private enterprise.' [12] It is worth noting here that although the government had no direct involvement in bringing a railway scheme to fruition, all bills were scrutinised and considered by parliament, which in the 'railway mania' of the 1840s meant over 400 different projects. This laissez-faire approach to regulation could delay and frustrate major infrastructure projects. As far as the committee were concerned though, it

was 'job done' and they could now wash their hands of the entire project. It was up to the company to find the necessary capital – in this case, a staggering £1 million; although in that respect, 'the gadfly' would have one more trick up his sleeve.

But the long-awaited stamp of approval had been successfully sought and gained, allowing the Metropolitan Railway to form the basis for the world's first underground railway. And it had happened because of the sheer bloody-mindedness and dogged persistence of Mr Charles Pearson.

Chapter 3

Money Makes the Train Go Round

If his constant badgering was anything to go by, it is probably safe to assume that Pearson was not the sort of man to let £1 million stand in the way of his long-held vision. The social and economic impact of the Crimean War (1853–1856) wasn't going to stop him, and neither was the huge leap of faith he was expecting the financiers to make. He was a man with a plan, and he intended to see it through.

Pearson spent the latter half of the 1850s doggedly pursuing the capital needed to make his dream a reality; remaining resolutely committed to the philanthropic aims of the scheme throughout. Crisis point was reached in 1858 when the Met was almost wound up without having laid a single track, but Charles Pearson was not to be defeated. As a last-ditch attempt to salvage the project, the company spent £1,000 of shareholder money on advertising, including a pamphlet written by Pearson titled *A Twenty Minutes Letter to the Citizens of London in Favour of the Metropolitan Railway and City Station*. Eventually, he was able to convince his employer, the Corporation of London, to invest £200,000 in the scheme, and sell the company cheap land in the Fleet Valley – an unusual feat given that public body funding for capital infrastructure projects was practically unheard of in the mid-Victorian era. It was hoped that the railway would serve the meat market on the new Farringdon Road, since it would carry passengers and freight thereby reducing congestion in the city. But one also can't help thinking its motivation extended to being anxious to see the back of Pearson and his relentless harrying.

With the financial backing of the Corporation of London, support from the Great Western and Great Northern railways, plus a handful of civil engineers and shareholders – and no doubt an enormous amount of huffing and puffing, and sleepless nights – the underground was born. It had only taken a mere twenty-one years, but construction finally began in 1860.

Money Makes the Train Go Round 11

As we traverse a twenty-first century underground; a behemoth of city engineering with all the trappings of modern life – contactless card and smartphone in hand – it is easy to forget the effort involved in bringing the idea to the point of construction, let alone the many years of challenges that lay ahead. The battle that was won in the later years of the 1850s was only one of many that would need to be conquered for the underground to even vaguely resemble the 'Tube' of today. From this one line, this one tentative step into the unknown, grew a network of over 250 miles of track, covering more than 620 square miles. Much of this was built by machine, once the technology became available, but in the early years, construction would be driven by people power.

Yorkshireman John Fowler, who was selected as chief engineer, had an infrastructure pedigree that preceded him, having worked on several major railways across the country. Fowler would be the driving force behind the decision to use the cut and cover method. This involved digging up the main roads of the route so that a trench could be built under them (the cut). Tracks would then be laid inside, and the walls supported by bricks. All of this would be housed under a roof (the cover) and the roads would be relaid on top. Stations could be accommodated either within the cutting and reached by steps, or on the surface. The method only needed to go a shallow distance under the surface, thus negating the need to enter the fiery pits of hell predicted by the naysayers.

While Fowler and his team of engineers were riding high on a tide of mid-Victorian gumption, what they really needed was brute force, hard labour and more than a few shovels.

Fortunately, mid-Victorian Britain was awash with a particular breed of labourer entirely suited to the task – the infamous navvies. While history tends to remember the black-hatted specimen engineers and industrialists of the era, the workmen who lent their efforts to the actual building process have been largely forgotten. Yet what they lacked in engineering skill, they more than made up for in hard work and a long pedigree of large-scale construction projects and back-breaking physical labour.

The navvies were men whose ancestors had cut their teeth on the navigations – the term 'navvy' derived from those who had worked on the navigable canals in the late-eighteenth and early nineteenth century. They were a travelling, ready-made workforce, made up of agricultural labourers from Ireland and Scotland, or tin miners from Cornwall.[1]

12 The History of the London Underground Map

They had a reputation for fearlessness; at work and at play; and it was not unusual for them to indulge in long drinking sessions and brawling once they had clocked off.

This didn't exactly endear them to the local population, whose noses were already out of joint at the havoc and disruption being wreaked by the Met. Hoardings obscured front gardens, whole streets were blocked off and many houses were shored up with huge beams to prevent them from falling over. As *The Daily News* observed in June 1862, 'For the best part of three years a great public thoroughfare has been turned into a builders' yard.'

Anyone brave enough to look down into the cutting – and therefore into the bowels of London – would be greeted with 'veins and arteries which it is a death to cut. There are water-mains, with their connecting pipes; the main or branch sewers, with their connecting drains; the gas mains, with their connecting pipes … and very often the tubes containing long lines of telegraph wires.'[2]

Inevitably, things got tricky. In June 1862, the notoriously revolting Fleet sewer burst. The Met would have to cross it three times to follow the planned route and the accident occurred on its third and final encounter with the railway. The 'imprisoned river'[3] had, according to the *Illustrated London News,* been 'nettled at the cavalier way in which it had been elsewhere treated'[4] by its 'unsavoury neighbour'.[5] Its response was to send a deluge of foul water and effluence into the workings east of King's Cross. Fortunately, no one was harmed as 'the massive brick wall, eight feet six inches in thickness, thirty in height and a hundred yards long, rose bodily from its foundations as the water forced its way beneath.'[6] The 'river of doom' is now safely ensconced in a pipe at Farringdon, never to trouble the underground again.

Luckily, the Met's PR machine was well-practised in damage limitation; often inviting journalists and illustrators to appraise the progress being made and laying on stage-managed trips on the unfinished line. These showcases usually included an element of eating and drinking, ensuring that even the most jaded of Fleet Street's hacks could be persuaded to write a favourable review. Following the Fleet sewer debacle, and anxious to reassure a rapidly cynical public, the Met organised more trips along the line in August 1862. On one occasion, over 500 VIP passengers were treated to an open-carriage trip from Farringdon Street

Money Makes the Train Go Round 13

to Paddington. Yet another 'very substantial luncheon'[7] was consumed at Edgware Road Station before the press and other VIPs were sent on their merry way.

It must have done the trick. The *London Daily News* later described the 'prosperous journey'[8], commending the railway on its triumph over the 'insidious fluvial enemy'[9] – the Fleet sewer – as well as the 'steady motion of the carriages'[10] and 'light, cheerful'[11] stations. The *London Evening Standard* also waxed lyrical with descriptions of the 'glittering lights ... shimmering through the steamy darkness.'[12]

The Met didn't need much of an excuse to lay on a good spread and there were to be several more in the run up to opening, as well as further trips on the line.

Happily, the men who built the line were not forgotten among all the feasting and merriment. In August 1862, the Met hosted a dinner for 600 workers at Gower Street Station, including the navvies and labourers in which 'several loyal and patriotic toasts were drank with musical honours ... and great enthusiasm.'[13] After several speeches, the 'conviviality was kept up till a late hour.'[14] After all, there was much to celebrate. The experimental scheme had been three years in the making. Three years that had seen two deaths from a boiler explosion, backbreaking labour, numerous compensation claims, false starts and financial struggles, plus the attempted *coup de grace* of the Fleet sewer. The achievement was, frankly, remarkable. The navvies must have done a good job as it wasn't the last time they would be called upon. Much to the chagrin of the well-to-do residents of Notting Hill and Kensington, they were also employed to dig the Metropolitan District Railway.

The most important VIP visit was the inspection by Colonel Yolland, inspector of railways for the Board of Trade. The opening of the line very much depended on his sign-off but on the day of the inspection on 15 December 1862, 'Cranks would not turn, and points refused to move, from some cause trifling in itself, and no doubt easily to be overcome, but sufficiently vexatious in effect, inasmuch as the approval of the Government officer must be retarded until the smallest details are perfect.'[15] Perhaps if they'd given him some lunch, the outcome might have been different.

The Metropolitan Railway Company finally opened the world's first underground railway almost a year late, in January 1863. As expected, the

14 The History of the London Underground Map

chosen method of celebration was yet more eating, drinking and back-slapping. A banquet was laid on for stakeholders and VIPs at Farringdon Street Station with no expense spared. A temporary room adjoining the station was erected with a 700-person capacity and 'lined throughout its entire length with red and white cloth, and banners of all nations were suspended from the ceiling and side walls.'[16] In a cruel twist of fate, the man whose vision had driven forward the scheme, Charles Pearson, had died the previous autumn, having never seen his revolutionary underground railway in full service.

Notwithstanding his relentless enthusiasm for the scheme, even Pearson couldn't have predicted the early success of the railway, drawing some 30,000 passengers on its first day of service on 10 January. The *Illustrated London News* reported that

> the desire to travel by this line on the opening day was more than the directors had provided for; and from nine o'clock in the morning till past midnight it was impossible to obtain a place in the up or Cityward line at any of the mid stations. In the evening the tide turned, and the crush at the Farringdon-street station was as great as at the doors of a theatre on the first night of some popular performer.[17]

Despite the doom-laden predictions of *The Times* in 1861 that the railway was 'Utopian and one which, even if it could be accomplished, would certainly never pay ... an insult to common sense',[18] the public, rather sensibly, decided to ignore such scepticism and voted with their feet. Faced with unequivocal evidence of the railway's success, the newspaper soon changed its tune, hailing the project as 'the great engineering triumph of the day'.[19]

Passengers had the choice of three different classes of carriage, and fares set at three pence, four pence or six pence for a single journey and five pence, six pence or nine pence for a return. The underground was yet to become the pluralistic experience we recognise today, with the class system very much in operation even at subterranean level. In case anyone forgot where they were supposed to be, signs hung along the platforms ordering passengers to 'Wait Here For First/Second/Third Class'. An early traveller, Sir William Hardman, who was most certainly a first-class passenger, recorded that 'The carriages (broad gauge) hold ten persons,

Money Makes the Train Go Round 15

with divided seats, and are lighted by gas (two lights); they are also so lofty that a six-footer may stand erect with his hat on.'[20] This was quite a boast, given the fashion for stove-pipe hats at the time.

The original line of seven stations – Paddington, Edgware Road, Baker Street, Portland Road, Gower Street, King's Cross and Farringdon Street – was depicted in detail by the *Illustrated London News*, who devoted a whole page of drawings to the new stations. The illustrations show the stations at street level, gleaming white in all their newness, and decorously Italianate. Journalist, playwright and advocate of reform Henry Mayhew complimented King's Cross for its 'very elegant structure – the roof especially being worthy of notice, for the length and proportion of its span.'[21] The accompanying illustration shows the station, complete with glass roof and gas-lit glass globes, suspended like pendants from the ceiling. As the passengers gather on the platform, a broad-gauge GWR train pulls into the station, under an all-important clock. Underground miles would forever more be measured in minutes as passengers would come to neither know nor care about the distance they travelled – their only real concern being how long they would have to ride through the dark to reach their destination. Quite literally, in the case of third-class passengers who had no lighting in their carriage.

The new underground railway sparked a host of references in popular culture, finding itself immortalised in both literature and music. Composer Watkin Williams made sport of the Metropolitan Railway in his music hall ditty, *The Underground Railway*[22], where a chivalrous gentleman aids a young lady who has fainted in a carriage, only to find himself stripped of his belongings after she has recovered and left. The comic song, which was penned in 1863 and sung with 'immense applause', reflects the novelty of the experience, with its 'strange locomotion, being more like a dream', steaming 'through a tunnel, as black as a funnel' as well as providing a warning against the dangers of pickpocketing. The railway also made its way onto the stage, described as a 'glorious pathway of shining light' in Dion Boucicault's 1868 melodrama, *After Dark; A Drama of London Life*, while also providing the backdrop to the climactic scene in which the hero finds himself tied to the tracks in the path of an oncoming train. This trope – the subterranean railway as the salvation of the working-classes, yet also something altogether darker; a space to be

16 The History of the London Underground Map

feared where the potential for dastardly deeds lurked in every shadow – occurred frequently during this period.

What the Met didn't know at the time was that the principal challenges it would face wouldn't come from crime or even public safety concerns. Its greatest test was to come firstly from the GWR, and secondly from its younger sibling – the Metropolitan District Railway – in a showdown worthy of any London stage.

Chapter 4

Things Get Smutty

With up to 30,000 passengers using the railway on a daily basis in the first six months of service, the Metropolitan soon found itself increasing the frequency of its service from fifteen-minute intervals to ten-minute intervals at peak times. To meet these demands, the GWR reluctantly brought in extra rolling stock and standard steam locomotives – an unpopular decision, promptly made worse by an ongoing inquest into the deaths of three people as a result of inhaling 'choke damp', the name given to the toxic fumes emitted by the locomotives. The Met soon found the GWR to be an awkward bedfellow and by September 1863, a mere nine months after the opening of the railway, things had reached boiling point. With little interest in the Met's underground shuttle service and with growing concerns over their budding relationship with another mainline suitor – the GNR to whom the Met had promised a connection at King's Cross thus allowing the GNR further expansion – the GWR rescinded on its agreement with the Met and withdrew all its services with two months' notice. With a final twist of the knife, it also refused to sell the Met the stock it had been using, leaving the railway with 30,000 passengers but bereft of any means of transporting them.

Driven by panic, the Met hastily arranged for its new sidekick, the GNR, to lend it the necessary locomotives and rolling stock, and purchased eight tank locomotives and thirty-four passenger carriages. The Met's relationship with the GWR thawed slightly during the autumn of 1863 when the spurned mainline railway resigned itself to sharing the Metropolitan Railway with its rival, the GNR.

But the GWR would have the last laugh. With the withdrawal of its stock, it also removed the condensing tank engines that had been designed to consume their own steam and smoke. This meant the loss of the technology that the Met had been relying on to keep up the pretence that the underground was a clean and odourless means of travel. Contrary

18 The History of the London Underground Map

to the official spin that the Met peddled regularly – that the smoke-filled tunnels were entirely harmless – there was a growing body of voices ready to condemn such assertions. Accounts of passengers 'almost suffocating' or being removed from tunnels in an 'insensible state' began to circulate. These concerns were given further credence when the GNR lent the Met its steam engines, which had no steam-condensing equipment, causing the already dank tunnel air to be choked with sulphurous fumes. Brunel's horse didn't just need its corn – it needed a gas mask.

In July 1864, Beyer, Peacock & Co. of Manchester delivered eighteen condensing locomotives to the Met, and ventilation grilles were fitted in Euston Road in 1872, but the issue persisted. These concerns would follow the Met around for years and with good reason. By 1884, a journey on the underground was being likened to a 'form of mild torture which no person would undergo if he could conveniently help it.'[1]

The Met hit back in 1898 with some fairly audacious claims, namely that the fumes were health giving and that Great Portland Street Station was 'actually used as a sanatorium for men who had been afflicted with asthma and bronchial complaints.'[2] In fact, it was only the coming of electrification in the early 1900s which allowed for the fumes to finally disperse; although unbelievably steam engines survived as the carthorses of the underground well into the 1960s – hauling maintenance and engineering trains after hours, once the electricity had been switched off.

The poisonous fumes weren't to stand in the way of expansion, however. With an uneasy public to mollify, and shareholders to appease, the Met introduced cheap 'workman's tickets' for use on early trains. Henry Mayhew would describe these passengers in *The Shops and Companies of London and the Trades and Manufactories of Great Britain* (1865) – the tools of their trade marking them out as distinct from other passengers, with their 'bass baskets in their hand, or tin flagons or basins done up in red handkerchiefs. Some few carried large saws under their arms, and beneath the overcoat of others one could see a little bit of the flannel jacket worn by carpenters.'

Not only were the workman's tickets an egalitarian nod towards Pearson's original aims, but it also allowed the Met the further expansion it so desperately wanted. In 1861, parliament had stipulated that any future development of the network through working-class districts was dependent on the provision of cheap trains for working men. The first

Things Get Smutty 19

tickets were sold in 1864, at just three pence (later reduced to two pence) and were valid for travel before 6.00am provided the return journey was made after midday. The tickets proved to be popular with passengers travelling overwhelmingly in third class. Around the same time, the Met managed to bury the hatchet with the GWR, and the two companies opened a joint venture – an overground extension to Hammersmith (now part of the Hammersmith & City line). By 1868 the underground was creeping north west from Baker Street to Finchley Road, an area which would come to be known as Metroland in the 1920s, and had moved south to Gloucester Road and South Kensington.

But something far more ambitious was afoot.

In 1864, a joint select committee of both Houses of Parliament recommended an 'inner circuit' joining 'all the principal Railway Termini in the Metropolis'.[3] This was the embryonic Circle line, a scheme which the committee suggested should be carried out by one unified management. As it turns out, it would take nearly seventy years and the creation of the London Passenger Transport Board for that suggestion to be taken up. Nevertheless, the seed had been planted, and the most obvious candidate to take on such a project was ... the Met.

However, there was one major sticking point – the estimated cost of the project was over £5 million. For a company which had already committed itself to several extensions, it was going to be quite a stretch. With this in mind, it was suggested that the railway should be launched as a separate company and raise its own capital, but with representatives of the Met on its board. It would be called the 'Metropolitan District Railway' and would share an engineer – John Fowler – with the Met. The 'District' would build the southern part of the circuit, while the Met would commit to extending west to South Kensington and east to Tower Hill, where the two railways would eventually link up, thus completing the circle. It was intended that the two companies would work closely together, eventually merging into one once the circle was complete.

It was a good idea on paper, but the reality was vastly different. Construction began in June 1865, but the District was beset by problems from the outset. Despite overcoming engineering issues involving yet another river – this time the Westbourne – the main challenge was money, or lack thereof. The Met was expected to raise £1.9 million and the District was to find the rest, the not insubstantial amount of

20 The History of the London Underground Map

£3.6 million. A banking crisis during the mid-1860s not only damaged investment prospects but sent construction costs spiralling, while Met dividends fell to an all-time low. The first stretch of the District, from Westminster to Kensington took three years to complete, opening on Christmas Eve 1868, and swallowing up £3 million of the capital raised for the entire project.

The burden of raising the extra funds for the District meant that the Met wasn't in particularly good shape either. It managed to open the first part of its western extension to Gloucester Road in October 1868, meaning that the two railways could at last be connected at the western end of the line. Services were provided by the Met – for half the ticket receipts – but in the first of many episodes of bickering, the District decided to strike out on its own and buy its own trains.

By 1869 the District had scraped together the remaining funds to finish the eastern section of the line and work continued at a renewed pace. Blackfriars opened in 1870 and Mansion House in 1871. The logical conclusion to this story would be the amalgamation of the two companies, probably accompanied by a fanfare, more back-slapping, and one of the Met's famous underground banquets.

But having only built a horseshoe, rather than a circle, there was little to celebrate. Relations between the two companies were about to collapse into a bitter feud – fuelled by two men whose intense personal rivalry would complicate and frustrate the development of the underground over the following twenty years.

The District would hold its own banquet in July 1871 to mark the opening of Mansion House. The event also presaged the inevitable estrangement of the two companies. William Gladstone, in the first of his many outings as prime minister, would be guest of honour, hailing the railway as a 'matter of great advantage to every resident of the metropolis'.[4] In the same speech he also managed to inadvertently foreshadow the coming of the deep-level tubes twenty years later, remarking that, 'the time may come when you will find another metropolitan railway underneath yours.'[5]

Also present at the banquet was managing director of the District, James Staats Forbes, an ostensibly easy-going character, who also happened to have a backbone of steel. He would need it to deal with the Met. Forbes had saved many an ailing railway from financial ruin, including the

London Chatham and Dover Railway (LCDR), which he went on to chair from 1872 to 1901. Within a year of the banquet, he would oust the chairman, the Earl of Devon, and take control of the District's finances. Forbes was to provide one half of the warring factions; in the other corner was Sir Edward Watkin, who had been appointed chairman of the Met in 1872. Watkin boasted a similar pedigree to Forbes, with controlling interests in several railways, but most importantly he was chairman of the South Eastern Railway – long-time adversary of the LCDR. He was also rich, shrewd and well connected, as well as a ruthless businessman.

Between them, the two men would ensure an endless quarrel festered underground throughout the latter years of nineteenth century; and all of London was invited to pull up a ringside seat.

Chapter 5

Mind the Map

As the underground rumbled on with discontent, the principal villains of the piece did manage to extend their respective railways. Unfortunately, this expansion took place in opposite directions – Bishopsgate (now Liverpool Street) was reached by the Met in 1875, with Aldgate following a year later; and the District decided to head west into the lucrative suburban areas of Fulham, Putney, Wimbledon, Kensington, Kew and Richmond.

The city was getting twitchy. Work on the long-awaited Circle had ground to a halt and, with no end in sight, another cohort of opportunists stepped in to get the job done, calling themselves the 'Metropolitan Inner Circle Completion Company'. The proposed scheme would see the building of a spur to Whitechapel, where it would connect with the East London Railway, which was finally putting to use Marc Brunel's doomed Thames Tunnel. While the Met and the District had been flirting with other, more salubrious, parts of London, instead of doing what they were supposed to be doing, which was closing the Circle, they were now in danger of missing the opportunity to pick up passengers from East London. An inquiry, which was probably designed to kick the two wayward companies into touch, recommended that they complete their promised circle.

The warring companies called a truce for the five years it took to build the closing section. In September 1882, the Metropolitan reached the Tower of London (now Tower Hill Station) and hastily cobbled together a wooden station to stop the District from laying claim to it. Despite being constructed in sixty hours, the station lasted until 1940, when it was destroyed by a bomb. By October 1884, the gap was finally closed by joining the Tower of London to Mansion House, and normal service was resumed. That is, the arguments and hostility resumed. *Normal* service on the underground would be anything but while the two companies waged guerrilla warfare on each other. Court battles over running costs;

Mind the Map 23

the promotion of each company's own branch services at the expense of Circle line services; lack of clarity in travel information; confusing ticketing systems, and misleading poster campaigns all helped to erode public confidence. The real casualties of the war were the passengers. Any effort to regulate the setting of fares was snubbed, leaving arbitration as the only road to resolution. The *London Evening Standard*, reporting on the half-yearly meeting of the District Railway, thought the whole episode shameful:

> At present they [The Metropolitan Railway and the District Railway] both lose money by being in antagonism to each other, and whoever is to blame for that antagonism, deserves no mercy from the proprietors of either Company. For fighting means waste, and neither Company can afford to lose a penny. The present troubles of the District Company should lead the Shareholders, not to turn out the Board or the Chairman, but to press the one and the other to do their utmost to bring about a working agreement with the Metropolitan Company. They now not only fight each other in the tunnels, but by omnibuses above ground as well, and much of this rivalry is petty in the extreme.[1]

Travelling on the underground meant a journey fraught with confusing signage, as passengers battled to make sense of which railway line they should be travelling on and which booking office they needed to attend to get the correct ticket. The introduction of advertising hoardings in the 1870s and 1880s only exacerbated the issue by obscuring timetables and station names. What passengers really needed was a map.

As one of the oldest forms of visual communication, the purpose of a map is to show an area as accurately as possible to its actual topography. Naturally, the Victorians applied these same principals to their transport mapping. In the case of the mainline railways this was simple, since they ran through geographical locations that lent themselves to visual representation, such as across towns and over rivers.

The mapping of the mainline railways was well established by the time the Metropolitan Railway opened in 1863. The famous mapmaker, George Bradshaw, who had started his business specialising in navigable rivers and canals in 1827 began to add passenger-carrying railways as they

24 The History of the London Underground Map

opened. By the early 1840s, Bradshaw's *Railway Guide* was being issued monthly and contained timetables and maps of all the railway routes operating in Great Britain. As a way-finding device, the railway maps produced by Bradshaw fulfilled their primary function most effectively. Bradshaw would go on to develop his guide to include illustrations and descriptions of the points of interest in towns and cities served by the railways.

Initially, the Met and District railways made use of Bradshaw's guide to promote their respective timetables, until they began to produce their own in-house publicity. Both railways would soon come to realise that mapping the underground with any sense of legibility was almost as complicated as its construction.

The Met wouldn't produce maps in any meaningful way until 1882 – almost twenty years after it laid its first tracks. However, one early example from 1866–67 shows the route (including extensions and projected route of the District in a dotted line) overprinted on a pre-existing street plan. Overprinting on to a base map was a familiar device, dating back to the 1830s with maps of the Liverpool and Manchester Railway. The main benefit of this approach was that the base map could be used repeatedly for separate editions. Red ink was used to emphasise the route against the black ink of the topography depicted on the base map. This need to root the passengers in the subterranean space with points of reference borrowed from ground level is a common theme in the majority of nineteenth-century underground maps. However, the 'navigational excess'[2] provided by the numerous streets, parks, River Thames and even buildings only served to distract and confuse.

What the Victorians hadn't worked out was that the 'less is more' approach was much more passenger friendly. The permanent elimination of topography would come much later, but for now the Met and District would stick to their tried and tested methods of map making.

Surprisingly, the early railways did make some attempt to use a coherent approach in their styling and design. Before the concepts of route-finding, corporate identity and information graphics integrated themselves noiselessly into our daily lives, the Met and District were paving the way with their own subtle stylistic consistencies and collective iconographies. The inscription of vehicles, the choice of detail on station architecture, the use of the same fittings on platforms – all would enable

Mind the Map 25

underground passengers to recognise which line they were travelling on and, hopefully, where they might end up. Despite the eventual merger of the underground in the twentieth century, and the ubiquitous stamp of modernity, this still exists to some extent today. Different lines carry their own unique aesthetics and associations that go beyond their designated diagrammatical colours. For London historian Peter Ackroyd, the 'Northern Line is intense and somehow desperate; the Central Line is energetic, while the Circle is adventurous and breezy. The Bakerloo Line, however, is flat and despairing.'[3] Interestingly, this sentimental characterisation of the underground isn't a modern phenomenon. As early as 1905, Ford Madox Ford wrote:

> I have known a man, dying a long way from London, sigh queerly for a sight of the gush of smoke that, on a platform of the Underground, one may see, escaping in great woolly clots up a circular opening, by a grimy, rusted iron shield, into the dim upper light.[4]

Love it or hate it; the underground has always had the ability to provoke strong feelings – never more so than during the latter half of the nineteenth century. But as the century wore on, and the tentacles of the subterranean beast started to spread ever further out of London, a different set of marketing and map-making challenges would begin to present themselves.

Chapter 6

The Underground Goes Overground
(and Falls Off the Map)

Throughout the 1870s and 1880s, the Metropolitan and District railways grew exponentially. Where the original scheme had looked inwards towards the city, the two operators began to look outwards in the direction of the suburbs. Suburban expansion was an attractive proposition, as a new line had the capacity to not only tap into existing residential markets but to create new ones. There would also be no bothersome engineering issues – since the tracks would be laid overground – or costly compensation pay-outs to the aristocracy. One can almost imagine Watkin and Forbes rubbing their hands together with glee...

As a man with a finger in many pies, Watkin had early designs on the suburbs north of the city. His autocratic approach to running the Met ensured he kept his own grandiose agenda in the limelight throughout the company's expansion projects – in this case his northern interests, because he also happened to be the chairman of the Manchester, Sheffield and Lincolnshire Railway. The Swiss Cottage branch line now took on a new shine, offering a gateway for mainline northern trains into the metropolis. By 1879 the Metropolitan railway had reached West Hampstead, Kilburn and Willesden Green – rural locations that went far beyond its original city remit. A year later the railway arrived in Harrow, eventually extending out to Pinner, Rickmansworth and Chesham, before reaching its northernmost limit, the isolated Verney Junction Station, in the 1890s. A map produced in 1882 for the Metropolitan shows its reaches – the emphasis of course is on the Met's own lines, followed by the GWR and GER in a similar bold style. The District, however, is demoted to a wispy, insubstantial afterthought. Such pettiness was rife at the time and only served to increase animosity between the two operators. Harrow, despite its diminutive suburban status, takes centre stage in the top left-hand corner.

The Underground Goes Overground (and Falls Off the Map) 27

The Met's inherent skill for self-promotion, coupled with its inclination to drive passenger traffic towards its north-westerly extension would be critical in the development of Metroland some forty years later. With new extensions and proposed extensions to promote, the scale and size of the underground maps were now becoming problematic. Some outlying stations were falling off the map entirely. This wouldn't be rectified in any useful way until Beck's Diagram of 1933.

Meanwhile, the District had slightly less ambitious designs. While the Met's gamble with its north-westerly extension wouldn't pay off until the 1920s, the District's expansion schemes closer to home did much to stimulate development during the nineteenth century. The Hammersmith extension of 1874 provided the means to branch out westwards to Hounslow (1883) and then to the south to Wimbledon via Putney, where it was hoped that the Thames would provide a steady stream of leisure traffic and tourists from the metropolis. The District's early maps would reflect this connection to leisure and bourgeois pursuits. *The 'District' Railway Map of London* of 1874 claims the District is the 'Cheapest and Quickest and Most Direct Route from The City to The West End', and boasts that the 'International Exhibition, South Kensington Museum and Albert Hall, is by the District Railway'. The cover of a later map of 1879 – *The Improved 'District' Railway Map of London* – gives prominence to London landmarks serviced by the District such as the Houses of Parliament and Nelson's Column. Driven by a sense of frivolity, rather than the more serious business of residential development, the District was able to capitalise on shows and exhibitions at Earl's Court and Olympia. *Buffalo Bill's Wild West* show regularly drew enormous crowds throughout its sojourn at Earl's Court in 1887 as 'train after train brought up the holidaymakers'.[1] On 31 May, it was so crowded the exhibition gates were shut, prompting the press to report that 'Special telegrams were dispatched to all the underground railway stations not to issue any more tickets for the Exhibition.'[2] The exhibition space of 23 acres was also lent to the show by the District, and it didn't escape the notice of the press that such generosity would 'doubtless find its substantial reward'.[3]

However, it is disingenuous to think that the District's aims were completely at odds with that of the Metropolitan. It also had suburban growth in mind, and had a far easier job than the Metropolitan in stimulating speculative housing along its route. This was primarily due

28 The History of the London Underground Map

to its geographical proximity to the city centre, but also because it wasn't trying to be a mainline railway like the Metropolitan. Both would have to wait until the massive suburban growth of the inter-war years to realise the true potential of their lines.

The underground maps produced in the 1880s and 1890s also hint at the ongoing tensions between the two railways and become less about the needs of the passenger, and more a game of cartographic one-upmanship. Metropolitan maps were issued as fold-out supplements, tacked on as an appendage to other promotional material such as timetables. Not to be outdone, the District produced an extensive range of maps, including more and more topographical detail each time. These were available in book form or as sheet copies, and were crafted with large-scale visual presentation in mind – to be displayed in hotels, libraries and offices. Yet the passenger was still missing from the design brief. The need to communicate as much information as possible – about fares, train times, local attractions and other non-essential travel information, ostensibly to outdo the other railway – was still top of the agenda. Maps from this period are practically groaning under the weight of their own verbosity.

But they did have one thing in common. Both were steam railways. And both were about to be compared, unfavourably, to the newest and cleanest way to get around the city – the Tube.

Chapter 7

Notice to Quit

On 23 August 1890, the *Berkshire Chronicle* reported that 'little zinc-covered domes – they look like minarets in the distance – have been noticed cropping up above the low level of the surrounding housetops.' The Victorians were tunnelling again, and the fruits of their labour were beginning to appear, like proverbial molehills, all over south London. Only this time the mole was some 10 foot in diameter and made of metal. The 'Tube' had come to town, bringing with it a fanfare for all that was new and shiny, and a death knell for the days of steam.

London was changing. No longer was it merely the hub of industry, finance and politics, now it was a playground, where leisure and entertainment could thrive unabated. During the 1880s, the suburbs had developed rapidly, and the new breed of suburbanites gravitated towards the bright lights of the West End, bringing with them a modicum of disposal income and a thirst for pleasure and excitement. Theatreland was *the* place to be seen; its music halls and variety theatres providing a riot of colour, laughter, song and alcohol.

Increased leisure time and better transport networks also allowed retail to flourish. And no type of shop was better placed to service the new culture of commerce than the department store. With Harrods already established in Knightsbridge, Harry Selfridge decided to make his mark on Oxford Street with a magnificent baroque-style department store bearing his name. It offered 100 departments, along with restaurants, reading and writing rooms, refreshment areas, and a rooftop garden. Allegedly, he also attempted to persuade the Underground Group to call Bond Street Station 'Selfridges'. The closest he got to realising this vision was an in-store booking office supplied by the Central London Railway. These new 'cathedrals of commerce'[1] were icons of metropolitan modernity; showcasing the newest building techniques and materials. Buildings were designed with the shopping experience in mind with vast

30 The History of the London Underground Map

expanses of floor space and plate glass – all housed within iron, and then steel frames. Inside, the most up-to-date technology was on show, such as the lifts and escalators that ensured a continuous flow of customers. Most importantly, the stores had electricity.

While overground London was becoming thoroughly avant-garde in the final years of the nineteenth century, underground London began to feel somewhat archaic. The original underground lines of the Met and District were still reliant on steam; a surprising fact, given that both Brighton and Blackpool offered electric transportation along their seafronts from the mid-1880s onwards. In an early example of investigative journalism, *The English Illustrated Magazine* sent their (not so) intrepid reporter, Fred T. Jane, into the underground tunnels in 1893, to examine the plight of the railway workers. Full of the usual Victorian melodrama, his ride on the footplate of locomotive No. 18 around the Circle line gives a useful insight into the conditions in the tunnels, which he likens to 'the inhalation of gas preparatory to having a tooth drawn'.[2] Jane goes on to describe how he 'crouched low and held on like grim death to a little rail near me. Driver, stoker, inspector and engine – all had vanished. Before and behind and either side was blackness, heavy, dense and impenetrable.'[3] On entering the oldest section of the line, the 'air grew more foul … the ventilation is defective',[4] leaving poor Fred 'coughing and spluttering like a boy with his first cigar.'[5] Ironically, the article appeared as part of series titled 'The Romance of Modern London'. It wasn't Mr Jane's final foray into the exciting world of transport journalism. In the same volume of *The English Illustrated Magazine* he also gets to have a go on a torpedo boat.

All this meant that passengers were being driven up to the surface again, in search of fresh air and horse-drawn transport – a decision made even easier by an ongoing price war between the London General Omnibus Company and the London Road Car Company, the result of which had driven down the cost of travelling short distances above ground.

And then came the Tube.

Amidst all the clamouring for modernisation on the original underground, the City and South London Railway (CSLR) was discreetly bringing its innovative new line to fruition. The first of the deep-level lines, running over 40 feet below the surface – the City and South London – was constructed by tunnelling rather than the 'cut and

cover' method used before. This time the burrowing was done, in part, by machine. Building on the earlier work of Marc Brunel's original Thames Tunnel shield, and the legacy of Peter William Barlow's doomed Tower Subway project, James Henry Greathead developed the technology that would allow a harder level of clay to be penetrated, meaning tunnels could be dug-deeper and were less vulnerable to collapse during construction. The principle of the Greathead Shield was the same as Brunel's original tunnelling shield. Men (now called miners rather than navvies) were employed to tunnel out a designated section of the shield. The entire device would then be shifted forwards by hydraulic jacks and the newly dug-out section of tunnel lined with iron segments to form a tube. Each track had its own separate tunnel with a diameter of just 10ft 2ins, making them 18ins narrower than the later tubes.

Steam was completely out of the question for the new line, which was planned to run 3.5 miles from King William Street in the city, to Stockwell in the suburbs. Not only did the depth of the tunnels prohibit any kind of effective ventilation system but the line was intended to be a showcase of modernity from the outset. With the new century beckoning, it was determined to set itself apart from the antiquated Metropolitan and District railways, which had forged their own innovative paths thirty years earlier. This was a new generation of underground railway, powered entirely by electricity. The line was formally opened on 4 November 1890 by the Prince of Wales, who was presented with a gold key with which to officially switch on the electrical current. In the days before the official opening, *The Birmingham Daily Post* reported that the 'City and South London Railway marks quite a new departure.'[6]

Yet the new railway went beyond technological novelty, for it also pioneered the concept of passenger flow and refashioned the movement of people from ground level to tunnel. Everything on the new line had to be designed from scratch, as Greathead himself said in an interview with *The Pall Mall Gazette*: 'we have really had to create everything. We had nothing to guide us, for the undertaking is in every respect a novelty.'[7] This presented the perfect opportunity for a number of 'firsts'. As well as being the first underground line to be powered by electric traction, it was also the first to tunnel beneath a major waterway. More importantly for passengers, it was also the first to install lifts at all stations and the first to line the walls of all passenger areas in white ceramic tiling to aid light and

32 The History of the London Underground Map

visibility. The recognisable features of a modern mass transit system were starting to emerge – one driven by accessibility, speed and economy of time. The two lifts were designed to carry a full trainload of 100 people between them, with doors on either side so that as descending passengers were exiting through one door, ascending passengers could enter by another. The whole process would take twenty seconds. Passengers were expected to enter the carriages swiftly, passing through a set of gates which would 'open and shut up rapidly like a pair of lazy tongs'.[8] Woe betide those who were tardy who, just like their modern-day counterparts, would find themselves wedged between two doors with a carriage full of bemused commuters looking at them. To aid efficiency, the departure of each station was on a decline so that the train could pick up speed as quickly as possible.

A uniform fare of two pence, irrespective of distance, was introduced. Passengers were asked to 'simply put down their coppers and pass on to the platform through a registering turn-stile',[9] meaning 'the issue of tickets and the cumbrous booking-office system'[10] could be done away with. This, coupled with the one-class carriages, made the CSLR look positively egalitarian compared to the Metropolitan and District railways.

The original five stations of the CSLR were designed by architect Thomas Phillips Figgis. With their lead-covered domes and single-storey, red- brick buildings, they marked a distinct move away from the Italianate and neo-classical stone buildings favoured by the Metropolitan and District. Care was taken over the design elements – the lead domes were not only aesthetically pleasing but also concealed the lift mechanism. Station names appeared in gilded relief, and railings contained nested Arts and Crafts motifs, which resonated with the red-faience tiling and burnt-red platform friezes. By modern standards, it was a clear attempt at establishing a 'house style' – an enterprise in which they appear to have succeeded.

While London got its head around the newest and cleanest member of the underground fraternity, the District was busy producing ever more elaborate maps – making further improvements to the already many times improved *District Railway Map of London*. The fifth edition of the 1892 map shows a shift in focus; drawing the viewer in to the western extensions and highlighting the suburbs the District was now servicing, particularly the Putney and Wimbledon section. Interestingly,

Notice to Quit 33

the 1892 map was the first to show the CSLR, although prominence is of course given to the District's own lines. London itself is shown in even more street-level detail, rendering the District station names almost unreadable. The cover, which depicts popular London landmarks, also includes the slogan 'Time is Money', which seems somewhat ironic given that deciphering the map itself would take a while.

Another cartographic innovation emerged in this period – the pocket map. Smaller maps had been used in guidebooks since 1883 and the Met had already produced *The Metropolitan Railway Company's New Pocket Map of London* in 1889, which included a directory of civic and leisure attractions as well as a list of the company's bus services, but the *District Railway Miniature Map of London* of 1897 was the first stand-alone map. It could be folded down to a perfectly pocket-sized 14½ cm x 10 cm, making it the first officially portable map of the underground network. This was perhaps the first nod towards a passenger-friendly approach, despite the continued overuse of topographic detail.

Meanwhile under the ground, steam was taking its final gasping breaths. As the nineteenth century ended, the technology that the underground railways had relied on for thirty years was losing its 'new and innovative' cachet. Steam belonged to a former industrial age and had no place in the subterranean landscape of the twentieth century. Old insecurities were also beginning to resurface – manifesting themselves in complaints over air quality, a lack of progress, and incessant bickering between the monopoly companies.

There were also concerns for public safety. Victorian middle-class sensibilities were easily upset, and as early as 1881 *Punch* magazine was fanning the flames of disquiet by featuring a cartoon entitled *Dangers of the Metropolis*. It depicted a top-hatted gentleman being harassed on a bus and then punched by some 'roughs' on the underground.[11] It followed this up in the same decade with further illustrations of city vice. The 1885 illustration of *A Cheapside Arcade for the Penny Hawkers. Let Anyone Wanting Their Noise And Rubbish Go Underground For It*, showed a group of ne'er do wells lurking in a passageway accompanied by a ballad warning passengers of the 'Irish clan' who had 'wrecked the Metropolitan'.[12] These cartoons appeared against a cultural backdrop of what we would now consider to be terrorist attacks – the bombings at Praed Street (Paddington) and the line between Westminster Bridge and

34 The History of the London Underground Map

Charing Cross in October 1883, Victoria Station in February 1884, and Gower Street to King's Cross in January 1885. The attacks were carried out by Irish republicans campaigning for independence from the British Empire. Every attack was given masses of column inches in the popular press, and was often accompanied by vivid illustrations, which only served to perpetuate a sense of moral panic. A crash on the District Railway near Earl's Court station in 1885 compounded the idea that the subterranean environment was a dangerous space, to be avoided at all costs.

The nail in the steam coffin came in 1897. Faced with a raft of complaints, and with the knowledge that poor visibility had been a contributory factor to the crash in 1885, the Board of Trade had no option but to launch an inquiry. The investigation focused on the section of line between Edgware Road and King's Cross, and while the board commended the Met's use of the 'best smokeless coal' in its engines, it was less than impressed with the lack of any other measures to alleviate the unhealthy conditions.

The decision was made. Steam was given notice to quit.

Chapter 8

The Twopenny Tube

With electrification now considered *de rigueur*, the final years of the nineteenth century saw a swathe of tube railways tunnelling their way across the city.

While the Met and District bickered over which electrification method they would use – the Met favouring overhead power and the District preferring the conductor rail system used on the CSLR – the Waterloo and City line came into being in 1898, followed by the Central London Railway (now the Central line) in 1900.

Of the two, the Waterloo and City line boasts a simpler existence. Compared to the chequered narratives of the Metropolitan and District railways, the Waterloo and City is remarkable if only for the sheer ease with which it integrated itself into city life. As the progeny of the London and South Western, the Waterloo and City line was created with one specific type of passenger in mind – the commuter. The line would connect just two stations – one at Waterloo, and one at the Bank - quickly earning itself the moniker 'The Drain'. Tunnelling began in November 1894 and was completed in 1898. There were no court cases or compensation settlements during construction, and the capital of £540,000 was raised easily. By 1900 it was already paying dividends of three per cent, which was akin to hitting the jackpot in railway shareholder terms. The London and South Western operated the service, which was popular from the outset, carrying 16,000 passengers on the first day alone. 'Everything has passed off without the slightest hitch,'[1] one official remarked at the time. In terms of underground railway building, it was quite the goody-two-shoes.

Such simplicity was the last thing on the mind of the Central London Railway, whose far more ambitious thirteen stations cut right through the heart of London, from Shepherd's Bush to Bank via Oxford Circus. The Met and District objected from the start – seeing the aspirational and slightly glamorous new railway as an unwelcome intrusion. Their fears

36 The History of the London Underground Map

would be realised when they started losing passengers to their new rival. But Edward Watkin of the Metropolitan wouldn't go down without a fight. He fell back on his familiar argument, claiming there was no future in electric traction and that steam was still the only viable option. Suffice to say, he was ignored.

Watkin's whinging was no match for the salubrious syndicate behind the Central London Railway. It was made up of eminent financiers who lent the scheme a distinctly continental air via their European connections. Henry Tennant, the original promoter of the line and former general manager of the North Eastern Railway, was joined by Sir Ernest Cassel, principal capital fundraiser and close friend of the Prince of Wales; members of the Rothschild banking dynasty; well-connected banker Henry Oppenheim; and leading the American contingent was wealthy philanthropist Darius Ogden Mills. Ogden Mills wouldn't be the only American to arrive on the scene, as we shall see.

Tunnelling began in April 1896 under the direction of Sir John Fowler, Sir Benjamin Baker and James Greathead. Of the three, only Baker would live to see the line opened on 27 June 1900, by the Prince of Wales, who had by now become the 'go-to' royal for such occasions. The Central London Railway had grand designs for its new line, so it stood to reason that its equipment would be equally imposing. Large, powerful locomotives were brought in from America, but it soon became clear that this was a serious error. The sheer size of the locomotives – which the *Shoreditch Observer* likened to 'an enormous alligator or hippopotamus'[2] – coupled with inadequate suspension, led to complaints about vibration, and the locomotives were swapped for lighter multiple-unit trains within three years. Another American innovation, the multiple-unit trains had a cab at both ends, meaning it could be driven in either direction as the driver could simply swap ends to make the return journey. Prior to this, a locomotive would have to be run around a train at the terminus before it could embark on its return journey. It was another small but significant step towards rapid transit and improved efficiency.

The Central line – as it would become – brought a touch of glamour to the underground. With its plush moquette upholstery, leather hanging straps and generous use of brass, it portrayed the pomp and elegance that so defined the early twentieth century. As Simon Heffer neatly surmises in *The Age of Decadence: Britain 1880 to 1914*, 'Swagger was

The Twopenny Tube 37

the predominant style of the period', a pervasive mixture of 'opulence, arrogance and ornament'[3] which reflected the rise of imperial power. Empire was the buzzword of the day, manifesting itself in monument building, pageantry and endless exhibitions celebrating progress, achievement and national pride. From 1871 to 1874 each annual International Exhibition attracted over one million visitors, although latterly these ran at a loss. Perhaps the public's attitude for pomp and ceremony was exhaustible after all. Queen Victoria's Diamond Jubilee was celebrated by a Victorian Era Exhibition at Earl's Court in 1897, and in May 1899 the ageing monarch laid the foundation stone for the Victoria and Albert Museum. It was to be her last public ceremony. As the century, and the mighty Victorian era drew to a close, it was perhaps fitting that the Queen's final public act was one of legacy – a bricks and mortar monument to a great age. Queen Victoria's funeral procession was an opportunity not to be missed as far as the Central London Railway was concerned. A map produced in 1901 by the railway company details the planned route, as well as the nearest Tube stations servicing those areas – all highlighted in black ink of course.

Many of the exhibitions at the end of the nineteenth century emphasised the notion of empire as an essential part of Britain's ongoing economic success. The railway companies followed suit, particularly the Metropolitan and District, who were on the back foot and looking to woo customers back onto their lines from the Central London Railway. Mainline railways were already using posters as an effective marketing tool, so the strategy was employed on the underground too, particularly for the coronation of Edward VII in 1902. The Met produced several elaborate posters advertising its services, all of which fully embraced the pomp and ceremony of the occasion, as well as informational graphics detailing late trains and special services.

The Central London Railway would also produce posters and one would catch the imagination of the public from the outset. But first it would have its day in the spotlight, basking in the cachet of being the newest Tube line. The *Daily Mail* was quick to lend its support to the new line. A gushing account following its opening spoke of 'voracious curiosity, astonished satisfaction and solid merit ... if this kind of thing goes on London will come to be quite a nice place to travel in.'[4] *The Globe* hailed its 'cleanliness, coolness, comfort, swiftness, and cheapness'[5]

38 The History of the London Underground Map

which was a 'bold stride forward into the real and substantial Twentieth Century'[6] and the *Shoreditch Observer* was in raptures over the 'splendid invention'.[7]

Passengers flocked to the line and in the remaining five months of 1900 almost fifteen million passengers were carried at the flat rate of twopence. The *Daily Mail* would come to play an even bigger role, coining the phrase 'Twopenny Tube' within days of its opening. The popularity of the term was almost certainly inadvertent, but it captured the essence of the new line perfectly and was quickly adopted into popular culture; appearing on board games, toys and in music hall songs. It also provided useful marketing fodder, and in 1905 the Central London Railway produced a cleverly designed publicity poster that spoke directly to the Tube-travelling public. Combining a mixture of graphics, cartography and catchy slogans, the poster deliberately sought to engage, detailing the passenger journey from collecting a ticket and taking the lift, to getting on the train and leaving the station at the other end. The images combine key aspects of the Central London Railway's look, such as the innovative electric trains and the familiar red-brick architecture. The poster also included a map, which was depicted as a route diagram, an early sign of what was to come in terms of cartographic development. This sense of educating people on how to use the Tube via step-by-step instructions can also be seen as an early attempt to orchestrate and control the passenger flow.

The message was clear: the Central London Railway was a place for order and stability, where one could escape the disorder of urban life on the surface. It was also a hint of what was to come. Modernity was just around the corner, along with mass capitalism, and together they would change the face of London and just about everything in it – including the underground network.

The 1905 poster was also remarkable because it targeted an entirely new type of passenger – women. Women were largely absent from the central narrative of the early underground. It was very much a man's world; men went to work and women stayed at home, where they could construct a safe nest of domesticity away from the dangers of the metropolis. Later in the twentieth century, women would play a much bigger role in the story of the underground, be that as a commissioned artist in the 1920s (of which there were many) or as a station porter in the Second World War,

but in the early part of the twentieth century they would have to make do with being depicted in publicity posters. By appealing to women, who might occasionally break free of their domestic sphere in order to undertake shopping trips, the Central London Railway could tap into a new, lucrative market and fill its daytime trains with shoppers. This idea was mooted as early as 1900 when the line first opened. In fact, the success of the line depended on it as confirmed in this extract from the *Dundee Evening Telegraph* after a reporter asked a gentleman associate of the railway what he thought of its financial prospects:

> His reply was rather a curious one, that a good deal depended on whether women would use it to any extent. Of the early morning and late afternoon traffic to and from the City there was no doubt; the uncertain question was, how would the trains be filled during the rest of the day? So far as experience has gone, the women have taken to the use of the new 'twopenny tube' as the electric railway has come to be called in the metropolis.[8]

Women's magazines also played their part, encouraging trips, ostensibly for shopping, to the up-and-coming West End.

A poster commissioned in 1908 by the Underground Electric Railway Company encourages travel 'into the heart of the shopping centres'. The image shows a carriage populated almost entirely by women. Such targeted publicity coincided with the development of Oxford Street, and the early twentieth-century department stores such as Selfridges. Over time, women would be encouraged to travel in the opposite direction, and on different lines; out into the suburbs for picnics, day trips and perhaps the most expensive shopping trip of all, house buying in what would become Metroland

In terms of cartography, the Central London Railway benefitted from an almost entirely straight line – its trajectory following that of London's best-known thoroughfare – as well as fairly evenly spaced stations. The maps it produced initially aimed to show its proximity to various attractions and leisure haunts, thus it made sense to print the line directly on to a topographical base, which it did in 1902. Subsequent maps and publicity took advantage of its straight line, such as the 1904 publicity postcard depicting the Power House at Wood Lane, which included a

40 The History of the London Underground Map

photograph of the Central London Railway's electricity-generating station and the most simplified route map to date – a straight line running across the bottom of the postcard. This example even introduced a degree of schematics whereby the geographical space between stations is distorted to give visual balance and informational clarity. Coupled with the turned-up line ends, the diagram is redolent of Beck's future map.

In January 1901, the Prince of Wales succeeded his mother, Queen Victoria, becoming King Edward VII. As the original purveyor of 'swagger' – his louche self-indulgence was legendary – his reign saw a social and economic revolution that swept Britain into the modern world.[9] Rather like the long country house weekends the era was famed for, Edwardian Britain is often thought of as an extended period of national rest; sandwiched between the frenetic advances of the nineteenth century and the coming storm of the First World War. But intellectual and scientific advances, along with the new political movements that were emerging from industrial Britain, would ensure that Edwardian Britain would be just as decorous and full of achievement as its Victorian predecessor. London was still the largest city in the world and suburban expansion was continually transforming the urban landscape. The ongoing process of electrification would see dramatic developments in the underground railways.

And the crown wasn't the only thing changing hands in 1901.

The pressure to electrify the ailing District Railway had become too much for chairman James Staats Forbes. On 6 June 1901, Forbes told his shareholders that 'gentlemen of reputation, acknowledged ability and financial means had been found who had come forward to assist the company.'[10] Forbes' statement was partially correct. The 'gentlemen' certainly had business acumen and more than enough wealth. As for reputation, well, that was up for debate. The assistance Forbes alluded to was in the form of share purchases, at one third of the shares' face value – which gave the purchaser a controlling interest in the underperforming railway.

With a weakened position, Forbes was easy prey. After nearly thirty years at the top, he was ousted from his position by crooked Chicago entrepreneur Charles Tyson Yerkes and his financial associates. The *Land of Hope and Glory* venerated in Edward VII's *Coronation Ode* was about to be invaded by the Land of the Free.

The greatest swaggerers of all had arrived in London – the Americans.

Chapter 9

Concerning Mr C. T. Yerkes

'A good many Londoners feel a direct and eager personal interest in Mr Charles Tyson Yerkes,' *The Bystander* wrote in 1905. 'They would like to get him in a corner, and interview him. They would take him by the coat and say: "O Financial Magnate, tell us of your charity, *when* are you going to get the District electrified?"'[1]

It was the question on the lips of many a Londoner.

Yerkes had arrived in London in 1898 with his latest paramour, 24-year-old Emilie Busbey Grigsby, allegedly to escape various ex-wives and ex-girlfriends in New York. Described by the *Weekly Journal* as 'a good-looking man', with an 'eminently deliberate manner',[2] a photograph taken in 1900 shows a steely-eyed man on the make, whose strong jaw and high forehead would later see him caricatured by the artist and writer Max Beerbohm under the heading, 'One of Our Conquerors'.

Born in Philadelphia in 1837, his reputation for bribery and crooked dealings preceded him; yet it was Yerkes who would have the biggest influence on the growth of the network and the eventual unification of the Tube lines in the early twentieth century. Having accumulated a fortune in financially dubious electric tram and elevated railway schemes, Yerkes came unstuck following a fire in the commercial heart of Chicago in 1871. The shock waves following the Great Chicago Fire, as it became known, rippled throughout the Eastern United States and Yerkes, who had his funds spread too thinly, was forced into bankruptcy. To make matters worse, he was unable to pay interest on money he was holding for the city of Philadelphia, meaning he was indicted for embezzlement, spending seven months in jail before being pardoned.

Yerkes set his sights on a second fortune – this time targeting Philadelphia's local streetcar network, the 'Continental Passenger Railway Company', which he helped to finance. Following a move to Chicago in 1882, horse-drawn tramways became his focus before he finally settled on the financing and construction of the city's 'loop' railway.

42 The History of the London Underground Map

How he managed his financial affairs remains a mystery. Suffice to say financial manipulation, political corruption, corporate backhanders and a tangled web of interlinked companies, subsidiary companies, holding companies and directorships all featured in his business dealings. All this meant that Yerkes' empire building was so complicated, it was beyond comprehension. And beyond the law.

But it did make him several enemies in high places, and it is likely that his arrival in London coincided with a need to leave the USA for more sinister reasons than a string of spurned lovers. His reputation Stateside was ruined, so he decided to conquer a British transport network instead. Fortunately for Yerkes, there was already an atmosphere of chicanery and dodgy dealings permeating the underground railway network in the early twentieth century – he slotted right in.

The trouble this time was with the fledgling Baker Street and Waterloo Railway, a route of 3 miles with intermediate stations between Baker Street and Lambeth North. The line was authorised in 1893, but the company was struggling to raise the necessary capital to bring the railway to fruition. In 1897, the company was approached by the London and Globe Finance Corporation, headed up by yet another shady businessman, Whitaker Wright. Wright was born in England but made his fortune mine prospecting in the USA before returning to the UK and building an estate in Surrey, complete with subterranean tunnels that led to a series of rooms under a vast lake.

The London and Globe Finance Corporation invested heavily in the Baker Street and Waterloo Railway, to the tune of £700,000, and construction began. But after eighteen months, the Globe's funds ran out. Like Yerkes, Wright's business empire consisted of numerous interlinked companies – some merely existing on paper – and the heavy losses of one invariably impacted on others. The problems quickly spilled over into the railway project, and despite Wright's attempts to salvage the situation by talking up the value of the railway's shares, the London and Globe was declared bankrupt in December 1900. Work on the railway stopped and the contractors waited to be paid, but while the workmen were downing tools, Wright was scuttling off on the first boat to France. With furious creditors hounding him and the threat of criminal prosecution looming large he headed for America, where he was promptly apprehended and slung on the next boat home. His trial, in January 1904, saw him found

Concerning Mr C. T. Yerkes 43

guilty on twenty-four counts of fraud to the value of £5 million. In the 'death-like stillness'[3] of the court, and in a 'low voice that at times fell to a silvery whisper',[4] the judge, Mr Justice Bigham, gave a damning sentence:

> I confess that I see nothing that in any way excuses the crime of which you have been found guilty, and I cannot conceive of a worse case that yours under these sections of the Act of Parliament. In these circumstances, I do not think I have any option except to visit you with the severest punishment which this Act permits, and that is that you go to penal servitude for seven years.[5]

Before being escorted from the court, Wright replied belligerently, 'All I can say is, I am as innocent of any intention to deceive as anyone in this court.'[6]

But there was more drama to come.

Wright was taken to a consultation room before being handed over to the prison authorities, apparently with 'remarkable vigour of mind'[7] and with 'some show of unconcern'.[8] But half an hour after the trial ended, he collapsed and never regained consciousness. Despite some initial speculation that he had died of a heart condition, rumours were quick to circulate that he had taken his own life. The story was given further credibility by a friend of the deceased who said Wright had told him 'he would never leave the precincts of the Court alive'[9] and 'would kill himself immediately upon receiving sentence.'[10]

An inquest held the following day showed that Wright had killed himself with a fatal dose of cyanide, most likely taken when he went to the lavatory alone. The inquest revealed that in the moment before his death, he drank a glass of whisky and water before conversing 'calmly and collectedly with his solicitor about the prospects of a new trial.'[11] His final words, directed at his solicitor, which 'betrayed nothing whatever as to his terrible condition to those around him – were, "Worters, give me another cigar."'[12]

The incident was a sensation. The *Illustrated London News* published a full page sketch of Wright receiving his sentence with the caption, 'The Most Dramatic Trial of Modern Times'[13] and *The Saturday Review* called it 'one of the gloomiest and most sensational dramas of modern finance'.[14] News of Wright's shocking demise quickly travelled across the Atlantic;

44 The History of the London Underground Map

The New York Times reporting that, 'Even in his life, which, with his rise from poverty to enormous wealth, was full of dramatic incidents, there was nothing that could compare with the manner of his death. All London tonight is thrilled with the news of it.'[15]

As one crook fell, another was waiting in the wings. Before Whitaker Wright's doomed court case, Yerkes had already approached the Baker Street and Waterloo Railway directors at the end of 1901 to cut a deal. Having been saddled with one charlatan already, one would have thought the railway would want to align itself with someone more respectable. Nevertheless, Yerkes' offer to buy out the London and Globe's shares was accepted. In exchange for this act of heroism, his financial syndicate was to have a majority on the board. Work on the line resumed, which would include an extension to the south of Waterloo to Lambeth North.

While the workmen on the Baker Street to Waterloo line picked up their shovels again, Yerkes was busy shaking hands with American investors – his special brand of charm convincing them to back his Metropolitan District Electric Traction Company. The company began life in 1901 with a capital of £1 million, and it was through this company that Yerkes was able to buy up shares in the District Railway, ousting chairman James Staats Forbes in the process. Plans were made to build a power station and electrify the railway, but Yerkes' vision went beyond a half-built Bakerloo line and an ailing underground steam railway.

Following lengthy negotiations with the GNR and a number of other parties, the company secured the right to construct what would become the Piccadilly line between Hammersmith and Finsbury Park. This involved yet more slippery manoeuvres – Yerkes would need to thwart a fellow American, John Pierpont Morgan, and his associates, via an act of ruthless commercialism to succeed – but the transaction was eventually completed in 1901. In the same period, Yerkes would also acquire the Charing Cross, Euston and Hampstead Railway – the embryonic beginnings of the Northern line.

The original capital of £1 million now seemed a rather pitiful amount. What Yerkes needed was a lot more cash. This time the money – £5 million – would be raised via German-born banker Edgar Speyer and a new company would be formed, the Underground Electric Railways of London (UERL), which would take over from the original Metropolitan District Electric Traction Company. Using his tried and tested methods

of dubious financial artistry, Yerkes was again able to secure significant funding for his projects, with the majority coming from American and continental investors.

And so, we return to the question with which we started: when *did* Yerkes finally electrify the District?

The answer is the autumn of 1905, some four years after he acquired the line. Yerkes would be dead within months of this watershed moment, having finally brought London some semblance of the cohesive rapid transit network he had envisaged.

But to get this far he would have to take on the District's old sparring partner – the Met – and it wasn't going to go down without a fight.

Chapter 10

The Monster and the Metropolitan

'To see what it is which is superseding the antiquated instruments of an old idea,' the *Berkshire Chronicle* reported in a flurry of excitement in early 1905, 'one must go to the huge power station in Lots Road Chelsea.'[1]

Yerkes now had four railway lines, as well as plans to build more Tube lines and acquire electric tramways. With high hopes of success in all areas, Yerkes and his associates set about building the largest electrical generating station in Europe. Sited at Lots Road in Chelsea, on the banks of the Thames, it was an 'enormous building, stately in proportion, ponderous in strength, full of marvels of machinery and of method.'[2] In other words, it was utterly in keeping with the fashion for grandeur and architectural arrogance. Boasting the largest chimney stacks in the world, among other adjective-laden claims, it was the ultimate expression of arrival. Yerkes was here to stay, and he meant business: here was the man and his 'Chelsea Monster', as it would become known.

Others weren't so readily impressed. The aged American artist, James McNeill Whistler, who was known for his ethereal night-time impressions of the Thames, was most upset, which was ironic given his known aversion to sentimentality. Perhaps mercifully, Whistler died in 1903 before the building was completed. The UERL would have the last laugh and in 1910 would produce a Whistleresque poster called *The Moving Spirit of London*, depicting Lots Road at night – a waterside cathedral of modern life. The poster was also used as a further opportunity to promote the power station's impressive statistics.

The site, building and equipment would come in at £1.3 million, which the UERL was quick to point out to a journalist was 'paid in sovereigns'.[3] It was an odd comment, but given its previous track record for selling worthless pieces of paper it was, perhaps, keen to put an end to its negative image.

The Monster and the Metropolitan 47

Lots Road would generate the power for most of the underground for the best part of a century, burning 500 tons of coal a day, which supplied eight turbo-generators producing a current of 11,000V AC. This was then converted at substations into 550-600V DC for the company's lines.

As with all activity undertaken by the District, the Met remained staunchly unimpressed by the newly formed UERL. It was also unimpressed by the proposals put forward to finally electrify the jointly run Circle line. The Met favoured the Hungarian Ganz overhead system, but Yerkes had misgivings over its safety. He preferred the familiar direct-current conductor-rail system he had used to great effect in Chicago. To break the stalemate, Yerkes offered to pay for the electrification of the Metropolitan Railway in return for a royalty payment – an offer it turned down. Then, to rub salt in the wound, Yerkes offered to run the Metropolitan Railway for the shareholders in return for a higher dividend than they had latterly been receiving.

The Met would finally see its plans go up in smoke via a twelve-day tribunal in September 1901. The Board of Trade ruled in favour of Yerkes and in a final display of defiance the Met refused to allow Yerkes to supply the electricity, preferring instead to spend money it didn't really have building its own power station at Neasden, which was completed by December 1904. The Met would introduce its first electric services in early 1905, which would be followed by the introduction of electric services on the Inner Circle – which would become the Circle line – later the same year.

Having given life to his electricity-supplying monster at Lots Road, Yerkes set about making improvements to his newly acquired railway lines. In a frenzy of activity, which would all be over by 1906/7, the UERL – headed up initially by Yerkes – set about modifying, refashioning and smartening up the look of the network. By autumn 1905, the District had been given the all-American treatment. Its new electric trains were given a snappy new trim in maroon and gold and remodelled to include open saloons and raised clerestory roofs. Londoners would breathe a collective sigh of relief as they waved goodbye to unreliable services, gloomy stations and a mouthful of smut. In its place they got rapid transit, efficiency and a mouthful of Americanisms – 'straphanging' and 'elevator' being two such examples – although true to form the British would drop 'straphanging'

48 The History of the London Underground Map

as soon as handrails came into use, and 'elevator' would die a death in favour of 'lift'. Why have four syllables, when you can have one?

A new etiquette needed to be learned too. Not one to mince his words, Yerkes identified, correctly, that early twentieth-century Londoners were

> the worst people to get a move on I ever knew.... To see them board and get off a train one thinks they had a hundred years to do it in; they are doing better, and in the end I shall work them down to an allowance of thirty seconds.[4]

His sliding carriage doors would ensure the experience was akin to leaping through the jaws of a hungry animal, and so the pace soon picked up. Scandinavian essayist Sigurd Frosterus wrote in 1903 of passengers being 'sucked in unawares through the mechanically opening double iron doors into the bogie-carriages of the accordion-like train.'[5] Unaware or not, ensuring that passengers actually got on to trains was better for business and guaranteed the tempo of the metropolis continued at a brisk pace.

Things were looking distinctly Stateside above ground too. The consolidation of lines under the UERL ushered in a new 'house style', epitomised in the station designs produced by architect Leslie W. Green. All three of Yerkes' Tube lines – the soon-to-be Bakerloo, the embryonic Piccadilly line and the Charing Cross, Euston and Hampstead Railway – either ran through or converged in the West End of London. A fashionable district needed equally fashionable stations, and so they were built to be two-storeys high and faced with ox-blood-glazed bricks. Their attractiveness cleverly belied not only their functionality, but also how adaptable they were as uniform pieces of architecture. Each station was of load-bearing steel-frame construction, around which pre-moulded brickwork could be positioned, and bay or semi-circular windows incorporated. The steel frame could not only take the weight of the lift motors, which would be housed on a mezzanine level, but it also allowed for a much wider entrance – which would assist passenger flow – and the addition of lettable retail spaces in the space below. The new stations, of which there would be more than forty, were more than a match for their single-storey contemporaries, eclipsing their Central line neighbours in just about every respect with their gold serif lettering and decorative cartouches. If you couldn't flaunt it in the West End, where could you?

The Monster and the Metropolitan 49

Inside, the décor and signage for each station had its own unique colour scheme. Patterns were used on the platform tiling to assist passengers in recognising their stop, and signs for the way out and the station name were fired into the tile work. The Bakerloo (formerly the Baker Street and Waterloo Railway) opened from Elephant & Castle to Baker Street in 1906, making it as far as Edgware Road Station by 1907 via Marylebone. By 1913 it would be extended to Paddington. The Piccadilly (the route formerly known as the not-so-catchy Great Northern, Piccadilly and Brompton Railway) opened in 1906 from Hammersmith to Finsbury Park. The Hampstead Tube (formerly the even-less-catchy Charing Cross, Euston and Hampstead Railway) would follow in 1907, which would eventually come to be called the Northern line. All three would appear on a UERL map of 1906 – the latter two lines already making an appearance despite being 'under construction'. The Hampstead would get a distinctive red white and black map to mark its opening in 1907. It is devoid of the topography that was so prevalent on the earlier maps and shows some geographical distortion – although this did little to ease the overcrowding in the Holborn and city areas. Interestingly, the map features a motif stating the Hampstead Tube to be 'The Last Link'. It was a celebration of the fact the Hampstead Tube marked the culmination of the UERL's scheme to construct and commence train services on the three Tube railways it managed within fifteen months.

Such a frenetic period of activity was all very impressive; a conscious attempt by the UERL to project a spirit of modernity and progression, while putting to bed the chicanery and underhandedness that got it there in the first place. A map cover from 1907 encapsulates this sense of importance. The UERL is 'swift and sure', a burst of electricity dominating the London skyline and what lay beneath. It alone could show you 'The Way Through London'. But underneath the glamorous and self-assured veneer, there was a crumbling edifice. Yerkes had left behind a legacy of beautiful architecture and a transit system fit for a twentieth-century metropolis, but he'd also spent five years papering over the cracks of a precarious financial structure that was on the verge of toppling over.

The problem was down to performance, or more accurately, underperformance. Yerkes' tubes just hadn't made the gains they needed to ensure financial stability. Although passenger numbers had grown,

50 The History of the London Underground Map

they had done so too slowly and were well below the projected pre-opening numbers. The estimates were optimistic: the Bakerloo had been expected to carry 35 million passengers annually but achieved only 20.6 million in its first year; the Hampstead planned for 50 million and achieved 25.2 million, and the Piccadilly trailed well behind the others, achieving just 25.8 million out of a predicted 60 million.[6] It made for fairly dire reading, particularly for the investors Yerkes had charmed into buying 'profit sharing notes' worth £7 million, which were due to be redeemed by 30 June 1908. Conveniently for Yerkes, he would die at the end of 1905, thereby releasing himself from any kind of responsibility for repaying this vast sum.

So, what to do?

Following Yerkes' death, banker and financier Sir Edgar Speyer took over as chairman. Speyer was well aware of the precarious nature of the UERL's financial machinations, since he himself had collaborated with Yerkes to raise the original capital for the scheme. Speyer's first job was to recruit Sir George Gibb, general manager of the North Eastern Railway, as deputy chairman and interim managing director. Gibb was a progressive-thinking Scottish lawyer and brought with him a raft of transport management experience.

His first measure was to reverse some of the fare reductions that were brought in to entice passengers onto the line. The reductions had cut revenue but hadn't increased footfall. He also had the rather inspired idea to amalgamate the three Tube lines into one company, thereby reducing overheads. This did not impress the American investors, whose unshaken faith in Yerkes meant that they still believed they were due a windfall via the individual companies once profits improved. The District was on the verge of bankruptcy and attempts to sell the UERL to London County Council had fallen flat. Speyer ended up ploughing money from his own bank into the company to try and stave off bankruptcy. Without the government assistance that major infrastructure projects enjoy today, Speyer and Gibb had only one option – to convert the troublesome 'profit sharing notes' into a long-term debt, redeemable in 1933 and 1948.

As Gibb and Speyer grappled with the figures, the Americans decided to look for some homegrown talent to appoint as general manager. Top of their wish list was someone who could help them protect their investment by preventing the merger of the lines under one management. Albert

Stanley arrived from the USA in 1907, on a three-year contract and with a remit to untangle the UERL's financial mess. For his troubles, he would be paid £2,000 a year. Ironically, Stanley would come to recommend the same amalgamation strategy as Gibb. Stanley was born in Derbyshire in 1874 but had lived in the USA since he was a small child. By the age of fourteen he was working on the railways, joining the Detroit Street Railway as a messenger boy, and by 1903 he had gained the position of general manager at the New Jersey Tramways. What Stanley brought with him was an almost intuitive understanding of how to run a large-scale metropolitan transport network. As well as bringing a new energy and dynamism to the role, he would develop new alliances and negotiate mergers with charm and aplomb. By (mostly) keeping on good terms with the press, he also helped grease the wheels of the UERL PR machine, and its predecessors.

Over the next three years, Stanley would come to know the company inside out and was therefore well placed to take forward Gibb's sensible reforms when Gibb stepped down as managing director in 1910, leaving the door open for Stanley to take his place. Gibb's stay at the UERL may not have been long, but he did gift to the city some exceptionally talented transport managers before he left. One, the fastidious and commercially minded Frank Pick, whom Gibb had worked with at the North Eastern Railway would, like Stanley, come to have a dominant influence on London's transport networks for many years. More on him later.

Stanley quickly recognised that the smaller underground and tram companies – of which the UERL had already acquired one under Yerkes' leadership, the London United – could not survive if they continued to be run as individual concerns. For a brief moment in 1907, it looked as though the majority of city transport operators – rail *and* bus – might consider coordinating on fare policies. Starting with the operators of east to west services, the Central London Railway and Metropolitan were persuaded to increase the fares for longer journeys to three pence. Following this, a meeting that included bus and tram operators, as well as representatives from the underground railways, would see operators tentatively agree to a series of coordinated fare rises. However, the thought of working together with the railways was a step too far for the bus and tram operators. With no official legislation to enforce the agreed fare policies, they would eventually withdraw. But it did force the underground

52 The History of the London Underground Map

operators to consider their individual futures. Motor buses were an ever-present threat to business. The Central London Railway, and CSLR were particularly affected in the bus-heavy West End and city areas, a problem further compounded by a lack of access to the more profitable suburban traffic. A meeting of all the underground railways including – *gasp* – the Met, would see the creation of a joint booking system which would allow through journeys without having to buy a second ticket. They would also agree to install illuminated 'UndergrounD' signs outside each station, a small but significant change in the fiercely independent mentality that had been the driving force behind every railway company up to that point.

By 1912, the UERL had gained control of another tram operator, the Metropolitan Electric, and was on the verge of acquiring the London General Omnibus Company, which ran the majority of the capital's bus services. It would use these services as feeders to its underground routes. By 1913, the Central and City and South London were purchased cheaply by the UERL – the two lines now struggling against the motor bus onslaught. In the same year, the UERL made an offer to the Met which it rejected, unsurprisingly. Instead, the Met bought up the Great Northern and City Railway. This left the Waterloo and City line, which would continue to be owned and managed by the London and South Western Railway. This seemed to suit everyone since it only comprised two stations and a shuttle service.

This new look amalgamated UERL would come to be known by the slightly Orwellian-sounding 'Combine' although Orwell's famous dystopian novel, *Nineteen Eighty-Four*, was still thirty-six years away. Luckily for Londoners, they wouldn't get a series of sinister looking posters to remind them that they were being watched by Big Brother. What they would get was a series of design icons, key branding elements and remarkable examples of creativity that would see the city through the twentieth century and beyond.

Chapter 11

Bullseyes, Bars and Circles

'London Underground Railways get nearly £100,000 a year from displaying posters in stations, trains, lifts and buses,'[1] declared the *Hampshire Advertiser* indignantly in March 1917. It was a tidy sum – worth over £5.6 million in today's money[2] – but it didn't make for tidy stations.

Selling advertising space in areas of the underground with heavy footfall was an important revenue stream for the UERL, but the mish-mash of artistry and promotional messages it generated also compromised the visibility of station names and other signage. Moving people around the network with speed and efficiency was part of the UERL's new ethos, but it would be difficult if passengers didn't know which station they were at to start with. As early as 1908, hot on the heels of the new 'UndergrounD' wordmark, Stanley was considering his options and a reconnaissance trip to France would bear fruit. In the Paris Métro, Stanley noted that each station name was repeated in white lettering on a strip along each station wall – sometimes up to ten times, which was much more frequently than on the London Underground. He would bring this example of French *par excellence* home with him and promptly order a series of signage trials at St James's Park. The first was a white panel with a long blue sign, which had the station name in white capital letters printed onto it à la the Parisian way. But it was decided that these were not distinctive enough, and so red paper half-moon discs were applied above and below the blue bar to give a 'bullseye' effect and draw the eye of the passenger. A trial proved that these were more successful than the nameplate alone, and the UERL would roll out the 'roundel', as it came to be called, across each of its stations over the next six years. And so began one of the greatest corporate branding coups of the early twentieth century.

It is impossible to discuss the story of how the UERL forged a new path to corporate modernity without giving due credit to the enormous contribution made by Frank Pick, who would be instrumental in

54 The History of the London Underground Map

introducing Harry Beck's Diagram to the world. Described by historian Nikolaus Pevsner as 'the greatest patron of the arts whom this century has so far produced in England, and indeed the ideal patron of our age',[3] Pick saw beyond the underground as just a 'railway amongst the sewers'.[4] He recognised it as something greater; an opportunity to provide a new vision of the city, thereby enhancing civic life.

Pick was born in 1878 in Lincolnshire. The son of a Methodist draper, he was described by Stanley as having 'a sterling character and steadfast loyalty', as well as 'an administrative ability which was outstanding'.[5] Pick joined the UERL in 1906, alongside his former manager at the North Eastern Railway, Sir George Gibb, becoming traffic development officer in 1909 and commercial manager in 1912. He would eventually rise to become joint managing director in 1928, and then vice-chairman and CEO under Stanley (by then, Lord Ashfield) when the London Passenger Transport Board was formed in 1933. Where Stanley would 'talk the talk' with shareholders, politicians and the public, Pick would 'walk the walk', ensuring that the behind-the-scenes administration and policymaking was implemented. As a double act, the two were complementary; Stanley as the charming poster boy of the UERL and Pick as the shy but determined public servant. Pick, as CEO, would find his responsibilities stretched across the entire organisation: staffing, finance, engineering, traffic, publicity, supplies – all would come under his remit – but it was in his earlier role as commercial manager that his legacy was forged. When Pick voiced his concerns over the ineffectual strategies the UERL was using to promote itself, which was self-evident in the frequent complaints about the underground service, overcrowding and the need for more passengers, Stanley's response was to put him in charge of the company's advertising. Fortunately, Pick's interest in the visual arts and eye for creative talent would not only raise the standards of design across the network but create an aspirational environment where modernity could flourish.

Pick and Stanley worked to dilute the American influence on the underground network. Although this was maybe not intentional, public perception of the UERL's dubious origins under Charles Yerkes was an ongoing concern. The travelling public had never really embraced the idea of the 'streetcar' suburbs either – a vision Yerkes had brought with him from his native Chicago at the turn of the century. One contemporary

account suggests that Yerkes had made reconnaissance trips around the Hampstead and Golders Green area in the autumn of 1900:

> two men drove in a hansom cab over the lofty heights of Hampstead Heath high over London. From time to time, the driver drew in his reins, allowing the men to leave and walk over the open spaces. Barely a rooftop could be seen. Later they took the cab down to see the level fields north of the hill. The only feature here was an isolated crossroad, fringed by a couple of old houses and some farm buildings. They had reached the rural hamlet of Golders Green, not far from Hendon.[6]

Regardless of whether Yerkes had meant to profit from the development of the land or not, he still chose the empty fields of Golders Green for the terminus and depot of the Charing Cross, Euston and Hampstead line. This decision would pay dividends later. Less than a decade after Yerkes' death a new community had sprung up, complete with shopping areas, parks, a cinema and other public amenities. By 1914, over 3,600 new homes had been built within walking distance of the Tube, transforming the once rural outpost into a modern suburban centre. With only a twenty-minute travel time to the West End, Golders Green saw 1.5 million passengers in its first full year of service in 1907, a figure that had risen to more than 10 million by 1914.[7]

Pick would look beyond the city too. To boost flagging passenger numbers, between 1908 and 1911, he commissioned a series of commercial posters designed to lure Londoners onto the Tube and out into the green hinterland of its suburban extensions. Featuring the now standard 'UndergrounD' wordmark, they presented a rural idyll that was somehow far removed from the bustle of the metropolis, yet accessible and easy to reach in just a few stops. They offered a new vision of the city, as well as encouraging passengers to visualise a new lifestyle via the promotion of 'Healthy Homes' in Osterley and Hounslow, and the ultimate 'Place of Delightful Prospects' at the original underground suburb, Golders Green.

Maps were high on the agenda during this period too. The 'Combine' would need to combine itself visually if it were to make sense to the travelling public, not just as a network, but as an organisation. Presenting a unified front would be a fundamental to its survival, and the UERL

56 The History of the London Underground Map

would achieve this with its cartographic output, particularly the 1908 pocket map which, with its colour-coded lines, was arguably the clearest map to date. Dispelling the less salubrious aspects of the underground's development, such as its fragmentary growth and bitter rivalries – not to mention those brash Americans – tidying it up into a neat and purposeful navigational guide was as much an exercise in PR as it was in cartography.

And let us not forget the Met.

The rebels of the transport network welcomed a new general manager in 1908 – Robert Hope Selbie – who, with his enterprising housing development schemes, would restore some of the old confidence the company had enjoyed as the original underground railway. It was this sense of assuredness that would lead the Met to reject the UERL's offer to amalgamate in 1913; though it would agree to cooperate on some joint marketing initiatives. The Met at least had the foresight to finally electrify its lines, although steam would still be used on the outlying extension beyond Harrow for several more years. The irascible Sir Edward Watkin may have been cold in his grave – he died in 1901 – but his expansionist ambitions still lingered in spirit. In June 1910, the Met would introduce a new long-distance service between Baker Street and Aylesbury, using two luxury Pullman coaches called *Mayflower* and *Galatea*. Baker Street was refurbished to befit its new status as the Met's gateway into the city and route out into the suburbs and beyond. A full-scale reconstruction of the existing platform configuration was ordered by Selbie, to accommodate four tracks and two island platforms in the style of a mainline railway junction. Two additional tracks were also laid south of Harrow to relieve congestion on the Uxbridge branch, although the line between Finchley Road and Baker Street would remain double track, causing a bottleneck of services. As the Met's flagship station, Baker Street would also accommodate the new company headquarters, and plans were drawn up for a grand five-storey hotel on the Marylebone frontage.

Watkin would not have been disappointed. The two Pullman cars were the first to be electrically hauled in Europe and were every bit as aspirational as Watkin would have intended. Each car was divided into two saloons, which were 'very handsomely appointed'.[8] Breakfast, luncheon, afternoon tea and supper were all served, and the last train departed from Baker Street at 11.35pm to catch the last of the theatregoers. Any latecomers would end up spending the night on the platform. However,

Bullseyes, Bars and Circles 57

at the outbreak of the First World War in 1914, building work at Baker Street ceased and the proposed luxury hotel was superseded by a plan for mansion flats which was finally completed in 1929. Although never a commercial success, the Pullmans survived the Met's eventual absorption into the London Passenger Transport Board and continued to run until 1939.

Not to be outdone in the 'logo' stakes, the Met adopted its own modified version of the roundel – a blue bar on a red diamond. While it lacked originality, it has stood the test of time and can still be seen at Farringdon Station above the former parcel office.

Now it had a corporate identity, the Met could put all its efforts into cultivating an image as a mainline railway. It had pushed further outside of London than any of its rivals, aided by its uniquely privileged position that allowed the company to legally retain surplus land it had acquired for development in the late nineteenth century. As far back as 1887, the Met had fortuitously formed a surplus lands committee to promote housing development alongside the railway. By 1919, this would be operating as an entirely separate enterprise – Metropolitan Country Estates Ltd – although it was still under the control of the railway. Its interests resided in its lands north west of the city, in Buckinghamshire, Hertfordshire and Middlesex.

The other railways could only look on in envy. In 1905, the Royal Commission on London Transport recommended that railway companies be allowed to buy land that had the potential to increase in value due to development. But the idea did not sit well with MPs, who would much rather the railways concentrated on doing what they were supposed to be doing rather than play at being property developers. The idea was quickly dropped, but not forgotten. Thirty-three years later, Frank Pick argued that the London Passenger Transport Board should be permitted to acquire property adjacent to projected lines and use the profits from its development to invest in its railway services. Once again the idea was met with a resounding *no*. The other lines would only be allowed to derive financial benefit from an increase in passenger numbers as a result of property development. In essence, they were politely asked to leave property development to the property developers.

Not so the Met. It would go forth and multiply; eventually spawning the epitome of modern suburbia – Metroland. What it didn't know at

58 The History of the London Underground Map

the time was that this rural idyll would make the perfect antidote to the horrors of the First World War.

Everyone else would have to be content with making profits the customary way, by building up passenger numbers and encouraging travellers onto underused, off-peak services. To achieve this, the humble poster would be promoted to new and dizzying heights. Maps would get a makeover too, becoming less about function and more about form, and aimed at the fairweather traveller rather than the seasoned commuter. Frank Pick's new cartographic approach would take its inspiration from the days of yore as modernity met with a touch of the medieval.

And so it was that the London Underground became the London *Wonderground*.

Chapter 12

By Paying Us Your Pennies

The Westminster Press they printed me
In all my artful devilry,
And painted me o'er in colours galore,
In A.D. One thousand nine one and a four,
For the Underground Railway Company,
The laughter of GODS is yours if you will,
As the wish of the artist is, MacDonald Gill

So went the legend to MacDonald (Max) Gill's 'perfectly wonderful map of London'.[1] And wonderful it most certainly was.

The first of its kind, Gill's *By Paying Us Your Pennies* (1914) was a complete departure from the traditional navigational map favoured by the railway companies. Drawing on elements of the richly illustrated medieval *mappae mundi* (world maps), Gill's masterpiece brought together heraldry and mythical creatures, literature and whimsy. Stylistically it was eclectic – a riot of colourful penmanship and calligraphic skill. It was also a bold choice as it wasn't in the least bit functional. However, as a tool to attract people, it was a stroke of genius.

Frank Pick knew that in order to capture the leisure market, he would need to change tact. He had already commissioned the calligrapher Edward Johnston (1872–1944) to design a letterform that could be used universally across the UERL's signs and posters. Now MacDonald Gill (1884–1947), a calligrapher, younger brother of the more famous Eric (1882–1940) and a former student of Johnston, was brought into the fold. His talent for creating images with strong colour and simple bold lines would propel him into the world of commercial graphics, where he would create advertising material for exclusive brands such as Rolls Royce and Selfridges.[2] The brief was simple – the map needed to capture the essence of London and all it had to offer. It also needed to brighten up station platforms and entertain waiting passengers. The finished version

60 The History of the London Underground Map

performed the latter so well that it made 'people watch so long they lose their trains – yet go on smiling.'[3]

Gill's creative licence would ensure the map was playfully inaccurate, but that was part of its charm. For instance, at London Zoo in Regent's Park an oversized griffin appears to gobble up a visiting child, who politely declares, 'I promised mother I would be home for tea'; and the Serpentine in Hyde Park is depicted as a dragon-like creature that is 'not really such a worm'. He gave characters speech bubbles, which was a nod towards the cartoon strips that had become a regular feature in newspapers over the past twenty years. The dialogue allowed him to address the audience directly, as well as make a topical commentary via his characters' interactions with each other and their vibrant surroundings. He also paid tribute to his commissioners, Frank Pick and Gerard Meynell (who was head of the map's printing company, Westminster Press). The reference to Pick is simple and is in keeping with what we know of Frank Pick – that he was modest to the point of shyness, as well as being hardworking and industrious. For Gill, this translated to a workman digging the road outside the underground's headquarters, muttering, 'My pick cannot be surpassed.' Meynell was depicted standing on top of the Westminster Press building, next to Westbourne Park Station, with a finished version of Gill's map in his hand.

The map wasn't just a feast for the eyes. It also contained subtle messages. For instance, Gill's tongue-in-cheek depiction of a motorbus being pushed up a hill suggested it was anything but a reliable way of getting around, much less a shining example of modernity. Gill was also pushing something else with this particular vignette – his luck – since the UERL had expanded in 1913 to include the London General Omnibus Company (LGOC). Gill was also keen to represent the newly accessible suburbs and extended countryside routes, as per Pick's overarching marketing strategy at that time. He achieved this with his customary flights of whimsy. On both sides of the map, Gill depicted town criers; the one to the west hailing, 'Oyes! Oyes! To Kew, Windsor, Oxford, Gloucester, Wales, Ireland, U.S.A.', and to the east, 'Victoria Park, Wanstead Flats, N. Ockendon, Chelmsford, Harwich, Russia … and other villages.' Gill's biggest achievement, however, was his inclusion of identifiable working and middle-class characters, from the signalman calling 'In time!' outside Victoria Station to the worker with the plough

By Paying Us Your Pennies 61

and horse next to Warwick Avenue. The map was for them, or rather their real-life counterparts living and working on the streets of the metropolis. The underground had come full circle, achieving the original pluralistic ambitions of Charles Pearson of a railway for the people. Contemporary posters also carried a similar refrain, that of a classless, civic-minded railway which was 'The way for all',[4] and the 'Popular service [that] suits all tastes.'[5]

The world was changing. By the time Gill's next map, *Theatre-land* was printed and displayed in the winter of 1915, the First World War was well underway. Nevertheless, Gill's newest map – which detailed the West End at night – shows London's theatres and their nearest underground stations. The scene looks as though it is illustrated on a stage curtain which is in the process of being lifted by an unruly orchestra. The map is full of Gill's usual eccentricity, and in keeping with its theatrical theme, plenty of melodrama. A damsel in distress lies, tied to the railway tracks at Charing Cross, exclaiming, 'I hope they don't feel the jolt!' – a hackneyed trope from the previous century that would have been familiar to theatregoers. Wartime London is the understudy in this show. Gill hints at the situation by portraying soldiers standing in ranks outside St George's Barracks, where a recruit is being measured for his uniform. A Zeppelin airship just about makes it onto the map at Lincoln's Inn Fields in the top right-hand corner, a portentous, if a little inappropriate, addition given that a bomb had struck the Lyceum Theatre killing seventeen people just days before Gill completed the design. Travel for pleasure was still being promoted three years after war began, only finally being discouraged from 1917 onwards. At this point, the underground put efforts into operational messages designed to keep passengers safe and promote the tunnels as a place of refuge, as well as attempting to keep the network ticking over in the face of major disruption. Soon after war had been declared, a propaganda poster had appeared on station platforms declaring 'War – To Arms Citizens of the Empire!!',[6] but astonishingly, nine months after war broke out, one poster was rather cheerfully stating, 'Why bother about the Germans invading the country? Invade it yourself by Underground and Motor-Bus.'[7] Despite seeming a little flippant to the modern viewer, Gill's *Theatre-land* was entirely in keeping with the 'keep calm and carry on' attitude of wartime Britain, which included taking leisure trips out of the city and into the countryside.

62 The History of the London Underground Map

The Met took a similar approach and ignored the war in much of its publicity. Instead, it decided that 1915 would be a good time to plant the seed for something far greater – a scheme that would pay dividends with a little patience and a catchy name – Metroland.

Chapter 13

A Verdant Realm

I know a land where the wild flowers grow
Near, near at hand if by train you go,
Metroland, Metroland.

George R. Sims's (1847–1922) rhapsody to the 'country with elastic borders'[1] north west of London was penned before the end of the First World War. It was idealistic and dreamlike – an ode to country inns, thatched roofs, green fields and endless summer days. A far cry from the horrors of the Somme and the 'monstrous anger of the guns'[2] described by poet Wilfred Owen (1893–1918). By the time the country had rung its church bells to celebrate the signing of the armistice on 11 November 1918, it would need places like Metroland (sometimes written as Metro-land), in all its bucolic glory, to offset memories of the rat and disease-infested trenches of the Western Front and the loss of 886,000 British military personnel.[3]

The world was a different place after the war. The sun had set on the Edwardian long weekend and, like a terrible hangover, the country emerged bleary eyed and blinking, but alive – just. Class was no longer so well defined. Instead, it became something fluid, as those inhabiting the highest reaches of society shared in their grief with the poorest of families, in the same way that the heir to a dukedom had shared a trench with the son of a labourer. As the great orator David Lloyd George surmised at a speech in Wolverhampton on 23 November 1918, 'There has been no distinction of rank, no difference of creed or faith, of state or condition of life. All opinions, all ranks, all creeds, all faiths have contributed to this memorable sacrifice to save the world.' The 'Lost Generation' was missing from every table, from the grandest – Lord and Lady Desborough suffered the loss of two sons, and former prime minister H. H. Asquith lost his eldest son – to the humblest.

64 The History of the London Underground Map

Despite this, the post-war mood was patriotic. Victory picnics and peace day celebrations with 'bands, processions and buns by the cartload'[4] buoyed up the masses. Nevertheless, dissent lurked in every corner. Those who were lucky enough to make it home soon became mired in disillusionment as the stain of unemployment spread far and wide.

Sir Albert Stanley had been asked to serve as president of the Board of Trade in Lloyd George's wartime government and Frank Pick was put in charge of the household fuel and lighting branch of the coal mines control department. Both would return to their original posts after the war, with accolades and promotions soon following. Stanley was rewarded in the New Year's Honours in 1920, becoming Lord Ashfield of Southwell, and Pick was promoted to assistant managing director at the UERL in 1921. The UERL had released half of its workforce to help the war effort, some 3,000 staff from its District Railway and Tube operations, and a further 10,000 men joined up from the company's bus division, the LGOC. The Met released 1,100 men, which was thirty per cent of its pre-war workforce.[5] The 137 Met employees who did not come home are commemorated on a memorial at Baker Street Station.

The year 1919 saw the emergence of Metropolitan Country Estates Ltd, the property enterprise owned and controlled by the Metropolitan Railway. This was a timely manifestation of the Met's plans to colonise its surplus lands and become a mainline railway. The post-war recovery scheme – of which 'homes for heroes' was high on the agenda – would present the perfect opportunity to fulfil this aim. With the spirit of Edward Watkin smiling down on him from above, Robert Hope Selbie approached the board on 21 November 1918 – a mere ten days after the armistice – to draw its attention to the opportunities presented by the end of the war:

> in view of the large demand there will be for houses once Peace is declared and the Forces are demobilised, and also in view of the advertisement the districts served have received during the War, I am of the opinion that the scheme should be taken in hand forthwith.[6]

Rather prophetically, his scheme embodied Lloyd George's pledge given just two days later that the government would make Britain 'a fit country for heroes to live in'.

A Verdant Realm 65

The original marketing campaign for Metroland began in 1915 to appeal to transient visitors such as ramblers and cyclists, looking for 'scenes of sylvan beauty'[7] where 'romantic villages, and half a dozen little country towns'[8] awaited. It was ironic then that less than four years later the Met set out to populate these 'haunts of ancient peace ... gorse-clad commons ... and out-of-the-way nooks'[9] with an enormous building programme. The Met had now turned its attention to those looking for a permanent move out of the city. Flowery descriptions of the 'quaint old-world'[10] arcadia that awaited potential house hunters were still in evidence, peppering the columns of the city newspapers as the Met touted its 'useful little publication'[11] containing a 'guide to the beauties of Hertfordshire and Buckinghamshire'[12] for potential residents. Those who got as far as purchasing the brochure and reading it, were in for even more of a literary treat:

The song of the nightingales, for which the neighbourhood is renowned; its mingled pastures, woods and streams; its gentle hills clothed with verdure; the network of translucent rivers traversing the peaceful valley render it a Mecca to the City man pining for country and pure air.[13]

Thanks to improved printing techniques, the 'useful little publication' – which was essentially a tourist guide cum sales brochure – included colour photographs of cows, ploughs and everything that was green and lovely. Targeted at 'those who desire a quiet, healthful and social life on the threshold of the Metropolis',[14] the guides must have seemed otherworldly to inner London residents. The use of nostalgia was a curious approach, since the Met was also attempting to sell the idea of modernity: the proposed houses would provide 'Fine elevations – good square rooms, fitted with modern labour-saving devices planned for your convenience'[15] as well as 'central heating and fitted wardrobes'. Yet all this innovation was housed inside a Tudorbethan shell, replete with gabled windows and mock Tudor beams. The Met wasn't just selling houses, it was selling the idea of continuity and a hopeful return to normality after the horrors of war.

The first development at Pinner, which had begun in the early 1900s, was well established by the time the concept of Metroland proper was

66 The History of the London Underground Map

launched. Work began on two new estates in the early 1920s; Chalk Hill in Wembley and Cedars Estate at Rickmansworth. A string of estates would follow at Northwick Park, Eastcote, Rayners Lane, Ruislip, Hillingdon, Chorleywood and Amersham. Most had new homes available, but if a purchaser was feeling plucky there was the option to buy a plot of land and plan their dream house to their own specifications. Most importantly for the potential buyer, the Met gave the impression Metroland homes sat alone behind picket fences, in empty streets, surrounded by vast fields. This, of course, would prove to be utter rubbish, once the reality of suburban sprawl had kicked in.

The extent of that sprawl is shown to great effect in the Metropolitan Railway's *Map of Extension Lines into Metroland* (1924). A red line snaking out into the green pastures (here, coloured in shades of rustic hay bale yellow) denotes just how far the Metropolitan Railway managed to push out of the capital. Much of the track laying was achieved in Edward Watkin's time, although he was still a good 150 miles from his desired destination of Manchester. The marked locations of the estates would have presented a tempting proposition to house hunters and prospective housebuilders as the four estates nearest to the city are well served by stations for the purposes of work, as well as golf courses for leisure. It was a clear indication of the type of passenger Selbie hoped to target – his first-class season ticket holders. Golf courses had been making an appearance on the Met's maps since 1920, and the *Pocket Metropolitan Railway Map* (1920) includes them alongside the Chiltern Hills. And if that wasn't enough to convince a potential purchaser, the reverse of the map showcases those all-important Metroland villages and towns, as well as 'An Invitation' to move to Metroland.

The lifestyle the Met was selling – that of a fast rail link, close to the city and the rolling hills of the countryside – was as appealing to the suburbanites almost a century ago as it is today. A slice of suburban life in the 1930s could be yours for £685 for a typical house on the Eastcote Estate in Harrow, all the way up to £1,599 for something with more kerb appeal.

Inevitably, the idea of Metroland wormed its way into popular culture. Balladeers wrote whimsical ditties about it – the cover for *My Little Metro-land Home* by Boyle Lawrence featured a Tudor-revival homestead in Pinner. Its literary heritage is even more impressive. Not content

A Verdant Realm 67

with lending its name to two characters in the works of Evelyn Waugh – Viscount Metroland and Lady Metroland appear in *Decline and Fall* (1928), *Vile Bodies* (1930) and *A Handful of Dust* (1934) – Metroland's absurdity and self-defeating beauty was championed by the 'hymnologist of Metroland'[16] himself, Sir John Betjeman.

Betjeman's long-standing love affair with Metroland is well publicised. Growing up during the boom years of its development, it was young travellers such as Betjeman whom the Met wished to lure outside of the city, 'to lanes in beechy Bucks'.[17] The writer's references to Metroland in his volume of poetry, *A Few Late Chrysanthemums* (1954) are full of the rose-tinted sentimentality only age and the distance of time can bring:

> And sepia views of leafy lanes in Pinner–
> Then visualize, far down the shining lines,
> Your parents homestead set in murmuring pines,
> > *The Metropolitan Railway: Baker St Station Buffet*

Twenty years later, in 1973, when Betjeman featured in his own BBC documentary *Metro-Land*, the area was beginning to show the first signs of age. As Betjeman wanders the empty warehouses of Wembley, which once housed the Empire Exhibition he laments, 'Oh bygone Wembley, where's the pleasure now? The Temples stare, the Empire passes by.' He then moves on to the leafy streets of Harrow, where houses are 'a bastion of individual taste, on fields that once were bright with buttercups'.

But for every Betjeman there was a historian such as A. N. Wilson, decrying the 'endless ribbon [of development] ... not perhaps either town or country'[18] or H. J. Massingham, the ruralist British writer, predicting the long-term decline of the English countryside at the hands of modernisation:

> it expels the native population, pulls down its cottages or puts them in fancy-dress, builds houses of its own as characterless and innocent of design as are all its acts, debases the neighbouring countryside and suppresses its crafts and husbandry.[19]

What was perhaps even more horrifying for the purists was the appearance of the flat-roofed, futuristic buildings that were starting to punctuate

68 The History of the London Underground Map

the skyline, because among the Tudorbethan homesteads, Modernism and Art Deco were also beginning to flourish. These architectural styles were used most convincingly on the commercial and civic buildings of Metroland, such as the Ovaltine Factory at Kings Langley, Denham Film Studios in Buckinghamshire, as well as many cinemas and schools. The exception to this was the collection of 'Sun Houses' designed by Amyas Connell, which were built on a hill overlooking Amersham in 1934. Built in reinforced concrete and with a full-height glazed wall at the front, they were all angles and geometry, and completely incongruous with their surroundings.

All of this was of little consequence to the Met. It stuck to its own brief throughout the years of development and expansion, which included a new branch from Moor Park to Watford (opened in November 1925, with an intermediary stop at Croxley Green), its first extension for some years. There were high hopes for the line, which was expected to have 'a tremendous future'[20] as a 'great and useful public purpose'.[21] In the speeches made at the grand opening of the line, politician Sir Clarendon Hyde rather optimistically predicted 'crowds' of passengers at Watford.

But the crowds never materialised. The line snaked out into the sticks with no real purpose. The siting of the station was also problematic as it was a mile away from the centre of Watford at the edge of Cassiobury Park, which once included the stately home seat of the earls of Essex. By 1927 this Gothic pile had been demolished, and the estate was being eaten up by development; or put more prosaically, 'the twentieth century was pressing hard at the gates, and they would yield before long.'[22] Unfortunately, the development of housing at Cassiobury did not translate to an increase in ticket sales on the Watford line. This failure would ultimately deter the Met from undertaking other extension plans, except the 4-mile Wembley Park to Stanmore branch, which would open in December 1932. This too would be a flop. Development along the line was minimal, and rather than ending in Stanmore Village, the line stopped short opposite the Warren House estate – then occupied by a rambling Jacobean manor. The Stanmore branch would be the Met's last adventure into the countryside before the company was subsumed into the London Passenger Transport Board in 1933. From then on, new lines and extensions would be subject to approval by committee. But those days were yet to come.

A Verdant Realm 69

The extension lines were furnished with stations designed by Charles W. Clark (1885–1972), but instead of capitalising on the design innovations coming out of the city, he played it safe with tall chimneys, pitched roofs and gables. Clark's retrograde styling for the new stations was a throwback to the pre-war era; vernacular, homely stations, designed to blend in to the new but paradoxically 'old-looking'. With the march of time – and modernism – red-brick stations such as Croxley Green (1925), Watford (1925) and Stanmore (1932) were doomed to look old before their time. In the capital, Willesden Green and St John's Wood (1925), Aldgate (1926), Edgware Road and Notting Hill (1928), Swiss Cottage (1929), Great Portland Street, Northwood Hills and Euston Square (1931) were all given an upgrade or a facelift. These were completed in a neo-Classical style, in marble white faience, and while they were more prepossessing than their country counterparts, they had nothing of the vision and flair of Charles Holden's designs for the UERL. As a consequence, the UERL was about to enter a period of unrivalled progress and enterprise that would set precedents in civic design for future generations.

Chapter 14

Brave New World

While the Met busied itself taking pictures of cowsheds and writing about the virtues of country living, the UERL focused its efforts a bit closer to home.

The exponential growth in passenger numbers using Piccadilly Circus – 1.5 million in 1907 to 18 million by 1922[1] – prompted a major reconstruction scheme below the surface in order to alleviate overcrowding and drag the station into the modern era. With the genius of Charles Holden at its disposal, and the statue of Eros safely ensconced in Embankment Gardens for the duration, the UERL set to work transforming the subterranean space into a grand avant-garde concourse, a fitting extension of the high-class shopping environment of Regent Street above. It had all the mod cons; twenty-six coin-operated ticket machines were installed in the circular booking hall, as well as eleven state-of-the-art nippy escalators to replace the original lifts. It was fitted out in suitably Modernistic style with marble wall panels, Art Deco uplighters and bronze fittings, as well as a train indicator showing arrivals and departures on all six lines and a linear world clock. All of this contributed to the overall impression that Piccadilly Circus was not only the hub of a modern transit system, but the hub of a modern city – 'like a turbine grinding out human beings on all sides. In the evening it sucks them in again, through the circle and down the escalators to the rushing trains.'[2] An enormous mural by Stephen Bone depicting the lives of passengers at work and leisure was the ultimate artistic embodiment of modernity. A 75ft long map of the world, by the same artist, suggested 'the idea that Piccadilly is the centre of the world'.[3]

The 'wonderful new Underground Tube station'[4] was opened on 10 December 1928 by the Mayor of Westminster and 'was not only the best underground station in London, but the best in the world, challenging comparison with any station in New York.'[5] The former 'creation of mid-Victorianism'[6] was now well and truly part of the civilised world.

Brave New World 71

The £500,000 modernisation scheme would allow up to fifty million passengers a year to pass through Piccadilly Circus, but it wasn't just the inner-city passengers the UERL had its eye on.

London's inter-war modernisation was underscored by the importance of the twice-daily commute. The city was spreading far beyond its original borders, and its expansion, and what to do about it, was high on the priority list. With a lack of any clear direction from the government – despite growing concerns over congestion and overcrowding on both the road and rail networks – the UERL pushed forward into a period of unprecedented growth and improvement. The dynamic duo of Ashfield and Pick understood that for the underground network to grow and meet the demands of the travelling public, it needed financial assistance. A slightly contentious poster by Irene Fawkes, *The Problem of the Underground* (1924), sets out the gargantuan numbers involved in moving 306 million passengers around the network in 1923 – 234,000 tons of coal, 71,000 gallons of oil, 10,000 staff, 6,000 tons of steel and iron and 200 tons of tickets. The artwork depicts a giant pipe-smoking gentleman wearing spats, sitting on a flatbed being heaved along by a band of miniature workers. As he reclines on a box labelled 'Taxes £184,000', the implication is clear – the real 'problem' is money, or lack thereof. It was all sounding awfully familiar.

Another familiar 'problem' was the lack of a coordinated approach to the city's public transport network. In the 1920s, the UERL and Metropolitan Railway were still operating as two separate enterprises. They, in turn, were separate from the overground suburban rail companies, the GWR, the London and North Eastern (LNER), the Southern Railway (SR) – which incidentally also controlled the Waterloo and City line – and the London Midland and Scottish. Things were just as chaotic on the roads. There were various bus and tram operators, ranging from small-scale independent bus companies all the way up to London County Council Tramways, which operated 113 miles of tramways. The piecemeal private development of London's transport network was beginning to stifle its progress.

The creation of a ministry in May 1919 – the Ministry of Transport – did nothing to alleviate the problem. Sir Eric Geddes (1875–1937), the first Minister of Transport in Lloyd George's Conservative Government was hopelessly ineffectual, which was embarrassing given his former role

72 The History of the London Underground Map

as head of military transportation on the Western Front. Geddes was also largely unpopular, and didn't help himself by implementing austerity cuts in public expenditure. Known as the 'Geddes Axe', the cuts depressed the economy further. It was against this backdrop that the conflicts and tensions between the separate transport operators played out. The UERL would eventually triumph, despite the lack of direction, and it would do it in style too.

Lord Ashfield had a plan that would circumvent the usual process of having to attract private funding – which frankly would have been like pulling teeth in the years immediately after the war, especially given the underground's track record on return on investment. This allowed the underground to push forward with a series of planned and authorised investment schemes that pre-dated the First World War. The funding came courtesy of the Trade Facilities Act of 1921, which offered Treasury guarantees against capital loans for schemes that could provide work. This was an attempt to mitigate the dramatic post-war rise in unemployment. The plans the underground put on hold during the war years were now ripe for providing jobs for construction workers, as well as contracts in steel and associated industries. It was a stroke of genius. But mostly it was a stroke of luck.

The UERL didn't waste any time. Between 1922 and 1926 a series of works were carried out to connect two Tube lines – the CSLR and the Charing Cross, Euston and Hampstead Railway (CCEHR), or the 'Hampstead Tube'. Construction between the CSLR's Euston Station and the CCEHR's station at Camden Town began in 1922 and it was operating by 1924. The second phase to link the CCEHR's Charing Cross (now Embankment) Station and the CSLR's Kennington Station opened in 1926. This section also provided a station at Waterloo, connecting to overground services, and a connection to the Bakerloo line. The new upgraded service could take passengers into both the city and the West End.

At the same time, the UERL pushed out into the countryside, going northwards to Edgware – which opened in 1924 – and southwards to Morden, which was open by 1926. The Met had Metroland and the UERL had … the Morden-Edgware line. Fortunately, someone came up with the Northern line before any of its other monikers, such as 'Medgeway' stuck. That wasn't until 1937 though. Legend has it that the line narrowly

Brave New World 73

escaped being called 'Tootancamden' following the discovery of the tomb of Tutankhamun in 1922 and the craze for everything Egyptian.[7] Thankfully, that name was lost to history *very* quickly.

While the Met took inspiration from the past for its station design, the UERL looked into the future. Frank Pick was already aware of the importance of functionality in modern station design and the new Northern line stations south of the Thames provided the perfect opportunity for the UERL to showcase its authority and design credentials. Architect Charles Holden (1875–1960), a partner at Adams, Holden & Pearson, was selected and immediately proved his worth. His use of wide entrances and minimalist styling chimed perfectly with the impression of efficiency and innovation that the UERL wished to project. By opening the station frontage and removing doorways, the passenger flow was vastly improved. The stations were designed in 'kit' form, which meant a consistent styling was used throughout, and each station could be tailored to fit its location. The Portland stone frontages had three sections that were either curved (South Wimbledon, Tooting Broadway), flat (Morden), or bent to fit a corner site (Clapham South, Balham, Tooting Bec, Colliers Wood). The first-floor middle section on all the Holden stations on the Morden stretch featured a glass frieze with the all-important 'UndergrounD' bullseye embedded into it. The spacious entrances were illuminated by chandeliers with exposed bulbs, which also provided a backlight to the glazed-glass frontage panel and the bullseye. Edward Johnston's ubiquitous typeface – 'Johnston Sans' – was rolled out across stations, from entrance halls to the platforms. This effort to unify all the different elements of the passenger journey, from their entrance at street level, to reading directional signs and planning their journey underground, was a showcase in design best practice. These 'prophetic beacons of the new age',[8] sitting pretty in their soon-to-be urban landscape, helped Holden to win the design commission for 55 Broadway, the UERL's new headquarters at St James's Park.

By September 1926 it was possible to travel from Edgware in Middlesex, through the heart of the metropolis and on to Morden, which was then in Surrey. The *Westminster & Pimlico News* reported:

The opening ceremony began at Clapham South station, where in the presence of several hundred guests Lieut. Col. J. T. C. Moore-

74 The History of the London Underground Map

Brabazon, Parliamentary Secretary to the Ministry of Transport, first operated an electrical contact which placed the station starting signal at 'clear'. He then drove the first train to Morden. It was a special containing about 300 guests.[9]

During the speeches, the MP for Balham and Tooting, Sir Alfred Butt, reiterated what the UERL had known all along, that 'cheap and frequent facilities for transport brought greater health, wealth and happiness to the people. They enabled them to get cheaply and easily to their work and return to sleep in fresh air.'[10] He concluded by perceiving – correctly – that 'The Morden extension would help to solve the housing problem, for between Morden and Epsom there were miles of undeveloped land.'[11]

So, the UERL gained its own slice of commuterville, despite not actually owning any of the land on the route. Just as Edward Watkin had smiled down on Robert Selbie of the Met, Charles Yerkes would now do the same on Lord Ashfield and Frank Pick. The precedent had already been set on the Hampstead Tube, where Golders Green had grown in fifteen years from a rural crossroads into a suburban township. From seventy-three houses in 1907, the town had achieved 471 by 1914 and by 1927 was boasting 'the paraphernalia of the post-war world – shops, houses, banks, and war memorials.'[12] The UERL now had a stake on both sides of the Thames, but speculative housing development was slow to follow the path of the railway from Hendon to Edgware. And so the publicity wheels were put in motion again, and an intensive campaign of press and poster advertising was launched to chivvy things along. Bus stop advertising at Golder's Green encouraged passengers that 'A change of residence is as good as a holiday', and Walter E. Spradbery's poster *Edgware* (1924) depicted the rural nature of the northern section of the line, while also promoting the 'fast trains every few minutes' that could be found among the fields and trees (although these are notably absent from the illustration). Kate M. Burrell's *Edgware or Morden* (1928) was displayed in the booking halls of the city stations, and showed a woman carrying a bunch of flowers in front of a suitably countrified background (including church spire and trees), which would have been an enticing prospect for a harassed city dweller on their evening commute.

South of the river, Morden was given a good outing in the UERL publicity too – quite literally as the UERL encouraged both househunters

and day-trippers onto its southern extensions. Charles Paine's *London's Freedom For the South West Suburbs* (1926) shows the great metropolis looming large in the skyline, backlit by a swollen sun. The Morden extension snakes away from the city, passing a solitary stag on its journey through the countryside until it reaches the welcoming domesticity of the suburban homestead in Morden. *Country Joys on London's Underground* (1927) by Mary Adshead represents the pleasures that can be gained by a journey outside of the city – picnics, rowing, fishing, tennis, painting and horseracing – all provided by the Roman goddess, Flora, and her overflowing springtime cup. It wasn't the first time an underground poster had taken inspiration from the Gods. A series of posters by Frederick Charles Herrick in the early 1920s used Hercules, Mercury and Diana to promote the underground as a fast, efficient and accessible mode of cross-city transport. And as far back as 1912, in Alfred France's *Hermes For Speed, Eros For Pleasure*, Gods and Goddesses were shown cavorting in the countryside in their togas. At first glance, this mixture of mythology and antiquarianism contradicts the image of the network as a paragon of modernity and progress. But this is why the promotional material stood out, and it was able to wheedle its way into the travelling public's consciousness. The departure from traditional advertising design was something which Pick encouraged, particularly when artists of some stature began to be employed and could bring their own stylistic treatment to the table.

Two things are striking from this period – the sheer volume of graphic material that was commissioned and produced, and the inherent value in each piece as a standalone work of art. These were not just functional, utilitarian designs, they were artworks of exhibition quality. Writing in 1923, in *The American Magazine of Art*, Harold R. Willoughby observed:

> Artists who have reason to know affirm that it is as difficult to get a poster hung on the boards of the Combine as to get a canvas hung in the Royal Academy. Even in their native environment, however, these designs transform the poster boards into veritable art galleries for the traveling public.[13]

Willoughby's fellow American, artist Edward McKnight Kauffer, gained prominence through his association with the UERL. Arriving

76 The History of the London Underground Map

in London in 1914, McKnight Kauffer's designs were initially not well received in the city. According to Willoughby, 'he was assured that the public would not stand for such creations'.[14] But his introduction to Frank Pick would change his life. He stayed in England for the next twenty-six years, becoming the underground's principal designer and a pioneer of commercial art. His initial landscape scenes for the UERL were painterly but McKnight Kauffer's later work would encompass broader artistic styles, such as Vorticism and Abstraction, which he revived in some of his most notable pieces, such as the *Winter Sales* series from 1921–1924. Works such as *Power – the Nerve Centre of London's Underground* (1931) and *Play Between 6 and 12* (1931) utilised imagery from the urban environment and showcased new techniques such as airbrushed lettering to achieve a 'machine' look. Art critic Roger Fry saw the power and influence of the new underground advertising drive, describing it in 1926 as 'a matter of hypnotism on a large scale … the poster has become the great weapon of the industrial companies, and the poster designer their great ally.'[15]

By the end of the 1920s a curious combination of part poster, part map was also being used by the UERL, although these were very firmly in the 'antiquary' camp. Following on from MacDonald Gill's series of decorative maps, which had 'created endless amusement and aroused public appetite for a continuation of the series',[16] a similar style was employed to promote the new suburbs, both as a leisure destination and a desirable location for aspirational homeowners. Edgware was one of the first areas to get the decorative map treatment, portrayed by John Dixon in 1928 as a 'fayre and pleasant retreat from ye bustle of ye city'. His *Pipers Green: Edgware* (1928) poster looks to the past for inspiration. Ye olde Edgware includes fair maidens in wimples, archers practising their shots, peasants faming the land and 'ye Lord of ye Manor' employing a piper to 'play to hys loyal tenants that they may make merrie and be of light heart at their divers labours.' By harking back to medieval times, Dixon presents a sentimentalised view of the soon-to-be-suburb – tapping into a nostalgic longing that would not have looked out of place in a Metroland brochure.

In a similar vein, but with a lot less romanticism, Herry Perry's (1897–1962) series of poster maps for Morden, South Harrow, Kew, Edgware and Hounslow took elements of Gill's decorative styling for inspiration and included similarly whimsical anecdotes and a cast of

Brave New World 77

colourful characters. In *Morden* (1929), everything a city dweller needs to enjoy suburban living is presented, including pursuits such as golf, horse riding and dog walking, as well as public houses, churches and points of historical interest. The promotion of a cheap return fare on weekdays and Sundays would do much to liberate middle-class London from its working weekday shackles.

Although MacDonald Gill's decorative maps, and others of the same ilk, were remarkable for their artistry, they didn't encourage efficiency of movement. In fact, they had the opposite effect, inviting the viewer to pause, consider and digest the information before carrying on with their journey. This lack of urgency was at odds with the needs of the serious traveller, who needed to get somewhere in a particular time. It was also at odds with the well-established underground etiquette that didn't allow for dilly-dallying and standing around.

In direct contrast to his previous work, Gill produced a network map in 1921. It was stripped of topographical detail, although it still retained his trademark embellishments, such as ornate calligraphic lettering and a decorative border. The decision to use calligraphy for the station names was unusual given Pick's drive towards the cleaner lines of the Johnston typeface. The result of this decision is a congestion of words in Gill's rendering of the city area, which leads to a lack of clarity over which name belongs to which station. There was, however, a welcome return to colour printing following its hiatus during the privations of the First World War when maps were printed in monochrome.

By 1924, the usefulness of Gill's map had run out and another solution was needed. This time Pick looked closer to home, and rather than outsource the work, he used one of the inhouse draughtsmen in the publicity office. Fred Stingemore (1891–1954) would eventually rise to become head of the commercial drawing office, a role he stayed in until his death. Between 1925 and 1932, Stingemore produced thirteen editions of the underground's most popular format, the pocket map. His 1925 card folder pocket map owes much to its cartographic ancestor, the original UERL pocket map of 1908, and borrows many of the best navigational features from the previous two decades. There is still an element of geographical representation evident, although as with Gill's map, the topography has been removed, including the River Thames. The lack of ground-level reference points meant that Stingemore could

78 The History of the London Underground Map

be liberal with the direction of lines, and the locations of stations, thus allowing space for the newly extended Edgware and Morden sections of the Northern line. Unfortunately, the same couldn't be said for the western branch of the District, which bleeds into the border after Northfields, and the East London Railway, which is left off altogether. The Thames was reinstated in the 1931 version and is present in subsequent maps – bar one ignominious edition – up to the present day. And this is with good reason. As the sole geographical point of reference, and the original bastion of city transport, the Thames represents a tradition that Londoners hold dear. London without the Thames just isn't recognisable as London anymore. As Peter Ackroyd puts it: 'The city itself owes its character and appearance to the Thames.'[17] So, when Transport for London made the ill-advised decision to remove it in 2009, the city's indignation was palpable. Mayor of London Boris Johnson allegedly received the news with 'a howl of derision',[18] before 'hitting the roof'.[19] It was promptly reinstated and never suggested again.

Stingemore's 1925 map had none of the panache of Gill's – and presumably none of the aggravation caused by the removal of the Thames – but it set the tone for a more user-friendly and functional approach to mapping the network. Hand-drawn sans serif lettering also aided clarity, although the central area remained crowded until the wavy lines were taken in hand and straightened by their next custodian.

One almost feels sorry for Stingemore with his 'almost-there-but-not-quite' pre-Beck map. In the space of a few short years Stingemore's efforts would be completely eclipsed by those of Harry Beck. There would be no 'design classic' accolade for Stingemore, but in some ways he understood better than anyone the need for a completely fresh approach to the design. And he knew this because he had had his own practical experience of drawing and redrawing the map.

It is worth remembering here that Beck's Diagram did not arrive on the page fully formed. Although revolutionary in its approach, it built on the work of previous dedicated cartographers and draughtsmen, such as George Dow – a draughtsman for the LNER who was already using a diagrammatic approach in his network designs – as well as from Beck's own modifications and improving skills as a designer. In an ironic twist of fate, it would be Stingemore who would push Beck onwards towards the final solution, for it was Stingemore who would recognise the potential of

Beck's Diagram, and despite the reservations of their superiors, encourage him to keep trying.

Perseverance would pay off for Beck in the early 1930s, and it would pay off for the UERL too. It would finally get its hands on the Met and a lot more besides. As was the case with many other great achievements in the history of the underground, it almost didn't happen – but then no one had reckoned on the shrewd persistence and political machinations of a cockney socialist called Herbert Morrison.

Chapter 15

All Change (Please)

'It is difficult to see the wood for the trees ... we cannot put the jigsaw puzzle of the present together, because we are sitting on the pieces.'[1]

So pondered *Saturday Review* editor Gerald Barry in a BBC radio broadcast on the final day of the 1920s. Barry was contemplating the year just passed, but his words could have equally applied to the haphazard organisation of London's transport network at the close of the decade. Despite the best efforts of Frank Pick and Lord Ashfield, there had been little progress towards a coordinated approach to the city's various transport services.

As the 1920s rolled into the 1930s, Britain was poised to say goodbye to a period of depression and decline and welcome in an age of prosperity and growth. Except that age didn't arrive for several decades. Despite an immediate post-war boom, the costs of war and a competitive global economy – not helped by high interest rates – plus a lack of investment in industrial processes, meant that the industrial regions of the UK began to feel the pinch. By the mid-1920s unemployment had risen to over two million, leading to long-term social problems such as poverty and ill-health, particularly in northern England, Scotland and the mining districts of Wales; a situation then compounded by the Great Strike in 1926. This only served to widen a growing divide between the declining industrial north and the consumer-focused – and richer – London and south east. Coupled with the Wall Street Crash of 1929 on the other side of the Atlantic, it all made for an exceedingly long and depressing farewell to the decade.

The aforementioned Gerald Barry, ruminating on the 'continued uglification of the countryside'[2], would at least concede that the country had 'become more conscious of the need of beauty and orderliness in our midst'.[3] Whether Barry believed that 'uglification' extended to London's new suburbs isn't clear, but he was right in his assessment that orderliness

All Change (Please) 81

was desperately in need. The tumult of British politics continued to lead to a state of inertia over the issue of industrial decline and unemployment, which by 1932 had climbed to almost 3.5 million. Ramsay MacDonald's Labour Government took power in 1929 – their second time in office – but seemed utterly incapable of untangling the economic mess they had inherited.

The UERL saw out the decade with two major projects, both of which were executed in style, despite the broader issues the country was facing. Following the success of the Piccadilly concourse redesign in 1928, Holden was commissioned to design the new UERL company headquarters. It not only needed to accommodate a growing administrative staff, be aesthetically pleasing and exude importance, modernity and progress, it also needed to be built on an awkward triangular site and incorporate St James's Park Underground Station below the surface.

Holden's solution was to design the building in a 'cruciform' plan which allowed the building to rise up in steps, with each elevation decorated at sixth-floor level with a relief representing one of the four winds, which was repeated, making eight in total. The whole building, which became known by its address, 55 Broadway, was clad in Portland stone and was the tallest office block in Westminster. It garnered critical acclaim in the architectural and engineering communities and won the prestigious Royal Institute of British Architects London Architectural Medal on completion in 1929. Advocate of good design (and founder of Puffin Books) Noel Carrington, found much to praise in the UERL's new design ethos. In his 1930 article 'Need Our Cities be Ugly?', he used a photographic comparison of the old station with the new, pointing out that 'the Underground have led the way, not only in poster design but in the efficiency and tidiness of their stations.'[4]

However, the city wasn't quite ready to have its sensibilities challenged by the avant-garde sculptures adorning the façade of the UERL's new headquarters. The man responsible for those – the enigmatic Jacob Epstein – was already being circled by the critics, who were fresh from lambasting his memorial to W. H. Hudson in Hyde Park. His sculptures *Night* and *Day* were carved in situ, but in the first few weeks of Epstein's residency the most controversial topic seemed to be his choice in attire. Reporters at the *Daily Mirror* were concerned with his 'terribly tattered overcoat, trousers which would have caused Savile-row to bulge its eyes,

82 The History of the London Underground Map

and a hat only to be described as indescribable.' His 'astonishing red jersey'[5] also raised a few eyebrows. It was obviously a slow news week.

The sculptures were 'certain to attract much attention, more especially as they are on the lower portion of the building where the details will be easily discernible.'[6] Unfortunately, the proximity of the sculptures to the street – particularly their *details* – was their undoing. Westminster could just about tolerate *Night*, which showed a shrouded female placing a giant calming hand over a man positioned on her lap. But *Day* showed a bearded male figure with a naked boy in front of him, facing the morning light. The depiction of the boy's phallus was immediately denounced as indecent, and the sculpture itself as an 'Awful Colossus in Stone'.[7] Epstein would answer these criticisms by suggesting that 'Non-creative people have muddled ideas about what is beautiful … I cannot understand it. All this stuff about my wanting to "shock" people and being a revolutionary in art is nonsense. It is ridiculous.'[8] He concluded by suggesting that 'the man in the street … on his daily way to work can always avert his eyes from it.'[9]

Frank Pick merely said, 'It looks awful.'[10] Presumably he would be one of those averting his eyes. Yet despite Pick's opinion of Epstein's work, he took responsibility for the decision and offered his resignation, which was not accepted. In an act of artistic compromise, Epstein chipped an inch off the offending penis and everyone eventually forgot about it. The penis is now Grade I listed by English Heritage, along with the rest of the building.

The same year, 1929, also saw a much-needed injection of capital for a long overdue extension.

Overcrowding at Finsbury Park had been an issue since the First World War. Where previous extension schemes aimed to generate traffic, such as those completed for the Hampstead and City lines, the driving force behind the proposed extension north of Finsbury Park was to improve public services. As an interchange between the mainline suburban railway, buses, trams and two Tube lines – the Great Northern & City and the Piccadilly which both terminated there – the station regularly saw a stampede of passengers, all attempting to reach their homes in north-east London. As a direct result of ongoing passenger complaints, the London and Home Counties Traffic Advisory Committee was established in 1925 to conduct a public inquiry into the issue. The inquiry

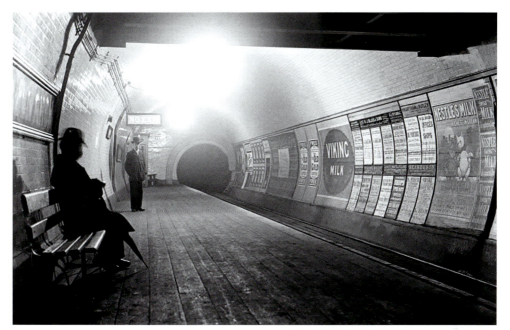

A platform at Marble Arch Underground Station on the Central London Railway (CLR) shortly after it opened in June 1900. The CLR brought a touch of glamour to the underground and its opening was greeted with enthusiasm by the press and public.

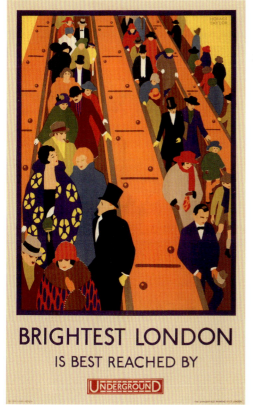

Brightest London is Best Reached by Underground – a 1924 poster print by Horace Taylor (1881–1934) for London Underground. Published in the golden years of publicity under Frank Pick, Taylor's design perfectly captures an age of aspiration, as well as conveying brand values.

Unless otherwise indicated, images used are either free from copyright or used under the Creative Commons licence.

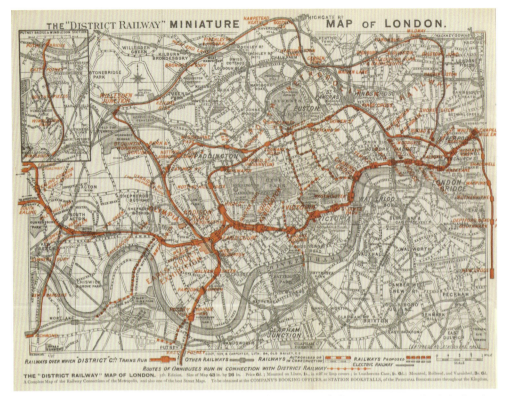

'The "District Railway" Miniature Map of London' (1897 edition) from *Cook's Handbook for London*. Both the Metropolitan and District railways made use of third-party city handbooks to promote their lines, as in this example. Overprinting on a geographical base map was considered the norm but this approach compromised legibility and was a challenge when the end of the line was off the map.

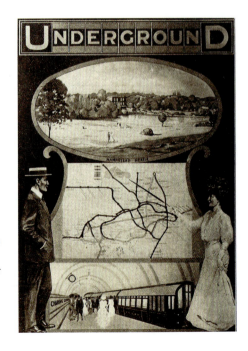

An image from the *Electric Railway Journal*, published in America in 1909. The accompanying article claims that a recent publicity campaign – which included the poster shown – 'has been responsible for a greater growth in traffic than the normal increase which might otherwise have been expected …. It is apparent from the experiences in London that a well-planned advertising campaign combined with good service can do much to develop the suburban business, increase the pleasure travel to outside resorts and even make the local public pay more attention than is customary to local museums and other places of public interest.'

The poster is an early example of combining a network map with illustrations.

From the *Electric Railway Journal* (1908). The 'No Need to Ask a P'liceman' poster by John Hassel is one of the most famous from this era, and another early example of how the underground network map was incorporated into publicity material. The caption reads: 'The sentiment expressed by this design is typical of the company's determination to give intending patrons every opportunity to make their journeys with the greatest possible certitude.'

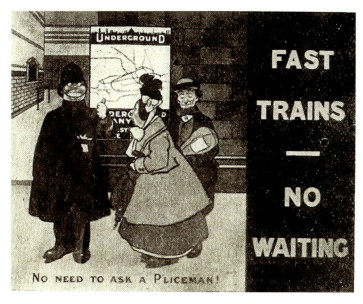

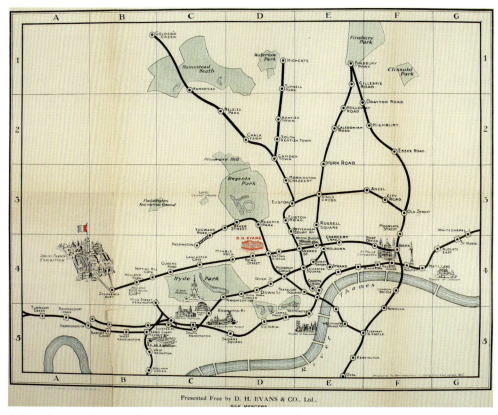

A UERL network map included in *A Brief Guide to London* (1908). The guide would have been aimed at visitors and day-trippers, particularly those wishing to visit landmarks such as St Paul's Cathedral, the British Museum and the Anglo-French Exhibition.

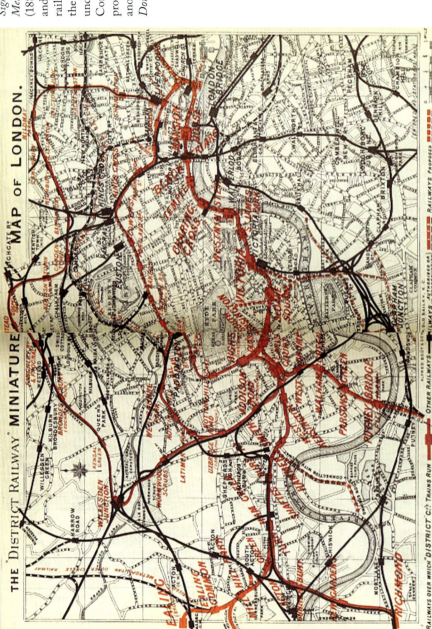

Sights of London illustrated: and Metropolitan Handbook for Railways (1883), printed by H. Herbert and Co, London. The jumble of railway lines and topography shows the difficulties in mapping the underground network at the time. Company rivalry is evident in the prominence given to one line over another. (*The British Library. Public Domain Mark 1.0*)

Aldwych Underground Station being used as an air raid shelter in 1940. The network was initially reluctant to allow sheltering on its stations but had little choice once the Battle of Britain started in earnest. A row of coats can be seen hanging on the tunnel wall.

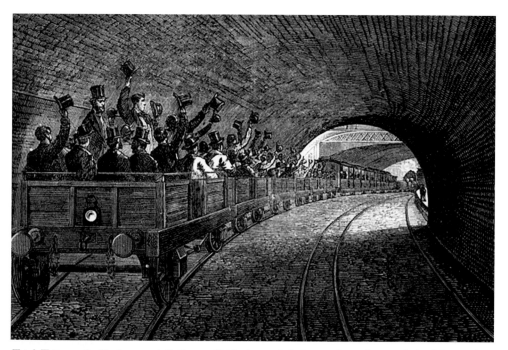

Trial Trip on the Underground Railway, 1863. An artist's impression of one of the Metropolitan Railway's famous trial trips of 1863 passing through Portland Road Station (Great Portland Street). This illustration from *Old and New London with Numerous Engravings From the Most Authentic Sources* (1890) by Walter Thornbury is thought to be a reproduction of a sketch published in the *Illustrated London News* on 13 September 1862.

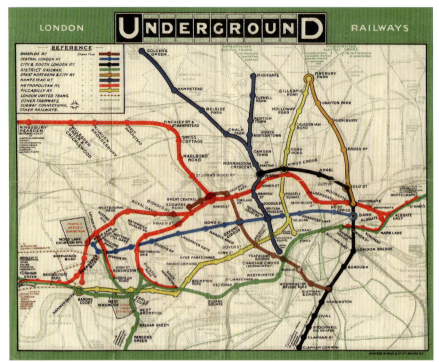

'London Underground Railways map' 1908. This map shows an early 'UndergrounD' wordmark – a feature that remained for over a quarter of a century. Street detail is still included but 'greyed out' so that the route lines have better prominence. An early distortion of geography is in evidence; the designer straightened the Neasden section of the Metropolitan line to fit around the key box. (© *TfL from the London Transport Museum collection*)

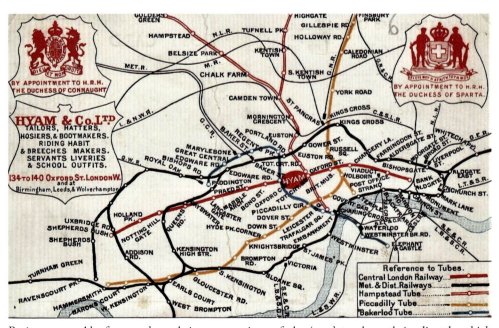

Businesses would often produce their own versions of the 'map' to show their clientele which underground station was the nearest to their premises. This version was produced by Hyam & Co. Tailors between 1900 and 1912 – after which the CLR was extended eastwards to Liverpool Street.

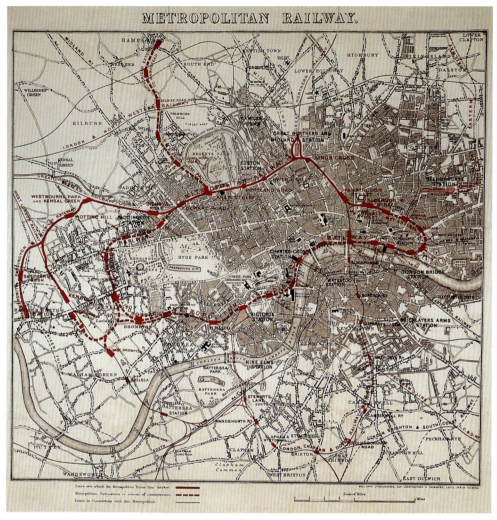

A map showing Metropolitan Railway extensions under construction from Edgware Road to South Kensington (opened 1868) and from Moorgate to Mark Lane (opened in stages between 1875 and 1882); the Metropolitan District Railway under construction from Mark Lane to West Brompton and Addison Road (opened in stages between 1868 and 1882) and the Metropolitan and St John's Wood Railway from Baker Street to Hampstead (opened from Baker Street to Swiss Cottage in 1868). Dated to circa 1867 (based on lines open and under construction).

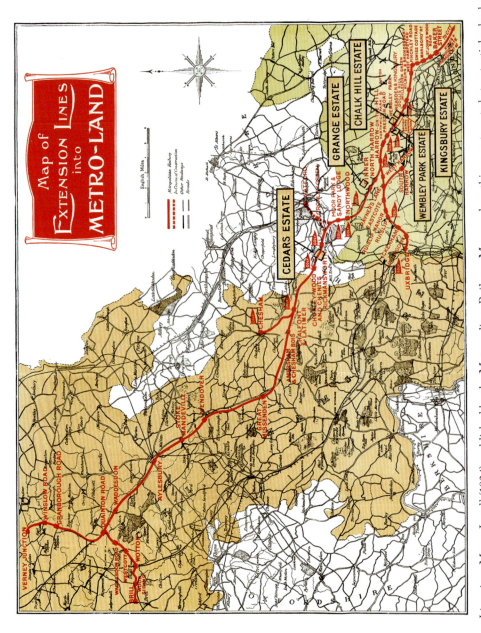

'Map of Extension Lines into Metro-Land' (1924), published by the Metropolitan Railway. Maps such as this were targeted at potential suburbanites, hence the inclusion of housing estates and golf courses for that all-important middle-class leisure time.

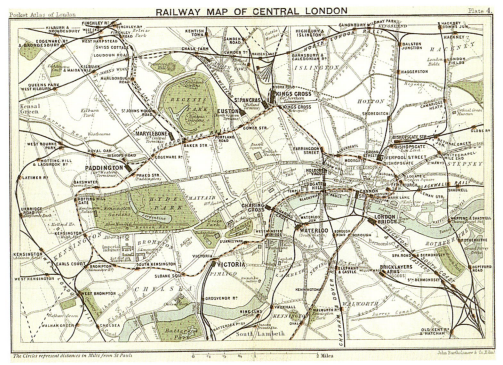

Map of central London showing both mainline railways and termini, and the Metropolitan Railway, 1899. From *The Pocket Atlas and Guide to London*, published by John Bartholomew and Co., 1899. The use of black for all lines, barring the Metropolitan, shows the difficulty in depicting connections without colour.

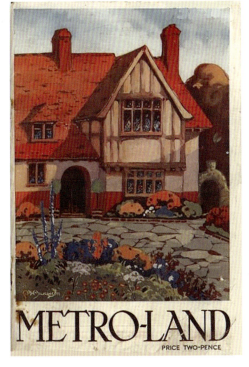

Metro-Land booklets were published annually from 1915–32 by London's Metropolitan Railway. This is the cover of the 1921 edition, which was designed by Cyril A. Wilkinson (1893–1926), and promoted housing in the area served by the railway. The 'Tudorbethan' design of the house was typical of the nostalgic approach the Met took to its marketing.

Construction of the Metropolitan District Railway circa 1866. The view is of Parliament Square looking towards the Houses of Parliament with George Canning's memorial precariously close to the works. Thought to be taken by Henry Flather, 1839–1901.

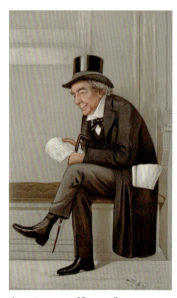

A caricature of James Staats Forbes (1823–1904) from *Vanity Fair*, 22 February 1900. As well as being director of the Metropolitan District Railway, Staats Forbes was also chairman of London, Chatham and Dover Railway (LCDR) 1874–1886 and a director until 1897. The business rivalry between Staats Forbes and Edward Watkin would stifle the development potential of the underground in its early days.

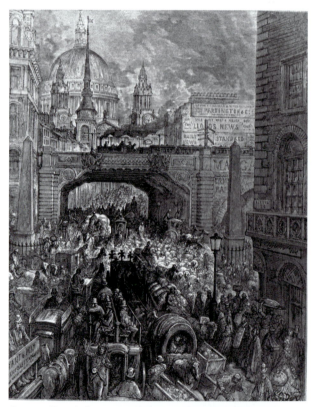

Gustave Doré's (1832–1883) famous depiction of 'Ludgate Hill – A Block in the Street', from *London, A Pilgrimage* (1872). The illustration shows the extent of the congestion on London's roads.

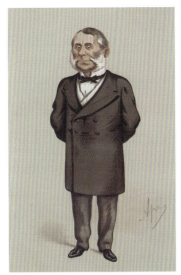

A caricature of Sir Edward Watkin MP, from *Vanity Fair*, 6 November 1875. The caption reads: 'The Railway Interest'.

Charles Tyson Yerkes (1837–1905). Photograph taken in 1904. Despite his shady business dealings, Yerkes' influence at the beginning of the twentieth century helped to bring the underground into the modern era.

Photogravure reproduction of portrait of Albert Stanley, later 1st Baron Ashfield (1874–1948) by Sir William Orpen (1878–1931) from circa 1925 (based on contemporary photographs of Ashfield). As the first chairman of London Transport, Lord Ashfield would prove to be one of the most influential in its history.

Stained-glass roundel incorporated into a clerestory window at Morden Station (1926). Architect Charles Holden brought the Johnston-designed roundel into station architecture to provide easy identification. The roundel would go on to become one of the most recognised corporate logos in history. (*George Rex, 2013*)

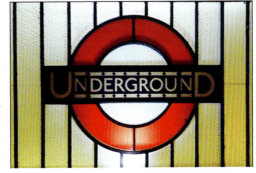

Jacob Epstein's (1880–1959) controversial 'Day' sculpture from the external wall of former London Transport headquarters, 55 Broadway. (*Jim Osley, cc-by-sa/2.0*)

Kilburn Park Station (1914–1915) on the Bakerloo line. The station was designed by Stanley Heaps in a modified version of Leslie Green's earlier Bakerloo line stations. (*Jim Osley, cc-by-sa/2.0*)

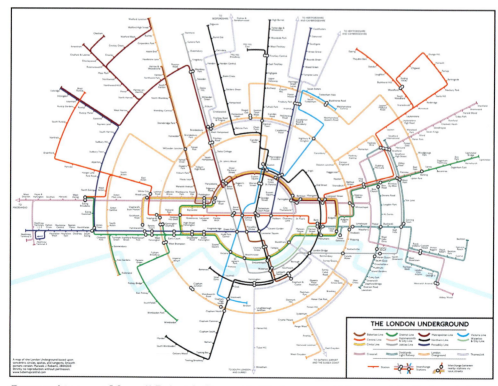

Cartographic expert Maxwell Roberts's Concentric Circles map, which was originally intended as a joke version of the Tube map, until it went viral on the internet in 2013. (*Maxwell Roberts*)

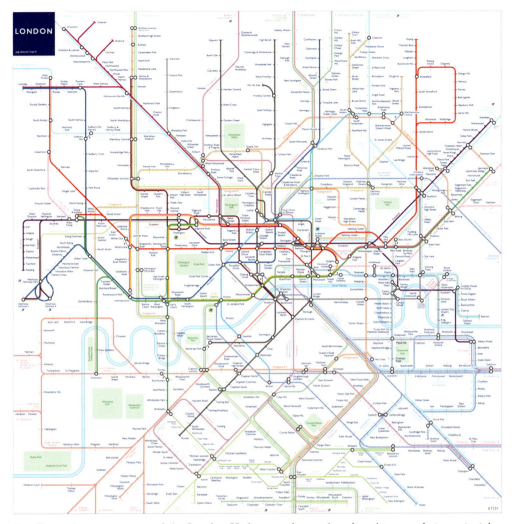

Jug Cerovic's interpretation of the London Underground map, based on his own design principles which he believes can be applied to most, if not all, the world's mass transit systems. (*Jug Cerovic*)

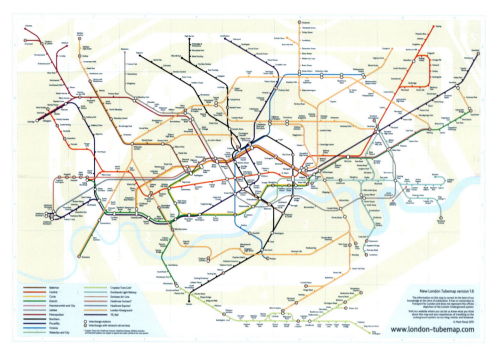

Mark Noad's original 'Tubemap' was conceived as a response to the disconnect between the official Transport For London map and street-level London. (*Mark Noad*)

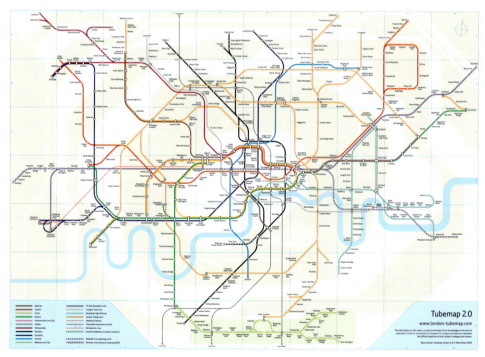

Mark Noad's Tubemap 2.0, an updated version of his original interpretation which incorporates the Elizabeth line. Noad admits that when looking at his original map he 'didn't like it very much anymore', which prompted him to try a redesign. He said, 'As well as the geographical parameter, I concentrated on making a simpler, more elegant solution adopting the 45 degree lines of the classic Beck original.' (*Mark Noad*)

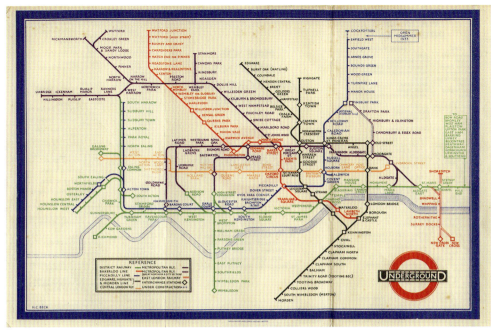

Henry 'Harry' Beck's iconic 1933 Diagram, in pocket map form.
(© *TfL from the London Transport Museum collection*)

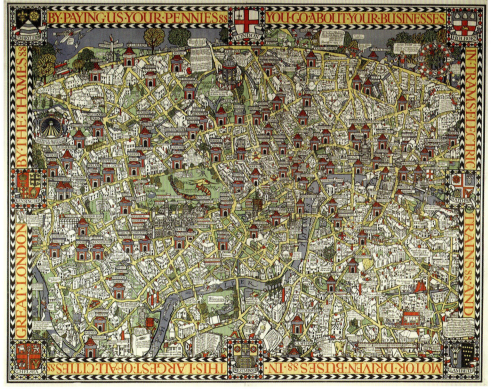

Macdonald Gill's decorative poster map *By Paying Us Your Pennies*.
(© *TfL from the London Transport Museum collection*)

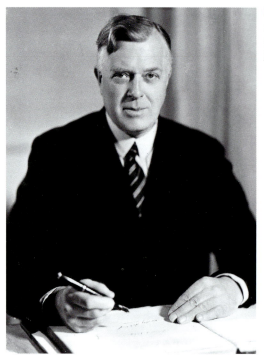

Photographic portrait of Frank Pick, whose career on the underground spanned more than thirty years. (© *TfL from the London Transport Museum collection*)

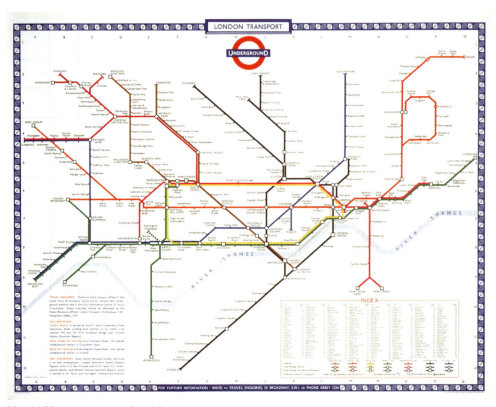

Harold Hutchison's 1961 Quad Royal poster diagram, which replaced Beck's iconic design. (© *TfL from the London Transport Museum collection*)

heard how 'pandemonium reigned It was like a free fight sometimes'[11] and that the 'condition of traffic outside Finsbury Park during rush hours witnesses described as being shocking.'[12] Seven Sisters Road, where the station was situated, was of particular concern: 'the number of people killed and injured in 1922 was 167, in 1923, 222 and in 1924, 236.'[13]

By November 1925, Frank Pick had delivered his evidence to the inquiry, which included cold hard statistics in case anyone was in doubt as to the nature of the 'traffic scandal'.[14] Tests had revealed that

> the buses on an ordinary weekday carried 57,000 passengers and the tramways 21,000, the total yearly figures amounting to 27 and 28 millions... . As regards the Underground railways at Finsbury park, they were not being used up to their full capacity because of the difficulty of carrying the people on from that point.

The solution was simple: 'the only remedy which would be of practical assistance today, and is the only solution for the future, is the extension of the Tube railway in a northerly direction, at least as far as Wood Green.'[15] The 1925 inquiry agreed and the UERL set about preparing a Piccadilly extension scheme, although at this stage no one knew how it would be financed. The LNER, which operated the mainline services through Finsbury Park, had no intention of modernising its suburban commuter services, preferring instead to concentrate on its more profitable freight services. The UERL would have to wait until 1929 for a source of capital to become available.

In that final year of the decade, the newly elected Labour Government committed to a programme of public works and support for the depressed industries, although they hadn't reckoned on the Great Depression and its impact on an already floundering economy. Their response was to immediately pass the Development (Loan Guarantee and Grants) Act of 1929, which would subsidise local authorities and public utilities to undertake capital development work, in the hope that it would relieve the burden of unemployment and stimulate the economy.

The UERL took immediate advantage of the Act and put forward a £12.4 million development programme which covered not only the northern Piccadilly line extension, but also a 4.5 mile extension westwards along the overground route of the District line. This would

84 The History of the London Underground Map

enable Piccadilly line trains to run as far as Hounslow and, via South Harrow, to Uxbridge. A new interchange station with the Central line at Holborn was also proposed.

Work on the scheme began in 1930 and was not for the fainthearted. Not only would it involve the creation of eight new stations, but much of the old District line infrastructure would need to be upgraded. This time Pick looked to the continent for inspiration, using the Piccadilly extension plans as a perfect excuse for a junket abroad with Charles Holden and Lord Ashfield's PA, Bill Edwards. Their seventeen-day tour in June and July 1930 took them to Denmark, Germany, the Netherlands and Sweden. What they brought back was a revolution in architectural style – a movement from the Netherlands called the 'Amsterdam School', spearheaded by Modernist architect Willem Marinus Dudok, that encouraged the use of brick, curved masonry, and 'ladder' windows with horizontal bars. The stations that Holden would ultimately design would incorporate these ideas along with Bauhaus principles – that of streamlined aesthetics, functionality, modernity, and, above all, the idea that 'an object is defined by its nature'.[16] This aligned neatly with Pick's own ideals for civic design, that fitness for purpose was a necessary consideration in intelligent design.

Holden tackled Sudbury Town first, creating a large circulating area with passenger facilities leading from it. The design was used as a prototype for subsequent stations. He also did his homework, diligently preparing graphs of passenger movement and designing each station around the flow of people passing through it, which was allegedly the first scientific based study into 'wayfinding'.[17] Sudbury Town, the first of Holden's 'brick boxes with concrete lids', was another architectural leap of faith for the UERL but it was one that paid dividends. Remarkably, it took just six months to build before opening in July 1931, but its legacy would transcend the years. The ideas it incorporated would be replicated not just on the other Piccadilly line extension stations but in numerous civic buildings up and down the country. A tall ticket hall gave a sense of space and light, especially when enhanced by sections of steel-framed glass, and traditional building materials such as brick were used alongside modern concrete. The whole effect was clean and unfussy and ensured that passengers could pass through from street to platform unhindered by obstructions or distractions. This was a new futuristic aesthetic; a portal

All Change (Please) 85

to the subterranean world. It was also the age of the great science fiction writers such as Aldous Huxley, H. G. Wells and George Orwell. All would re-imagine this theme, seeing the modern transport network and its architecture as both a transformative and unstoppable sign of progress, yet something that ought to be feared and mistrusted. The 'technopolis' in Huxley's *Brave New World* (1932), with its 'Charing-T Tower', the 'disk of shining concrete'[18] that embodies Huxley's recreation of Charing Cross Station, stands as a testament to hegemony and social conditioning. It is of little wonder that Huxley took such flights of fancy with his writing. With stations such as Arnos Grove, the 'drum on a cube', and Southgate, the 'flying saucer' topped with an illuminated feature resembling a coil from an alchemist's laboratory, for inspiration it is hardly surprising.

At the same time as Holden's foray into London of the future, the Met was busy going the opposite way. It had also secured a capital loan under the same scheme as the UERL, which enabled it to extend Wembley Park to Stanmore. The line opened in 1932 and it was to be its last as an independent operator. Change was on the horizon, but first it wanted to see that its newest extension at least had stations. Rather than going out with a bang, it opted to finish with a fizz. Falling back on its tried-and-tested 'is it a house or is it a station?' styling, courtesy of Charles W. Clark, the new line had stations at Kingsbury, Canons Park and Stanmore. Queensbury would join the party two years later in 1934, and in 1939 the whole section was transferred to the Bakerloo line. The extension was to be the Met's swan song – within a year it would become part of the city's newest corporation, the London Passenger Transport Board.

The original underground railway company that took its name from the city but spent seventy years trying to escape it ceased to exist in 1933. The Metropolitan lives on in name only, a burgundy line running north west across the map, still looking for adventures further afield.

At the close of the 1920s, the UERL was powerful but it wasn't *that* powerful. It had taken seventy years of discussions, debates, and arguments for there to be even a modicum of cooperation among London's transport providers. This was despite the recommendation from the House of Lords Committee in 1863 that a single transport authority should be established to integrate the capital's services. Had belligerent old Charles Pearson still been on the scene, his constant harrying would have probably ensured compliance in all quarters. But the continuing conflict

86 The History of the London Underground Map

of interest between private operators, the London County Council who ran the central London trams, the UERL who ran most of the buses (via the London General Omnibus Company) and the majority share of the underground lines, plus a handful of other private stakeholders, had ensured the process of amalgamation had been tediously slow.

In 1928 it looked as though the two largest operators, the UERL and the London County Council, might have reached an agreement, and would promote two separate bills in parliament to allow full coordination and joint management of their services. But hopes were dashed by an unfortunately timed general election in May 1929, which saw Labour come to power with Ramsay MacDonald's government. Labour didn't look kindly on a deal that seem to favour the privately run UERL and threw both bills out.

However, it would be Labour, or more accurately their new Minister of Transport, Herbert Morrison, who would eventually manage to slot all the pieces together and gift to London the neat, amalgamated package that we have today. Morrison, a socialist who grew up in the capital, made no secret of his distaste for the private ownership of London's various transport services. Described as 'pugnacious and reasonable',[19] he was also known for his quiff, spectacles and taste in bowties, which no doubt provided endless fodder for the political satirists. His reform of London's transport network began with a wholesale obliteration of all inherited proposals for merged public transport services. But through ministerial discussions, political bargaining and Morrison's own knack for bonhomie at the crucial moment an alternative solution began to emerge. It was a new public corporation, run on similar lines to the newly established BBC, with responsibility for most passenger traffic services within the London area. The overground suburban network, run by the big four companies – the GWR the LNER, the SR and the London, Midland and Scottish Railway – was not included in the new scheme. They would continue to run as separate concerns. Initially, the Met was firmly opposed to the scheme, but the sudden death of Robert Selbie in 1930 had weakened its position and it had little option but to fall into line.

Morrison brought the bill to the Commons in March 1931, confident of its aims being realised. In order to gain cross-party support, he promoted the socialist aspects of the bill as well as emphasising its economic benefits.[20] Yet progress was destined to come to a crashing halt yet again.

The collapse of the Labour Government five months later, in August 1931, meant an end to the bill, and an end to Morrison's hopes, as well as his parliamentary seat.

Nevertheless, despite the fact that Morrison had been removed from office, the legislation was eventually passed by the Conservative-dominated National Government in 1933, and on 1 July the new authority was born – the London Passenger Transport Board (LPTB), although it would quickly come to be known simply as London Transport. The date was chosen to coincide with the end of the half year, so that accounts of the various individual companies could be made up then closed, therefore facilitating a smoother transition. It marked the end of an era; one in which private operators had been allowed to dominate the city's transport provision and chase (often non-existent) profits in the name of growth and expansion. These private concerns – revolutionaries in their own way, for they had influenced the size and scope of the network – were offered either cash payments or shares in the new organisation and sent on their way.

There was some state control, particularly in its financing, but as railway historian, Christian Wolmar, recognises:

> It was much more than that. LT was the first example of how a public body could be invested with commercial as well as social responsibilities, and carry out both aspects successfully London Transport was the right solution at the right moment It represented the apogee of a type of confident public administration run by people imbued with a strong ethos of service to the public and with a reputation that any state organisation today would envy.[21]

Heading up this new powerhouse of public service would be the dynamic duo themselves – Lord Ashfield as London Transport's first chairman and Frank Pick as chief executive. Contemporary press reports announced the coming of London Transport with some staggering numbers even by modern standards:

> While Britain slept last night a transport change involving over £100,000,000 was effected, and the greatest traffic combine of its kind in the world is now in existence... . When Londoners

88 The History of the London Underground Map

scramble for their bus, trams, and trains this morning, the only visible indication of the change will be bold official notices to the effect that they are no longer the paying guests of the L.G.O.C., of the L.C.C., the 'Met' the District, or the Tube, but of the London Passenger Transport Board.[22]

The Lancashire Daily Post went with the headline 'Quiet Revolution in Transport' but told of 'A change which puts into the hands of the London Passenger Transport Board 6,000 omnibuses, 2,240 tube train coaches, and 226 railway stations, and the arrangements for four billion passenger journeys annually.'[23]

Somewhat astutely, the press also predicted the demise of the tram with the coming of the new transport combine: 'There is some curiosity as to what the board's attitude to trams will be. Its chairman (Lord Ashfield) is said to look upon them with no kindly eye, but, even if this is true, he will probably be slow to banish them.'[24] It actually took until 1952 for London Transport to overcome the protests of its leading campaigners – the Light Railway Transport League – and decommission them entirely. In a fitting conclusion to their 92-year-history, the driver of the final tram journey, from Woolwich to New Cross, was none other than the deputy chairman of London Transport, John Cliff, who had begun his career as a tram driver in 1900.

London Transport wasted no time in making the necessary changes, ensuring that 'The task of obliterating the existing identity marks on the buses, trams and trains is already in hand. Vehicles will appear next week with the name of their new owners neatly printed on the side.'[25]

The importance of iconography was not lost in the transition. If anything, the corporate hallmarks developed over the previous decade became stronger and imbued with an even more powerful meaning. And these artistic lexicons, established so successfully by the UERL, were about to be joined by a diagrammatic map that would one day become *the* map of London Underground.

Chapter 16

A New Design for an Old Map

There is something poignant about the fact Harry Beck's famous diagrammatic map was conceived in a period of widespread economic and cultural decline. Beck was unemployed when he produced his first sketch of the Diagram in 1931; the privations and austerity measures brought in under 'Geddes Axe' throughout the 1920s had touched all areas of society, including the public sector and service industries such as the UERL. It is remarkable then, that a cultural landscape so bleak and enmired in the shifting sands of social and political change was able to inspire something so inherently organised and uncluttered. It provided a different vision of the city – one that was sorely needed at the time – a landscape free of chaos and the semantic noise of everyday life, rationalised and distilled into one simple design. Beck would untangle the infinite set of street-level journeys a traveller might take in the heart of London – the 'great avenues of civilisation'[1] that 'strike this way and that'[2] and reorganise them into clean, geometric lines. But those neat lines also distorted the truth.

Henry (Harry to his friends and associates) Beck was born in 1902 in Essex. His father, Joshua, was an artist and monumental mason, and Harry was sent to Italy to study marble after leaving school, presumably with a view to following in his father's footsteps.[3] He also attended art classes in Highgate, where his family moved in 1910 and where he met his wife Nora, whom he married in 1933. A photograph of him proudly holding his beloved Diagram, which is kept in the London Transport Museum collection, shows an honest and pleasant-looking man who seems entirely at home in the London Transport offices.

Beck's first role for the UERL was as a junior draughtsman in the Signal Engineers Office in 1925. However, as a 'temporary' employee he had the ever-present axe of Geddes hanging over him, and he was dismissed several times from the UERL during the latter half of the 1920s. After some months of unemployment, Beck was delighted to return to the

90 The History of the London Underground Map

'old firm' again, but his joy was curtailed when he was dismissed again. Fortunately, he was invited to return again, and in many ways, Beck's loss of employment was London's gain, for it was during these periods of inactivity that he began to experiment with the underground map.

His initial exercise book sketches, in pencil and coloured ink, include features a modern traveller would recognise today – the stylised River Thames, following the angles of the underground lines, which themselves are simplified to be vertical, horizontal or diagonal – as well as the circles to denote stations (although these are now only used to represent interchange stations). To say it looks nothing like a traditional map is both an understatement and a truth. Here is where Beck's creation departs from all previous attempts to 'map' the system. Because to deal with the profuse and unwieldy dimensions of the city and its network, it was necessary to ignore the values inherent in traditional maps – those of geographical accuracy and scale. The result has been described as a cross between an electrical circuit board and a Mondrian painting,[4] as well as 'part of Constructivism'[5] and a 'modernist electromechanical imagination'.[6] What Beck would have made of such interpretation we will never know, but he referred to it simply as a diagram, which of course, it is. It is well documented that Beck's co-workers teased him, saying he had merely adapted an electrical circuit diagram, of which he was so familiar, and imposed it on the map. In response, he drew a spoof diagram for the employee magazine the *Train, Omnibus and Tram Staff Magazine* in 1933 in which station names were replaced with electrical references, such as 'Bakerlite Tube' for Bakerloo line, 'Amp' for Hampstead, and the top of the Piccadilly line becomes an antenna. The caricature presents a strong case for being his source of inspiration, although Beck would never confirm this.

Despite the Diagram's heritage of design principles, and more recent alias as a 'Journey Planner', it is ironic then that most users still refer to it as 'the Tube map' even though it fundamentally lacks key mapping elements such as topography and urban detail. What is does do, however, is encourage a *mental* map of London – one that exists inside the passenger's head and allows them to traverse the city at subterranean level, while also making sense of the city at street level. In Janet Vertesi's 2008 study of 'the Tube map' as an interface between its users and the city, respondents consistently drew London *as* the map – one interviewee exclaiming

confidently that, 'It's on the Tube Map, therefore it must be London'. This echoed other responses which said that if it is on the map, it is in London and if it's off the map it isn't.[7] The fictional London depicted by Neil Gaiman in his fantasy novel *Neverwhere* is equally indefinable without the trusty Tube map to decipher it: 'When he had first arrived, he had found London huge, odd, fundamentally incomprehensible, with only the Tube map, that elegant multicoloured topographical display of underground railway lines and stations, giving it any semblance of order.'[8]

Beck, of course, would have been unaware of the Diagram's future cultural significance at its conception in 1931. At the time, it represented a challenge to Beck, as well as a chance to prove his worth to his employers. The map needed tidying up, and Beck was the man for the job.

Beck's 'tidying up' involved replacing the sinuous curves of the Stingemore map and constructing a network of straight lines, running horizontal, vertical and at 45 degree angles from the Central London Railway (Central line) which acted as a base line. By eschewing topographical street-level detail, he was able to play with distance and scale – enabling him to enlarge the central area, which had the highest density of underground stations, and place every station at equal distance from the next. It also meant he could compress the furthest reaches of the network – except for the eastern section of the District Railway beyond Whitechapel, which ended up as a list of stations in a box. His reason for this radical approach was that by divorcing the lines from their geography it allowed the Diagram's intended purpose as a navigational tool to take precedence. Accuracy and distance were not important – what *was* important was the sequence of stations and how they related to the rest of the network.

The UERL did not agree. Encouraged by his colleagues, including Fred Stingemore, Beck presented his design to the publicity department for the first time in 1931, but to his surprise and disappointment, it was decided the Diagram was too revolutionary, and it was handed back to him.

It is easy to deride the UERL's dismissal of Beck's Diagram through a retrospective lens, but the design was way ahead of its time. In those days, a map was expected to employ at least some degree of visual authenticity. Conversely, when designer Mark Noad attempted to reinstate an element of geographical accuracy to the Diagram in June 2011, reimagining the

92 The History of the London Underground Map

network without the constraints of Beck's straight lines, not everyone was enamoured with it.[9] Noad reported that reactions to his version of the map – Tubemap 2.0 – ranged from 'beautiful' to 'an ugly waste of time' and 'aesthetically frightful'.[10] The Tube-travelling public of 2011 weren't quite ready for a different approach; just as the UERL of 1931 wasn't ready for something so *modern*. Particularly something that would have to be accepted by an unindoctrinated public.

Luckily, Beck knew his audience better than the UERL. He understood the underground topological space, stating rather pragmatically in his later years that 'If you're going underground, why do you need to bother about geography? It's not so important. Connections are the thing.'[11] Those connections would become something of a nuisance in the years that followed, but for now he was confident that the public were capable of understanding the concept of his Diagram and embracing the change. He waited a year and then – like all recalcitrant innovators who have an unswerving faith in their own abilities – he decided to try again.

By early 1933, the UERL was on the cusp of change itself and by the summer it would be refashioned as London Transport. Did this new start mean it was more receptive of Beck's Diagram? Perhaps. Certainly, Beck's idea of 'tidying up' the lines corresponded with London Transport's desire to 'tidy up' the transport network into a unitary administration. It also embodied the UERL's ethos of functionalism in design – a principle that had been growing in importance over the previous decade and had been upheld rigorously by Frank Pick. Moreover, the scope of the Diagram went beyond London Transport's; it also offered a rational interpretation of urban life, that the disorder of the city could be erased and replaced with an organised and controllable metropolis.[12] Whatever the reasons, by 1933 the UERL (soon to be London Transport) had come to recognise the merits of Beck's Diagram, and decided to try it out.

Beck refined his ideas before the Diagram was committed to the printing press. The whole Diagram was redrawn from scratch and the non-interchange station 'blobs', or circles, were replaced with 'ticks', giving it a cleaner and more dynamic feel. This also aided clarity since each tick pointed in the direction to the station it referred, meaning the station names could be arranged on either side of the route line. Finally, the Piccadilly line was changed to dark blue, the colour it has remained ever since. Beck was paid ten guineas for the design and artwork of the

A New Design for an Old Map 93

first card folder edition of the Diagram. Unsurprisingly, this is now considered to be a derisory amount given the longevity of the Diagram's design and iconic status, but doubtless it was a welcome sum in the cash-strapped 1930s, especially as Beck was in and out of work. The fact he was paid as a contracted freelancer for the Diagram, yet also remained a paid employee of London Transport would ultimately prove to be his undoing.

In January 1933, 750,000 copies of the Diagram were ordered. It is telling that the words, 'A new design for an old map. We should welcome your comments' were printed on the cover. Any comments, good or bad, have been lost to history, but any anxieties the UERL had as to how the Diagram would be received were unfounded. The printing of a further 100,000 copies just a month later suggest it was an instant hit, although Pick was rather underwhelmed by the quad royal version – despite its overwhelming size of 40 x 50 inches – commenting in August 1933 that 'upon a large scale this looks very convenient and tidy and is a better map than any we have had so far.'[13] Praise indeed...

That same year, 1933, also marked the beginning of Beck's married life. Nora Beck proved herself to be, above all things, patient. Harry Beck's obsession with his Diagram would be all-consuming and his continued involvement with the map was non-negotiable. He could tolerate the demands of the constant amendments and tasks related to its existence if it meant he could retain control over its design. Beck's niece, Joan Baker, recalled:

> Whenever you went round to see Harry and his wife, Nora, Harry would be working on the map, which would be spread out on the floor. He'd be very polite. You could ask him any questions you liked about the map, but what you *didn't* have to do was stand on it.[14]

Beck would need a certain amount of mettle to cope with the evolution of the Diagram. And evolve it did, many times over. Although there was no completely new line until the Victoria line opened between 1968 and 1971, several existing lines were extended or modified, prompting a new set of challenges and redrawings.

The Diagram was never static for long. Its ability to grow and evolve along with the city itself meant that it can be understood as effortlessly in 2022 as it could in 1933. But in many respects, the Diagram was

94 The History of the London Underground Map

also a product of its time; an instinctive reaction to something far greater than the problem of representing an ever-expanding network. It achieves a mythic status; not just because it upholds the utopian principles of integrating art with modern life, but because it is the ideal image of modern time and space: orderly, regular, efficient and entirely functional.[15] It even transcended its own period in history, being just as easy to understand on a smartphone as on a 1930s station platform. As such it is thoroughly embedded in our modern-day cultural conscience yet remains comfortingly tethered to Beck's original design principles almost a century ago.

Chapter 17

Say It With a Poster

London is indeed typical of the best city life at this stage of evolution. It comprehends much more than other cities, and so it lacks clearness of definition...but it is certain that the future of London cannot be an accident like the past. If it is to hold together, to remain a workable, manageable unit, it must now be planned, be designed, be organised.[1]

<div align="right">Frank Pick, 1926</div>

After 1933, the Beck Diagram became the authorised representation of the underground network. Despite its teething problems, it eventually continued the design legacy that had spanned the previous twenty years. From as early as 1909, Frank Pick had advocated the use of high-quality promotional material to convey, not just useful travelling information, but the objectives of the entire organisation. Quality design provided a way of symbolically conferring corporate values on to the newly merged London Transport. Each poster was designed to communicate an overarching message – that the underground network was safe, organised, efficient and easy to navigate. But in some respects, the responsibility Pick felt towards the travelling public went deeper – the network had to be efficient, yes, but also aspirational. It needed to be an environment that enhanced the lives of those that used it. He would return to this vision both in his personal reflections and public addresses, during his time at London Transport. In December 1935, he ended a talk at the Royal Society of Arts with a rousing refrain:

underneath all the commercial activities of the Board, underneath all its engineering and operation, there is the revelation and realisation of something which is in the nature of a work of art ... it is, in fact, a conception of a metropolis as a centre of life, of civilisation, more intense, more eager, more vitalising than has ever so far obtained.[2]

96 The History of the London Underground Map

Born in 1878, on the cusp of the burgeoning Arts and Crafts movement, Pick understood that the integration of art and aesthetics in everyday life had the potential to counter the alienating effects of mass industrialisation. As historian Oliver Green asserts, Pick 'was attracted to the idea that moral and civic harmony could be achieved through integrating art and design with everyday life.'[3] This blend of genuine utopian impulse and a desire to improve the civic space, of which the network was a part, was admired by Pevsner when he made his 'ideal patron' eulogy.

Pick's approach was also reactionary. The LPTB was formed in a turbulent period of erratic economic expansion and rapid technological change, with the transformation of processes of labour and the growth of the modern corporation altering traditional workplace hierarchies. New social values, borne out of the requirements of mass-production, such as efficiency, functionality and standardisation, became the slogans of the modern era. These prompted industry and commerce to look to art and design to create corporate identities that embraced these concepts and obscured the turbulent processes that enabled them to come into being.[4] In a sense it was a way of rewriting history – a neat obscuration of what had come before, which was exactly what London Transport needed if it was to press forward into the modern era. Branding and design gave London Transport a chance to finally present a unified system, rather than the illusion of it, which is what the pre-Beck maps had sought to achieve. It gave form to an idea of urban transit that was logical in the context in which it was designed, an era of intense industrialisation and the concentration of capital.[5]

The period was also marked by a strong sense of impending disaster – an idea that

> won a broad popular audience in [an] inter-war Britain receptive of anxiety as one of the defining features of contemporary culture, cohabiting uneasily with the glittering promise of mass consumption and a narcotic hedonism, which for the lucky minority was real enough.[6]

For the generation who had lived through the First World War, and witnessed its devastating effects in the years afterwards, the prospect of imminent crisis, 'a new Dark Age',[7] became an habitual way of viewing

the world. This sense of morbidity was disseminated by new modes of mass communication, such as mass publishing, public meetings, demonstrations, radio broadcast and popular literature – all of which became the conduits through which pessimism and anxiety filtered down to civic society.

Despite Pick's best efforts to mollify the pervasive attitude of a 'civilisation in crisis', with the calming panacea of underground art, not everyone was convinced. George Orwell saw the LPTB as the ultimate symbol of bureaucratic control, since one of its aims involved the promotion of commuting, an essential cog in the machinery of a capitalist society. He returned repeatedly to themes of obliteration in his writing – particularly of the countryside and rural values – and the potency of modern technology, attacking everything that was 'slickness and shininess and streamlining. Everything's streamlined nowadays'[8] including, of course, the Tube network. This was J. B. Priestley's 'New England', which he identified in his 1934 book *English Journey*, a place of increasing standardisation, roads and motor cars, suburban sprawl and the spread of American culture. Priestley's rambling account of his travels in the autumn of 1933, journeying through urban, suburban and rural England describes a country in the grip of economic collapse where traditional values sit uncomfortably alongside modernisation. His observations are at once delightful yet angry, railing against the issue of long-term unemployment and the ubiquitous north south divide. 'What,' he argues, 'had the City done for its old ally the industrial North? It seemed to have done what the black-moustached glossy gentleman in the old melodrama always did to the innocent village maiden.'[9]

It was Priestley's disappearing landscape – the 'Old England' of minsters and manor houses – that Pick would recapture in the artwork he commissioned to promote the newly created suburbs. Beck's Diagram did much to promote ease of access to the suburbs since its schematic layout concealed the larger distances between suburban stations, making them appear closer to the city centre. Thus, Uxbridge was as close to Hillingdon as Leicester Square was to Covent Garden. The idea of time as short intervals – a three-minute walk, five minutes between stops, ten minutes to the centre – and how it related to distance and everyday movement began to be reshaped. Traditional notions of place, and the narrative of 'going on a journey' à la J. B. Priestley and his leisurely stroll around

98 The History of the London Underground Map

England, suddenly became less significant than getting somewhere as quickly and efficiently as possible. The immediate popularity of Beck's Diagram was testament to the growing might of the working classes and the Modernistic mindset – one that had no time to engage in their surroundings or while away the hours watching the world go by out of a motor-coach window. The new breed of passenger simply needed to get from A to B, or from home to work and back again, using the quickest means possible.

The new expanded suburbs were overwhelmingly residential, and their habitués relied on the city for all their consumer needs, including recreation and employment. So to bridge the disconnect between the experienced duration of a commuter journey and the shortened distances displayed on Beck's Diagram – thus achieving the hallowed forty-five-minute commute that Pick was convinced was the limit of a person's tolerance – the system had to be as tight and efficient as possible. A series of reforms were implemented. Signalling was improved and platform waiting times were reduced, therefore increasing the speed and flow of trains across the network. The passenger flow was also refashioned and Charles Holden's new station architecture ensured an unhindered passage from street to train. He designed and implemented larger station entrances and separate lanes depending on ticket type, as well as illuminating the main thoroughfares with better lighting. New technology was introduced both for those operating and monitoring the network and for passengers. The Machine Age would gift to the underground suites of automatic push-button printing machines that allowed tickets to be issued in a fraction of the time taken before. No detail was too small in terms of timesaving, and the newest type of machine, which was debuted at Piccadilly Circus, could be operated by a passenger merely inserting a coin. It would also give change if a sixpence or shilling were used for a lower-price ticket. Designer Christian Barman wrote:

> When tests were made of passenger movement from street to platform an average saving was found of 2½ minutes on the time taken in the old station at the corner of the Haymarket. This may not be a great deal of time, but it made a most useful addition to all the other little savings that were helping to speed the traveller on his way.[10]

Self-service information booths – which involved twirling a dial so that a machine could inform you of where you needed to go, plus the exact fare and platform number for the next train there – were installed. The act of making an internal staff phone call was also speeded up as automated letter dialling codes, similar to the WHItehall 1212 numbers of the public telephone system, were introduced.

The acoustic environment wasn't overlooked either. Public announcements reminded passengers on escalators to 'Please keep moving. If you must stand, stand on the right. Some are in a hurry, don't impede them.'[11] It had taken thirty years, but Londoners were finally getting a move on. Unfortunately, it had taken so long that Charles Yerkes had been dead for over twenty-five of those years and therefore missed this momentous achievement.

The rolling stock was also improved and given enhanced acceleration, which was achieved by having half the axles motorised, and asymmetrical bogies that put more weight on the driven wheels.[12] Passengers could open the pneumatic doors by simply pushing a button, and single doors were made a thing of the past. Instead, four pairs of double doors, two pairs in each side, were positioned away from the ends of the cars, so that every seat had easy access to a set of doors. The door openings were widened too – to a practically cavernous 4ft 6ins – and unobstructed by a middle pillar. In terms of mechanical improvements, a new 'wedgelock' automatic coupler made it easier and faster to lengthen or shorten trains as required.

Regulating the flow of passengers at interchange stations was made a priority during architectural remodelling, above and underground – Piccadilly Circus being one obvious example, which was depicted in an impressive cross-sectional drawing in 1928 by newspaper illustrator Douglas Macpherson. The illustration shows for the first time the movement of people from the street level entrances on Regent's Street all the way down into the subterranean domain of the underground. Here, they can change direction with ease – swapping from Bakerloo to Piccadilly without ever having seen daylight. Macpherson's illustration shows the complexity of the concealed subterranean space – a network of hidden arteries, pounding with people – simplified for the travelling passenger to two colour-coded lines by Beck and his Diagram. Macpherson became something of an expert on sectional drawings, and Pick would

100 The History of the London Underground Map

commission further poster artwork from him for Charing Cross (1929), Leicester Square and Highgate (1941).

With passenger efficiency well established, Pick could concentrate his efforts on improving the travelling public's appreciation of art – for those that had time to stop and look at the underground's artwork, of course. No doubt he was keen to distance himself from the Epstein debacle of 1929, and there was nothing particularly startling or controversial in many of Pick's choices, although a small proportion of the poster output was aesthetically challenging enough to not pass without comment. Pick himself was somewhat of a conservative but was willing to consider some of the finest Modernist artists of the day, including Paul Nash, Graham Sutherland, Edward McKnight Kauffer, and for a continental flavour, László Moholy-Nagy and Man Ray.

The mundanity of life was transformed under the skilled hands of these brightest of inter-war artists. Information about fares was a chance to introduce geometric designs; the promotion of travel to the winter sales was abstracted and stylised; and Johnston's bar and circle roundel was interpreted as a planet, a wrist-watch and a clock. Time was of the essence on the underground and the concept was represented visually as part of London Transport's ongoing promotion of 'peak' and 'off peak' – as well as a useful reminder to the passengers that underground trains don't wait.

Pick also attempted to counter the sense of impending disaster that lingered following the Wall Street Crash, and the theme of reassurance was the leitmotif running through posters of this period, particularly those by Maurice Beck (no relation to Harry).[13] *Nothing Left To Chance: The Dead Man's Handle* (1930) and *Always in Touch: The Tunnel Telephone* (1930) used a combination of text and photography, with a Surrealist treatment, that was 'powerfully evocative of the intriguing interior world of the Underground... . The technological innovations they promoted appeared not – as they would so often be shown in the 1930s – as a sinister threat, but as a development introduced to safeguard both the paying passenger and the staff of the company.'[14]

Pick's drive towards 'art for all' would see the underground, and London Transport's network as a whole, transformed into an ever-changing art exhibition. However, it was not easy for him to stick to his own design philosophy. His own tendencies towards the conventional, such as the traditions and values embodied in the Arts and Crafts movement, jarred

with the new Modernist perspective. Pick would have to contend with the shifting mood of the country as well as contradictions in the social and cultural landscape. As historian Oliver Green suggests, 'Pick like many others, often found himself drawn in two directions towards philosophical opposites. Social progress and romantic tradition, radicalism and conservatism, socialism and capitalism, efficient large-scale industrial production and individual craft skills, the creative metropolis and the manageable community.'[15]

Whether Pick managed to influence public perception of art, and achieve the social objectives he set out to fulfil is debatable, but many at the time believed he had. His use of artists such as Edward McKnight Kauffer, who saw his work in advertising as no lesser calibre than his work for exhibitions, ensured public acceptance of Modernistic styles. Art critic Anthony Blunt, reviewing an exhibition of McKnight Kauffer's posters in 1935, referred to him as 'an artist who makes me regret the division of the arts into major and minor.'[16]

Conversely, by 1949, Prime Minister Clement Attlee was referring to London Transport posters as 'the poor man's picture gallery', when they were displayed in the Victoria and Albert Museum. Some rather pluralistically minded individual allegedly pointed out to Attlee that London's great art galleries were, in fact, free for all sections of society – rich or poor.[17]

The public's appreciation of the posters was tangible though – translating into an additional revenue stream for London Transport. Surplus posters were available for purchase from London Transport's headquarters, the most popular being those that adhered to a more traditional style. But for some, even these had been bastardised. The application of bright colours to otherwise natural scenes, such as those used on Edward Lancaster's *Greet the Sun* (1939) and McKnight Kauffer's *Look! Under That Broad Beech Tree* (1932) were seen by some as a national affront. Oliver Green points to a Cockney lament found among Pick's surviving private papers, which appeared in *The Manchester Guardian* in the 1920s:

> Oh I want to see the country
> Like when I was a boy–
> When the sky was blue and the clouds was white
> And the green fields was a joy

102 The History of the London Underground Map

> I want to see the country
> But the posters seem to show
> The country ain't no more the place
> Like what I used to know
>
> For the sky is pink and the fields are mauve
> And the cottages all turned yellow
> And the sheep all green or tangerine
> Enough to stun a fellow
>
> Oh, I want to see the country
> And I wouldn't mind where I went ter
> So long as I knoo the trees weren't blue
> And the cows all turned magenter![18]

Evidently, Pick had found it amusing, and kept it as a memento.

Public engagement with the posters remained high, even though some of the Modernist representations only seemed to appeal to a select group of high-minded individuals. It was the cheapest form of modern art available – in the 1920s, copies were charged at between two and five shillings, dependent on printing costs[19] – but rather than devalue the work, it did the opposite. With a healthy annual publicity budget of £90,000, and with £12,500 of this ring-fenced for commissioning posters, London Transport was able to attract the very best artistic talent, including a new crop of young British artists who had not previously worked for the UERL. These included Christopher Greaves, artistic partners Tom Eckersley and Eric Lombers, and Clifford and Rosemary Ellis.

In 1937, more posters were sold by the London Transport shop than in the previous four years put together. Popular choices featured landscapes, gardens and zoo animals, depicted in tempered Modernist style. These were safe subjects in uncertain times. By 1937, the political situation on the continent was deteriorating rapidly, and war loomed large following the Munich Crisis of September 1938. Cutting-edge styles were toned down in favour of escapism, as London Transport encouraged its passengers to *Go Out into the Country* (Graham Sutherland, 1938).

Art and design had well and truly permeated the capital's transport system, and as a result the metropolis too. Pick's tireless pursuit of art,

for the benefit of civilisation, transcended his everyday role at the helm of a large public utility, where his mind was often 'a jumble of headlines and paragraphs about everything in particular but nothing in general.'[20] In his pamphlet *This is the World that Man Made*, he would define art as 'the attempt of man to secure some semblance of beauty and harmony throughout his civilisation, to introduce order and meaning into the world he has built and fashioned for himself.'[21]

In September 1939, this statement would be put to the test with the announcement that Britain was at war with Germany. A year later, beauty and harmony would come under threat once more as civilisation tore itself apart, destroying the world it had made in the process. London Transport would keep the city moving during this challenging time, but Pick would mercifully miss seeing his adopted city – the city he had dedicated his working life to organise – reduced to rubble. He retired from London Transport in 1940, and after a short but unhappy time as director general of the Ministry of Information, he died at his home in Golders Green of a cerebral haemorrhage on 7 November 1941.

His will included a bequest to the Tate Gallery. The painting *Ely* (1926) by Francis Dodd is a suitably pastoral scene, depicting the cathedral under a blue summer sky. A horse and cart amble towards the town, passing a couple on a country stroll. Despite his obligatory acceptance of modern art, this was Pick's idea of beauty – the 'art of living' in visual form. It was a fitting tribute for a man who had spent his life living for art.

Chapter 18

Design For Life or Design For Strife?

Beck's Diagram may have become the standard London underground 'map' but this did not automatically confer a sense of ownership or control over its evolution. Beck was always one step removed from the decision-making process, being neither a member of the publicity office nor the senior management team. LPTB agreed in August 1933 that all London Transport maps in use should be regularly reviewed, and the Diagram became a regular item on the agenda. Beck was not invited to these meetings, even though changes and improvements were frequently discussed – rather, he would be briefed separately, and expected to implement any modifications during his own time.

One of the first modifications requested for the second edition of the Diagram was to substitute the diamond interchange stations for rings. While the rings proved to be a popular and long-lasting addition to the Diagram – as well as being much more in keeping with the London Transport brand and ubiquitous roundel – the diamond story did not end there. Like the Metropolitan's doomed 1914 logo, the diamonds would hang around just long enough to be a nuisance before being consigned to history. The other nuisance addition to the second edition was the inclusion of a north pointer. It served absolutely no purpose, other than to state the obvious, and had no business being there. Nevertheless, some ill-informed personage at the LPTB (not Beck) clearly thought it a good idea, even though Beck's Diagram worked on the assumption that geography was not necessary to make sense of it, and thus to navigate oneself around the city. Fortunately, Beck seemed to have a way of dispensing with these erroneous inclusions by stealth, and evidently on this occasion he was successful, for the pointer was not seen again. The diamonds did, however, get bigger, and were forced to accommodate station names, before they were dispensed with entirely.

Under London Transport's ambitious New Works Programme, which took place between 1935 and 1940, several lines were due for

Design For Life or Design For Strife? 105

modernisation. With a capital injection of £40 million (£2.25 billion today), one of the first plans was a scheme of major work on the Central London line, which was approved in 1936. The extension would see the line stretching westwards out to Denham in Buckinghamshire, and eastwards through to Ongar in Essex – as well as a looped extension via Hainault. The proposed extension was duly added to the Diagram in 1937, regardless of the fact the work was yet to start.

In 1938, London Transport commissioned graphic artist Hans 'Zero' Schleger to undertake the design of the card folder (pocket map) rather than Beck himself. Schleger's work was visually similar, taking the same diagrammatic approach as Beck, but the use of airbrushing to draw attention to the inner area was entirely the brainchild of Schleger. His use of a blueish-green to denote the outer zone was prescient of the 'zoned' underground maps we are familiar with today. Beck was unhappy with the alterations – which had been made without consulting him – as he believed he was the rightful custodian of the Diagram, and all edits and alterations pertaining to it.

This slight was the first of several Beck would endure concerning the Diagram. The issue of who was permitted to work on the Diagram would resurface in 1946 and then blow up again spectacularly for the final time in 1960. Without a written record of the agreement made between Beck and the LPTB in 1933 – something that was conceded later by both parties – it is difficult to assess where to apportion the blame for this misunderstanding. Beck was naturally protective of his design – arguably to the point of obsession – but LPTB seemed to be under the impression that it owned the design and could do with it whatever it wished.

In 1935, LPTB's publicity office was joined by Christian Barman (1898–1980). His architectural background, which saw him working for a short time under Sir Edwin Lutyens, coupled with his experience in household product design for HMV, ensured that he had an inherent understanding of Pick's design principles and 'fitness for purpose' mantra. This did not always mean they had similar tastes: where Pick was conservative, Barman was firmly in the Modernist camp. John Betjeman would bestow the name 'Barmy' on him, in recognition of his artistic preferences during Barman's time as editor of *The Architectural Review*. It was while he was working at *The Architectural Review* that he was head hunted by Pick, and the two men would work together for five years

106 The History of the London Underground Map

to ensure the highest standards of design at London Transport. As an artist and designer – as opposed to Pick, whose background was in law – Barman positioned himself as a sympathetic intermediary between the artists and the board; he had a unique insight into the challenges of being a commissioned artist working for a public body in a time of instability and change. But where Barman was understanding of the artists' lot – hence his soothing approach to Beck – his successors would be less so, which would ultimately be Beck's undoing. Described as 'self-effacing'[1] as well as 'modest and unassuming',[2] Barman was praised for his grasp of the subtleties of effective organisation, as well as his ability to translate admirable intentions into action.[3] He would play a key role in design policy for London Transport until 1941.

As 'a pioneer in the management of design',[4] Barman was also under pressure to get it right. At the same time as his run-in with Beck in the summer of 1938, he was also heavily involved in the adoption of the Carr-Edwards report. The report, which would inform the management of signs, notices and maps, took its name from William Edwards, Lord Ashfield's personal secretary, and the assistant publicity officer, Henry T. Carr. In light of the 1933 merger and New Works Programme, Carr and Edwards were working alongside Barman towards a coordinated approach to signage and other visual representations of the network. The outcome was arguably 'the first attempt to compile a manual of graphic standards – certainly in any transit organization – and was rigidly adhered to for almost every sign erected as part of the NWP [New Works Programme].'[5]

The report was prescriptive and intricate. It included a portfolio of drawings detailing the standard bullseye design, standard signs for platform walls and illuminated signs, among others. The report recommended the installation outside every station of bullseyes, the name of the station, the name of the line and a system map.[6] As any regular users of today's Tube will attest, the resulting signage has been rigorously adhered to. However, there was one anomaly worth mentioning here – the recommendation that

> the map on the outside of the stations should be in geographical form. Passengers requiring to make use of maps outside stations are normally strangers, who may not even know the name of the station they require, but merely have a rough idea of the neighbourhood which they wish to visit.[7]

Design For Life or Design For Strife? 107

There is some sense in this proposal. When underground station names do not reflect their location – such as Elephant & Castle and Mansion House; or are named after the road they are on such as Queensway – an unindoctrinated traveller from outside of London *could* become easily confused. However, this recommendation was only adhered to half-heartedly – the suggestion being that the board was already committed to, and financially invested in, Beck's Diagram – and to return to a geographical representation would be as good as taking a step backwards. The report would set the standard for years to come, although the idea did not catch on quite so quickly abroad. As author Mark Ovenden acknowledges, 'Some public-transit bodies took *decades* to comprehend the need for such simplicity (New York City Subway, for example, took until the late 1960s to tackle its hodgepodge of mismatching signs).'[8]

As the 1930s drew to a close, London Transport would have bigger issues to contend with than whether a sign adhered to regulations. A month after Barman's memo appeasing Harry Beck, Prime Minister Neville Chamberlain was attempting to accomplish the same outcome with Adolf Hitler in Munich. The stakes were understandably that much higher for Chamberlain. It was hoped that 'peace for our time' would stop Europe succumbing to Hitler's expansionist designs before they resulted in bloodshed. These two disparate episodes – one played out on the world stage, the other in London Transport's publicity office – would have one thing in common: both would result in a worthless bit of paper and several broken promises.

Chapter 19

Blitz

Two days before Chamberlain's pointless trip to Munich, six underground stations on either side of the Thames were closed for 'urgent structural works'. It was the evening of 27 September 1938, and with loud rumblings of discontent on the continent, London Transport was taking no chances. With little indication as to the reason for the closure, it announced in the newspapers that 'the Bakerloo and Northern lines at Charing Cross must be closed at eight o'clock tonight until further notice.'[1] Rather ominously, the notice was printed above one from the BBC, 'Warning Against Rumour', which said:

> The B.B.C. last night broadcast a warning to listeners to disregard rumours. 'At times like these,' the announcer said, 'rumours are always circulating. The public are advised to make sure that the source of any report is official. For instance, a rumour that normal railway services are to close down on Friday night was circulating in London this afternoon. This is untrue. The only effect of these rumours is to cause alarm.'[2]

The 'urgent structural works' were in fact a preventative measure in case of imminent German aerial attack. By sealing off the lines beneath the river with concrete plugs, it was hoped that any bomb damage wouldn't necessarily result in the Thames flooding the system. Even as early as 1924, the Committee of Imperial Defence had identified the deep Tube railways as an essential cog in the drive to keep the capital moving in the event of war. And the underground wouldn't just provide a means of transporting the living, it would also need to evacuate the dead. It was for this reason that LPTB needed to keep the trains moving, rather than fill them with people trying to escape bombs. The expectation created in the First World War – that the Tube would provide a safe shelter for Londoners; something the underground did nothing to dispel

with its friendly 'bomb proof down below' posters – meant that resident Londoners anticipated a similar scenario in the Second World War. But in the intervening twenty years, attitudes had shifted. The underground was to provide a vital service in the great war machine – the service of dispersing people, alive or dead, to their intended destinations. There was also a belief among certain factions that the civilian population would shelter underground, and then – out of sheer terror – refuse to leave. 'Deep shelter mentality' had the potential to severely hamper the efficiency of the network and compromise the wartime workforce.

Chamberlain's infamous piece of paper declaring Hitler's promise to use peaceful methods to expand the German empire, provided the reassurance London Transport needed to restore normal cross-river services again, and the concrete plugs were removed. Metal floodgates, which operated electrically and took just thirty seconds to close during an air raid, were installed instead. Twenty-five floodgates, at a cost of £750,000, were installed between September 1939 and October 1940 – just in time for the Blitz – and were activated via a control centre at Leicester Square.

Almost a year after the 'urgent structural works' on the Bakerloo line, at 7.30 am on 1 September 1939, a succession of GWR trains began to pull into Ealing Broadway Station. Their destinations were locations around the rural south west, and their passengers were to be 50,000 children from schools around West London, who had arrived at the station via the Central line.

'All the children appeared to be thoroughly enjoying themselves,' reported the *Middlesex County Times* gaily:

> their cheers as each train left the station, rivalled those at a cup-final... . One little boy apparently thought that he was going on his holidays, for besides his two packages, he carried a bucket and spade... . The organisation at Ealing was remarkably efficient ... and the behaviour of the children was admirable.[3]

A similar scene was being witnessed at underground stations across the capital, as Operation Pied Piper got underway. Germany had invaded Poland, and an aerial attack on London was now much less a rumour and more a grim reality, prompting the biggest mass movement of people in

110 The History of the London Underground Map

British history. Four million civilian casualties were predicted in London alone, and as early as 1922 – with the Zeppelin bombings of the First World War not yet a distant memory – Lord Balfour spoke of 'unremitting bombardment of a kind that no other city has ever had to endure'.

In the first four days of September 1939, three million people were transported from towns and cities across the country to places of safety in the countryside. Of these, 600,000 were Londoners moved across the network by London Transport. On the same morning, Frank Pick silently observed proceedings at Enfield West on the Piccadilly line, so he could be satisfied that the detailed evacuation plans he'd spent months preparing on behalf of the government was effective. He wouldn't be disappointed. The unprecedented event, which had the potential to be a logistical nightmare, was triggered by the terse order to 'Evacuate forthwith' issued at 11.07am on Thursday, 31 August. As the *Daily Mirror* reported:

> The evacuation went off with remarkable smoothness. With eleven minutes after the arrival by District Railway at Wimbledon, 500 children from Merton Road School (Southfields) and Wandsworth School were in a main line train station on their way to an undisclosed destination... . The dexterity with which children were shepherded through crowds of morning workers at Waterloo Station was a perfect piece of organisation... . Little tots smiled gleefully and boys whistled and exchanged jokes. One boy, carrying a kitbag over his shoulder in true military style, kept humming to himself as he marched along.[4]

The cheery accounts of children 'going on an adventure' and swinging their luggage and gas masks to and fro as they all sang *Wish Me Luck As You Wave Me Goodbye* masked the reality of the situation. Most evacuees were unaware of where they were going, who they would be living with and when they would see their parents again. The sense of upheaval was compounded for many children when they reached their destination. Organisation at the other end of the process had been poor and many reception areas for evacuees didn't have sufficient provision to house them. Hundreds of children arrived in the wrong areas with insufficient rations, and billeting the children rapidly became a joyless task.

As far as London Transport was concerned, the part it played in Operation Pied Piper was wholly successful, which was good news, because it would end up repeating the whole exercise nine months later. When the bombs failed to appear, the 'Phoney War' lulled everyone into a false sense of security. Evacuees started to drift back into the cities, so when France fell and the bombing began in earnest the following summer, the evacuation process was revived again, and quickly.

A new government body was formed to assume control of the railway network for the duration of the war. The Railway Executive Committee (REC) took the strategic lead, coordinating the national response, but the day-to-day running of the network was retained by LPTB. From a publicity perspective the war had an immediate impact. Unnecessary travel was discouraged, and London Transport was quick to dispense with the dreamy rural images and suggestions of 'invading the country', in favour of providing useful, and often statutory, information. London Transport was expected to fall in line with the demands of the REC, as well as work closely with the Ministry of Information (MOI) and make free-of-charge provision for its posters. The MOI was already negotiating a minefield of its own. Home Intelligence reports recorded allegations that the British state was becoming frighteningly similar to the one it was fighting, in terms of its propaganda output. William Crawford, head of advertising agency W.S. Crawford Ltd, argued that people wanted a ministry that would disseminate facts, free of political spin and embellishment. Its reputation was damaged further by crude attempts to censor the press, which unsurprisingly resulted in media hostility.

With pictorial leisure posters out and public information posters in, the focus shifted to instruction and direction. One of the first examples related to the controversial bomb shelter policy – a policy supported by LPTB who knew that the cost of establishing an appropriate environment for shelterers was prohibitively high, and the risk of flooding and overcrowding too great. As soon as war was declared, London Transport issued no-nonsense posters stating that 'Underground stations must not be used as air raid shelters. The public are informed that in order to operate the Railways for essential movement, Underground stations cannot be used for air raid shelters.'[5]

That plan was doomed from the start. The alternative to the safe cocoon of the underground was manifestly inadequate – brick shelters

112 The History of the London Underground Map

built in the very streets that were being bombed, which unsurprisingly proved to be highly unpopular. There was even an organised resistance to the ban, led by the Communist Party, who ran a sustained media campaign throughout 1940 promoting the need for a proper strategy for air raid protection, including the provision of deep-level shelters. The Communist Party framed their argument as part of a wider class war in which the humble worker was once again at the mercy of the ruling classes in their 'luxury shelters'.

Frontline underground staff had been instructed to turn away non-essential passengers once the bombs began to fall – a stance that would be difficult for even the most hard-hearted of London Transport workers to maintain in the face of human suffering. Their first great test came on the evening of 7 September 1940. They would not have known it then, but that night was the start of the most devastating series of continuous night-time aerial bombing raids in history. The Blitz saw the relentless targeted bombing of civilians by Nazi Germany and by the time it was over, in May 1941, the Luftwaffe had destroyed one million homes and killed over 20,000 men, women and children. The raids on 7 September had begun with 350 German bombers advancing up the Thames estuary and targeting London's docklands area. As the daytime raid ended and night drew in, the bombers used the fires caused by the earlier attack to locate their targets, which inevitably included the built-up East End. Crowds rushed to use the underground for shelter, looking to escape the 'onslaught of Hitler's bombers'.[6] A staff reporter from the *Press Association* described the scene:

> It was to a sun-bathed city, bent on Saturday afternoon amusement, that the bombers came in early evening – riding in waves, high above the barrage balloons, in an azure blue sky, which in a few minutes was filled with bursting shells, hurtling aeroplanes and falling bombs... . As darkness fell the raiders came again – to a blacked-out London, soon lit up by the glow of fires. They came in from different directions, one at a time, and dropped their bombs as close as possible to where the fires were burning.[7]

London Transport staff were put in an impossible position – made worse by those who realised that if they bought a cheap penny ticket they could

Blitz 113

get access to the station platform, where they would then refuse to move. Short of posting armed soldiers at the entrances to every Tube station in the capital, who would then have the unenviable task of turning away women and children seeking refuge, London Transport had no alternative but to allow unofficial sheltering on its premises. In that first raid 'at least 400 people were killed and between 1,300 and 1,400 seriously injured'.[8] At Liverpool Street Station a huge crowd gathered and forced its way to the platforms as officials looked on, helpless. One particularly depressing incident occurred when a bomb struck a crowded shelter, falling directly on a ventilation shaft made of corrugated iron sheets – the only vulnerable place on the underground structure. The press reported that

> Children sleeping in perambulators and mothers with babies in their arms were killed when a bomb exploded on a crowded shelter in an East London district in Saturday night's raids. A special correspondent who visited the shelter writes: what is described as a 'million to one chance', the bomb fell directly on to a ventilator shaft measuring only about three feet by one foot. It was the only vulnerable place in a powerfully-protected underground shelter accommodating over [one] thousand people.[9]

Such distressing reports weakened the government's position further. By November 1940, posters stating that 'This station will now remain open during air raid alerts'[10] appeared at station entrances. Soon, up to 177,000 Londoners were occupying seventy-nine of the deep-level stations every night. In addition, the disused section of the City & South London Railway to its original terminus at King William Street was made available, as well as several disused stations and partly built tunnels, including the new, unopened stations between Liverpool Street and Bethnal Green. Six months later, government research into the shelters inevitably concluded that they were essential for maintaining public spirit. The MOI reported:

> In the past months it has become increasingly noticeable that the morale of the civilian population depends more upon material factors, acutely involving their lives, than upon the ebb and flow of the events of war beyond these islands. It now seems certain that the way civilians stand up to continuous night raiding depends largely

114 The History of the London Underground Map

on their having the feeling that there is a safe refuge somewhere for themselves and their families. They are willing to put up with the discomforts and dangers of the present, if they can look ahead to a few good nights' rest in the future-just as, in the last war, the troops in the trenches could always look forward to security in 'Blighty'.[11]

With trains still officially running until 10.30pm, London Transport needed to juggle the needs of its paying passengers with a civic responsibility towards its shelterers, who ranged from upper-middle class girls from Kensington to cockney barrow boys. Home Intelligence reports suggested that despite the class divide, the shelters were united in their uncomplaining cheerfulness – which seems remarkably optimistic given the conditions. Drinking water was limited and a bucket in the corner often sufficed for a toilet. People slept wherever they could lay their head, be that in a passageway or on an escalator, and with the fear of a gas attack ever present, the ventilation fans were switched to minimum – meaning it wasn't just hot, but also fetid. A reporter from the *South London Press* gave a dismal – but probably more accurate – account:

> I stumbled over huddled bodies, bodies which were no safer from bombs than if they had lain in the gutters of the streets outside... . Little girls and boys lay across their parents' bodies because there was no room on the winding stairs. Hundreds of men and women were partially undressed, while small boys and girls slumbered in the foetid atmosphere absolutely naked... . On the platform, when a train came in, it had to be stopped in the tunnel while police and porters went along pushing in the feet and the arms which overhung the line.[12]

Eventually, after overcoming initial problems which included a plague of mosquitoes, outbreaks of bedbugs and a rat infestation, London Transport accepted its duty towards the city's inhabitants. Better sanitation arrangements were introduced and by the end of October 1940 there was even a refreshment train, staffed by London Transport's women workers who ensured shelterers had access to an all-important cup of tea and a bun. Beds were eventually installed, with accommodation for 22,800 people, as well as medical teams with their own treatment areas.

Some stations even had libraries and amplifiers to play music. Raffles were held, cards and dominoes were played, and newsletters created – the latter often providing an amusing insight into life underground.

These improvements went some way towards boosting morale and enabling Londoners to remain stoic in the face of adversity. The experience rapidly became the norm for many, acting as a unifier and linking the city together in a way that offered continuity and much-needed stability. During wartime at least, London Transport was no longer a symbol of capitalist ideals. Instead, it was able to reposition itself along socialist lines – as a force for urban camaraderie and a shared sense of community.

'An increasing number of people are making use of the Underground Railway stations as dormitories, and many of them, I am told, enjoy the experience,' wrote a reporter for *The Belfast News-Letter* in 1940. 'The women bring their sewing or knitting with them, and until they get drowsy, there is a constant flow of conversation.'[13] Class divides also broke down as 'Families from the East End with scraps of bedding jostled West End folk with luncheon baskets and expensive travelling rugs.'[14] The bombing was indiscriminate and upper, middle, and working classes were all at risk. This levelling of the classes made for some 'Strange Bedfellows', as one headline reported. It was not unusual to see

bearded Bohemians, dignified dowagers and typical Cockneys... . A station official said that this cosmopolitan crowd in which there were many 'regulars' got on well together. There were rarely any disputes and when anyone tried to claim more room than that to which they were entitled others soon put the 'offender' in order.[15]

The MOI identified the importance of this sentiment, recognising that the 'Belief in equality of sacrifice' was a critical part of withstanding adversity; 'As long as people believe that all classes and sections are suffering and enduring equally, they will put up with very great hardship.'[16]

Media reporting also provided a useful platform for propaganda. Artists, journalists, and filmmakers all played their part in ensuring the 'People's War' captured the public's imagination, both at home and abroad. Newsreel footage of defiant Londoners receiving their tea and buns from London Transport's refreshment train played in British cinemas, as well

116 The History of the London Underground Map

as in the USA, which at this time was still maintaining neutrality. The communal nature of the Tube was also captured by artist Henry Moore, whose work was fully endorsed by the War Artists Advisory Committee. Moore was appointed an official Home Front war artist, alongside others including Evelyn Dunbar, John Piper, Graham Sutherland, Paul Nash, and Stanley Spencer. His work sought to depict the fear and anxiety of the underground shelterers as well as their stoicism. There is a quiet fatalism to Moore's sketches which is at odds with its morale-boosting purpose. He would later comment in an interview that

> like everybody else at that time in London, the drama and the intense excitement ... and the fear, everything else about it, at the London shelter, I felt just as much as other people, and so one couldn't leave that out.[17]

For Moore this translated to simplified human forms, united in a sense of vulnerability.

Photographer Bill Brandt's representations of shelter life would become some of the most iconic images of London during the Second World War. His pictures were reproduced and exhibited widely, and a set of prints even made their way across the Atlantic to President Roosevelt to persuade him to continue his support of the Allies. Brandt's enduring images of sleeping bodies heaped on top of one another, heads lolling, limbs at angles, played on a wider wartime narrative – that of mortality. To Brandt, the Tube shelters were 'places that gave the appearance of death, even as they preserved life'. Just as corpses from an air raid were laid out above ground, the underground space served the same function for the living. The subterranean space had, once again, become the stuff of nightmares.

Death did eventually come to the underground, proving that nowhere in London was truly safe from the Luftwaffe. Between September 1940 and May 1941, 198 people were killed when Tube shelters received direct hits from bombing raids. One of the worst incidents took place at Balham on 14 October when a bomb penetrated the road surface above the station, fracturing a water main and causing devastation on the platforms below. Sixty-four shelterers died, along with four members of London Transport staff. Bounds Green Station also saw tragedy when nineteen

shelterers – sixteen of them Belgian refugees who had escaped during the Dunkirk evacuation – were killed following a raid. On the evening of 11 January, a huge bomb blew open the sub-surface booking hall of Bank Station killing fifty-six people on the platforms below. Censorship of the press ensured that the location of the 120 foot crater and exact details of the incident were sketchy but the *Daily Mirror* was able to describe the 'terrible scenes', reporting that

> It was impossible yesterday to estimate the number of people who might still be trapped, but the bodies of a woman and two men were recovered.... . Men, women and children staggered through the debris and were dragged out of the crater by helpers. One child who had lost her mother was crying and repeatedly asking for 'mummy'.[18]

One of the most tragic events in the underground's history occurred on 3 March 1943, when 173 people were crushed to death. This time the loss of life had nothing to do with the Germans or enemy bombs. A mother carrying a baby tripped in the dark rushing down a stairwell at Bethnal Green Tube shelter, causing other panicked shelterers to fall on top of her. The incident was particularly distressing because sixty-two of the dead were children. With only a 25 watt bulb to guide the way, and steps that had been made treacherous due to heavy rain, an estimated 1,500 people made the descent into the station between 8.17pm – when the warning sirens began – and 8.27pm, when the disaster occurred. A new type of anti-aircraft rocket let out a salvo in a nearby park. The sound, being unfamiliar, immediately spread panic, causing the crowds to surge forwards, creating a domino effect. The incident lasted just fifteen seconds yet caused untold suffering for those involved. A local policeman arrived on the scene and managed to crawl over the mass of bodies to the bottom of the nineteen steps and found an estimated 200 people in a space the size of a small room. Having sent a message for help, he began to assist with the recovery. Fearful of the damage to public morale, the incident was hushed up by the government and those involved were told not to speak about it. A plaque and memorial sculpture now mark the scene of the accident.

The shelterers also shared space with some rather important occupants, although they wouldn't have realised it at the time. Some of the disused

118 The History of the London Underground Map

stations and platforms were converted into emergency office suites and accommodation for government and military use. Down Street Station distinguished itself in the line of duty by hosting the War Cabinet in 1940–41, including Prime Minister Winston Churchill, who had his own private facilities there. The REC also used the station as a headquarters from which to manage the wartime railway network. Similar facilities were established at six other stations, including Brompton Road, which became the headquarters of the anti-aircraft batteries and a 2 mile section of an unfinished Central line tunnel, which was converted into an underground factory producing aircraft materials.

One of the more unusual inhabitants of the underground during the Second World War was the Elgin Marbles, which were housed at Aldwych Station. This fact was kept from the public – for obvious reasons – until 1946. As one newspaper proclaimed following the war, 'Thousands of Londoners who used the Aldwych Tube as a raid shelter during the "blitz" did not know that in the same tunnel lay the secret hiding place of London's art treasures, valued at £4,000,000.'[19] The famous Greek sculptures were joined underground by various art treasures from the Tate Gallery – many of which were housed at Piccadilly Circus – as well as works by Rubens; *objets d'art* from other London museums and government offices; treasures from St James's Palace and early Saxon work from Westminster Abbey. After a period of repair and restoration, the 100 ton Marbles finally emerged from their wartime hideout in 1948, having spent ten years away from their usual residence, the British Museum.

Along with much of the population, Frank Pick did not have a good war. He had to endure watching his functional, efficient and 'fit for purpose' underground railway become a chaotic, disorganised dormitory for displaced Londoners. His *magnum opus*, in civilian terms, was the complex evacuation scheme which he successfully oversaw in 1939, but at sixty years old and in poor health he was rapidly becoming disillusioned. He was no longer the progressive artistic champion of before, and the more avant-garde work commissioned by London Transport during the latter half of the 1930s almost certainly came from Christian Barman's influence. Once the country was in the throes of war, the design and urban development ideals that Pick had spent his working life advocating fell by the wayside. They were no longer important, and neither was the

unfinished New Works Programme which was suspended in 1940. Some of it was never resumed.

To compound matters, a rift had developed between Pick and Lord Ashfield. The reason for this is unclear, except that it culminated in a dispute over the government terms for the financial management of London Transport during the war. As a result, Pick offered his resignation, which Ashfield accepted in April 1940. The official line was that Pick was resigning due to ill health but a few days later he cast doubt on the truth of this announcement. Pick was engaged to read a paper to the Institute of Transport, and when he addressed the members, he insinuated that reports that the government had lined him up for a different public role due to his bad health were exaggerated. Pick was clearly troubled.

London Transport's publicity officer Barman, who was in the audience at the time, later recalled that around the time of Pick's resignation, following a meeting of the REC at Down Street Tube station, he bumped into him in the street:

> We stopped for a moment. Suddenly he started talking about the struggle he had had overcoming a terrible impulse to step out on to the old tube platform and throw himself under a train. It never occurred to me that he might be speaking seriously; it was probably just a joking reference to the tedium of those hours spent down in the shelter listening to the railway chiefs. It was not till a few weeks later that I learnt the truth.[20]

Pick was not asked to reconsider his resignation, and his relationship with London Transport ended just before the Battle of Britain began in May 1940. It was a miserable end to an illustrious career, and a partnership that had seen both tears and triumphs over its thirty years.

Things did not get better for Pick. At the beginning of the Blitz, he had a lucky escape when the house next door to his home in Hampstead Garden Suburb was severely damaged by a stray bomb. While the damage was fixed, he moved to a flat in the city, but was almost caught up in a second bomb-related incident in Victoria. His frustration at his lack of occupation was evident in his personal letters. 'I am now a super-annuated man,' he wrote to his sister Ethel on 19 May 1940. 'It could not

120 The History of the London Underground Map

have come at a worse time, with this war in a critical state … I shall go mad if I am to be idle. It is strange that no one has offered me a job.'[21]

He would come to regret these words. Shortly after Ethel received the letter, Pick briefly found employment as the director general of the MOI, a role in which he famously crossed swords with Winston Churchill prompting Churchill to announce that he never wanted to see 'that impeccable busman'[22] again. Pick was unhappy and was likely relieved to be sacked from the post just before Christmas 1940. It is ironic that a man who was such a gifted corporate communicator would struggle to adjust to a role that on the surface seemed entirely suited to his skillset. After all, the ability to convey an idea or message effectively to the public was one of the principal legacies of his time at London Transport. But spreading misinformation and propaganda was part of the ministry's wartime role – a concept that was wholly distasteful to the moralistic Pick. In response, Pick announced that he had never knowingly told a lie and would not be doing so as part of his wartime work. Having been given a thorough dressing down by Churchill, the sacking was quick to follow.

Pick's last professional project was for the Ministry of Transport, where he reported on the canals and inland waterways. He also found the time to write essays in which he shared his concerns about the impact of the war and how society might progress at its conclusion. The essays formed *Paths To Peace,* which was published as a book in October 1941. Pluralist to the last, Pick argued for 'finding in every human activity scope for education and means of culture. It is recognising the craftsman of the hand and eye equally with the craftsman of the tongue or pen.'[23] He urged those in power to seek 'talent and ability wherever they may be … so that the highest posts in politics, in commerce, in administration, in industry, are open to all as well as the highest positions in literature, science and art.'

Pick was no doubt pondering such matters as he finished his afternoon tea in his house in Hampstead Garden Suburb on 7 November 1941. He had just returned from posting a letter to his old friend, B. J. Fletcher, in which he confided that, 'I am in a bad way spiritually, as well as physically…. However, I am picking up and expect a job next week which may wake me up and give me fresh interest in life.'[24] Sadly, the benevolent Frank Pick wouldn't live to see the following week, or indeed the end of

that day. That afternoon he collapsed with a cerebral haemorrhage and died just before midnight.

Of all Pick's memorials – and there are several, including two plaques (one blue, which resides on his former house) and a permanent art installation, *Beauty < Immortality*, at Piccadilly Circus – the most enduring is London Underground itself. 'The moment you enter the London Underground,' wrote Danish architect Steen Eiler Rasmussen in 1934, 'you feel, though you may not be able to explain exactly how you feel it, that you are moving in an environment of order, of culture.'[25] And so it is today. The essence of Pick lives on – in Beck's Diagram, in the roundel, in Johnston signage and in a lasting sense of urbanity. All make for a fitting tribute to the man who turned transport into an art.

Chapter 20

Life After Pick

As the landscape of London changed forever, Beck's Diagram stayed reassuringly familiar. Although many maps were banned from being printed in wartime due to the risk of them falling into enemy hands, the Diagram continued to be distributed as it was deemed too abstract to pose a threat. From 1940, the network lines on the majority of underground maps still in circulation were printed in brown due to ink shortages, which must have made planning a journey across London an interesting experience.

During the war years, Beck was seconded to the War Office on secret work, the details of which have never been divulged.[1] One likes to think of him beavering away in a bunker somewhere, shoulders hunched over his draughtsman's board as he plots diagrammatic military tactics. Whatever he was working on, we do know for certain that he had returned to one of his favourite pastimes – tinkering with the interchange symbols on the Diagram. His experiments would yield puzzling results. The 1940 version incorporated oversized interlinked rings to denote interchanges, meaning that at some stations there were three overlapping rings – a device that meant well but did nothing to aid clarity. In case of passenger confusion, these stations also had their names repeated in triplicate; which was somewhat excessive. Beck also experimented with angles again on this version, changing the angle of the diagonal route lines from 45 degrees to 60 degrees. The use of a steeper angle meant that the network's expansion east and west could be more easily accommodated on the Diagram, but this approach was short lived. With the abandonment of the New Works Programme, the extension plans were shelved along with the 60 degree representation. Luckily, they also took the interlinked rings with them.

The 1941 map was a different beast altogether. Enhanced diagonals were out, and instead were reduced to an absolute minimum, which aided clarity and made for a cleaner look. However, it meant the map was now even further away from the street-level reality it represented. Surprisingly,

Life After Pick 123

this didn't seem to bother London Transport and it remained the standard form until Beck's final version of 1959. Beck's wartime experimentations with clarity may have been prompted by navigational problems that were highlighted by additional passenger traffic on the network during the war. Servicemen, particularly, would need to travel across London – many of whom were unfamiliar with the both the city and its underground network – and so the diagrammatic system maps at London Transport and mainline stations were given prominence. A new, smaller poster map was also issued, highlighting the all-important central area and mainline stations. A colour-coded index was provided underneath to assist passengers with their journey planning. A companion poster, issued around the same time, was designed to help out-of-towners navigate their way around the metropolis. *Be Map Conscious* explained in layman's terms the significance of the five different colours used on Beck's Diagram, as well as how interchange stations were denoted.

The Diagram was, for the most part, reassuringly unchanged during this period, which is just as well given the tumultuous events that were being witnessed above ground. London continued to use its beloved Tube network for safety as well as travel; although the movement of people around the capital was of relative insignificance compared to the mass movement of displaced persons around the world at the time. There was a sense of comfort in the Tube, despite the basic facilities. It was, for the most part, an unchanging landscape; a space that made sense at a time when little else did.

'It is only natural that the nightly visits of Nazi raiders should lead people to a search for the deepest shelter, so a troglodytic influx to London's Tube station platforms has resulted,' the *Illustrated London News* reported on 5 October 1940. 'Even the unused escalators are providing comfortless perches for shelterers.'[2] For some, even the safety of the Tube wasn't enough. On 1 November 1940, the *Daily Herald* ran the headline: 'Mother Had To Sleep in Tube: I Killed Her'. The paper reported that an ARP worker had walked into a London police station and confessed to strangling his 75-year-old mother. "I did it to save her being dragged round the shelters," he said. "She was suffering."[3]

The Tube removed the sights and most of the sounds of war, until it was time to ascend the steps. As shelterers trickled back out onto the devastated streets, it was to a transformed landscape, of strange

124 The History of the London Underground Map

silhouettes, twisted metal and ruins. For some, it was nothing less than hell, akin to Dante's journey through the Inferno. But the underground was still there – exactly as it always was – shutting off passengers and shelterers from the city above and the reality of the Blitz.

Such messages were reinforced by London Transport's wartime poster campaign. Fred Taylor's *Back Room Boys – They Also Serve* (1942) was a series of eight morale-boosting posters highlighting the role of staff behind the scenes who kept the network running. There is some irony in that many of the posters feature women workers, despite the gendered title. Just as in the First World War, women were recruited to fill the employment gap left by men called up for military service. The majority worked as bus conductors, but approximately 5,000 worked on the railways and in the engineering departments. London Transport was pioneering in its approach, providing nurseries for women with children, although their wages remained lower than their male counterparts, and they were barred from some roles, such as driving. A set of glamorous prints was produced to entice women workers into the underground, and onto the trams and buses. *Enjoy Your War Work* (1941) and *A Woman's Job In War* (1941) used posed images of smiling women as they went about their work. For their effort, they were rewarded with 'Good Pay, free uniform and an interesting job', although on a separate poster produced for staff, they were also warned: 'when on duty – for safety first, don't wear high heels, they're quite the worst.'4 In case anyone was in any doubt as to what constituted suitable footwear, an image of 'the RIGHT HEEL for the job' was also provided.

Women also appeared on Eric Kennington's *Seeing It Through* series, which commemorated the heroism of London Transport staff. Each poster included a portrait painting of a member of staff who had shown courage in the face of adversity, as well as a verse text by A. P. Herbert. Sitters included Frank Clark, who led his passengers to safety despite his train being hit in the Sloane Square bombing, and Mrs M. J. Morgan, a bus conductor, or 'trusty Captain' according to the poster, who saved four children in an air raid by pushing them under the seats of the bus.

By 1944, the underground was ready to help London confront its Blitz experience. A series of six posters, titled *The Proud City*, was commissioned from Walter Spradbery to celebrate the city's survival, and provide a visual reminder that the spirit of London was very much intact. Using various

Life After Pick 125

landmarks which had survived the raids, such as St Paul's Cathedral, the Tower of London and Lots Road Power Station, and accompanied by a verse or quote, there is quiet resilience to the prints. Spradbery was a pacifist, and as a result the images invoke a sense of futility, a hopeless acceptance of what Wilfred Owen called 'the pity of war'.

The end was, however, in sight, bringing new hope and a sense of relief. London Transport would now need to balance inspirational, forward-looking posters that celebrated the dawning of peace with ones that confronted the realities of everyday life. With the city's infrastructure hanging by a thread, the tone shifted towards recovery and reassurance. Fred Taylor's series of *Rehabilitation* posters made a clear case for exercising patience, reminding passengers that '23 railway stations, 15 bus garages and 12 trolleybus and tram depots had direct hits or suffered severe damage from enemy action. Replacements and repairs are in hand – but it takes time.'[5]

London Transport's post-war publicity office was considerably slimmer than it had been in 1939. There was no dedicated head of publicity, and publicity officer Christian Barman had moved on in 1941 – first to a role as assistant director of the Directorate of Post-War Building, and then to GWR in 1945 as publicity adviser. The pool of artists on which the publicity campaigns depended had also been decimated. Several were no longer in Britain, including stalwarts Edward McKnight Kauffer and László Moholy-Nagy, and some of the younger artists had not survived the war: Rex Whistler had been killed by a mortar bomb, and Eric Ravilious was lost in action when his plane went missing.

The printing industry had also been devastated by the war, and those who had stayed in work were approaching retirement. Wartime privations had also affected training schemes and apprenticeships, and now there was an even smaller pool of young men from which to find new recruits to work in the sector. Oil-based ink was difficult to come by and paper rationing would continue for some time. By 1949, even the *Daily Mirror* was still only eight to twelve pages long, and it would take until 1953 for newspapers to return to their minimum pre-war pagination, which was usually sixteen pages. Posters, therefore, were a luxury – even those produced by the doyenne of graphic art, London Transport.

However, London Transport needed to start promoting its extensions again – which it did via Beck's 1946 Diagram. Beck retained the

126 The History of the London Underground Map

rectilinear approach that he introduced in 1941 but was finally allowed to dispense with the irksome duplication of station names. For added clarity, station names were also printed in black rather than their line colour – a cartographic practice that was fifteen years old and had overstayed its welcome.

When Beck stated that 'connections are the thing', he meant it. After many years of experimentation, the 1946 map saw Beck finally settling on a device to denote interchange stations, and the 'white line connectors' that had been missing since 1912 made a welcome reappearance. There is no evidence to suggest that Beck took his inspiration directly from the earlier map, but he certainly would have been aware of previous versions, and it made for a neat symbolic connection between the geographical maps of the past and the continuation of Beck's Diagram into the future. It was a wise move – the white line connectors remain to this day.

In the same year, Beck's Diagram was given a slight facelift with the addition of a decorative border and fancy heading à la MacDonald Gill. The border had been mooted prior to the outbreak of the Second World War in 1939 but original discussions between London Transport and printers, The Baynard Press, had stalled due to production costs. The duration of the war was not the ideal time to experiment with embellishments and so the border was shelved until 1946, when the country was in a better frame of mind to be jolly.

The designer was Charles Shepherd, who was commissioned by Henry Carr, Christian Barman's former publicity assistant, and London Transport's acting publicity officer since 1941. Beck would now have to share his credit with a someone else, although 'Shep' was relegated to small print in the corner of the border. There is no official record of Beck's reaction to this intrusion, but in his mind, his agreement with London Transport that he would be the primary custodian of the Diagram still stood. However, a worrying pattern of evasive manoeuvres was beginning to emerge on London Transport's side.

A new publicity officer was appointed in 1947. Harold Hutchison (1900–1975) came with a commercial pedigree that was well suited to life at London Transport. An official photographic portrait in the London Transport Museum Archives by Walter Bird (1960) shows a moustachioed Hutchison striking a dynamic pose, his trademark cigar poised for the next drag. Born at the dawn of the twentieth century, Hutchison grew

up in Sefton Park, Liverpool and was educated at Liverpool Institute, a prestigious grammar school that would one day educate future Beatles, Paul McCartney and George Harrison. His professional background was in advertising, and he joined Lever Brothers as an executive in 1922. In 1928 he moved to a London advertising agency, C. Vernon & Sons Ltd, where he took on the role of copy and production editor, before returning to Lever Brothers – now Unilever – in 1934 as the copy production executive. His appointment to LPTB was announced in February 1947 in the *Liverpool Echo* – presumably because he was an 'old boy of Liverpool Institute'[6] and 'local boy done good', but also because his elderly father spent many years on the staff at the *Echo*. According to the newspaper, during Hutchison's 'twenty years career in advertising he has been behind many well-known advertising campaigns.'[7] So far, so good.

Hutchison would have his work cut out on several levels. Post-war austerity was not conducive to big-budget advertising campaigns, yet Hutchison's remit was to restore public confidence in a bruised and battered transport network that had no money and shortages in all the things it needed to drag itself out of the doldrums – materials, manpower, equipment and fuel. Passenger tolerance for post-war poor service was beginning to wane by 1946, and this was exacerbated by exponential growth in passenger numbers across both the rail and road services. Additional exits – on stations that had them – were opened at peak hours to alleviate overcrowding in the ticket hall, but the problem persisted, leading to a rise in passenger complaints. A 'politeness campaign' was rolled out to encourage people to observe appropriate underground behaviour and to try and prevent them from losing their tempers.

'Tomorrow all the cars in the London tubes will carry two pictures urging passengers to improve their manners,' wrote *The Scotsman*. 'The chief acts of discourtesy which they will illustrate are the habits of sticking one's feet out in the aisle and of planting oneself and one's luggage by the doorway.'[8] However, the reporter was not optimistic of success:

> It is doubtful whether even the archest of pictures will lead to a reform of behaviour among those who journey underground. Even the most gentle of creatures when he reaches the foot of an escalator is transformed into a rampaging beast... . Even a saint would turn surly in rush hour on the underground.[9]

128 The History of the London Underground Map

The London reporter for *The Bradford Observer* was most put out by the new directive. 'The badgering becomes unbearable ... to begin yelling, "Hurry along please" before the train has come to a standstill ... is a breach of the new code, if it ever existed.'[10] He concludes with a warning that 'the Londoner's patience is not inexhaustible'.[11]

Londoners continued to have their patience tried until 3 December 1946, when the Liverpool Street to Stratford extension of the Central line was opened by Minister of Transport Alfred Barnes (1887–1974). Given the scarcity of steel at the time, it is remarkable that any tracks were laid at all, but London Transport benefitted from the fact that the tunnels on the proposed 32 mile route had been completed before the war, and the overground sections east of Stratford shared existing infrastructure with the mainline, thus saving capital on labour and materials.

The £3.5 million extension would provide 450 trains a day to the notoriously underserved north-eastern suburbs, the 'poor relations'[12] according to *The Yorkshire Post and The Leeds Mercury*, and 'the first big move to allay London's traffic congestion since the war ended.'[13] The line would reach Woodford and Newbury Park by December 1947. Westwards, the Central line reached Greenford in June 1947 and pushed onwards to West Ruislip a year later.

To promote the new extensions, elements of Beck's Diagram were stylised in the artwork of several posters produced at the time. *Extension Central Line* (1946) by Hans Schleger (who was also known as Zero) included the familiar red line and circles denoting the locations of the new stations on the eastern stretch and Mary Le Bon's *Area, Journeys* (1946) used a basic depiction of Beck's Diagram to demonstrate the reach of the network. Cartographic representations of this kind were used by many of the artists commissioned to produce artwork for the Central line extensions. The posters were produced at different times due to the route opening in sections, suggesting that the inclusion of mapping elements was part of the publicity office brief, rather than the concept of the individual artist.

Beck's Diagram would also prove its usefulness in other ways and via other mediums. One of the concerns raised in the Carr-Edwards report related to signage, particularly for those who were new to the system and not familiar with the different lines and connections. The solution was a new type of machine – the 'Sperry' (named after the manufacturer)

route indicator. It combined an illuminated version of Beck's Diagram with a panel which included a button for each station of the underground network. To see the best route to their destination, a passenger would simply touch the button for the station they needed to get to, and the electronic diagram would show them the way. The new machine was trialled at Leicester Square Station in 1947 and was used 23,000 times in a week, although a longer study showed that the average weekly use was closer to 8,000 once the novelty had worn off.[14] By the 1980s, the information on the indicators was too dated to be useful to journey planning and the few machines still in the network were phased out.

Also in 1947, Beck resigned from his staff role at London Transport (but more importantly, *not* the Diagram) having been tempted by a lecturing post at the London School of Printing and Kindred Trades (later the London School of Printing and Graphic Arts). At the same time, a new thinking in graphic design was emerging. American Paul Rand (1914–1996), was busy visually transforming the States with his radical new methods for advertising, design and logo creation. Rand would go on to help shape the brand identities of some of the most well-known corporations in history, designing logos for IBM, UPS, and investment managers Morningstar Inc.

On this side of the Atlantic, a cohort of influential designers was establishing itself as a powerhouse of design creativity and experimentation. This hub of graphic enterprise centred around the Central School of Arts and Crafts. Its principal, painter William Johnstone (1897–1981), surrounded himself with elite artists, craftsmen, and designers – all experts in their field and with notable industry contacts. Jesse Collins, a founding member of the design research unit was recruited as head of book design and production at the Central School. He in turn managed to tempt typographer Anthony Froshaug (1920–1984) and designer/cartographer Herbert Spencer (1924–2002) into staff roles. Both were exponents of what would later become known as 'information design' – of which Beck's Diagram, already fourteen years old at this point, was the doyen. From this melting pot of creativity grew a new understanding of visual communication, as graphic design moved away from its non-professional origins towards a long overdue recognition that not only was it a skilled discipline, it was a key element of corporate and public life.

130 The History of the London Underground Map

As 1947 rolled around into 1948, the concept of 'public life' would have new resonance for the LPTB. On 1 January 1948, the LPTB lost its quasi-autonomous status as a board-controlled organisation and was nationalised – becoming part of the huge British Transport Commission (BTC) which was responsible for virtually all mainland road and rail services, as well as ferry services. The sense of dynamism achieved by Ashfield and Pick, something of which was lost during the Second World War, would never be truly reclaimed.

The occasion was barely mentioned in the press and the *Belfast Telegraph* reported that 'there was nothing to indicate the fact to the travelling public... . No public ceremony marked the handing over of the various systems to the British Transport Commission'[15] – although, according to the reporter, a London Transport bus conductor had greeted his passengers at St Albans with a cheery, 'Hurry along shareholders'.[16]

The day-to-day management of the new body was delegated to a London Transport Executive (LTE), whose members were appointed by the Minister of Transport in consultation with the BTC. However, sourcing recruits to lead LTE who were of the calibre of LPTB's previous executive board proved difficult – a task made harder by salary constraints imposed by the commission. The underground was low down on priorities in terms of government investment, having recently benefitted from extensions and upgrades via the New Works Programme. For the next fifteen years, most of the BTC's energy and resources would be funnelled into mainline improvements. The national rail network, now renamed British Railways, was run down, in dire need of modernisation in all quarters and had sustained substantially more damage during the war than the underground. According to *The Bradford Observer*, it also had terrible sandwiches. Under the headline, 'Railway Sandwiches Will Be Examined By The Commission', the newspaper reported that the chairman, Sir Cyril Hurcomb, 'spent yesterday inspecting the principal railway stations in London.' Following his tour, Sir Cyril announced that 'One of the objects of the commission ... is to improve public catering facilities on railway stations and make the buffets brighter.'[17]

Fortunately, Ashfield and Pick had left the underground network in relatively good shape, so for a while it was able to maintain the standards and values for which it was known; but within a decade it would slip into a long and painful decline. Lord Ashfield retired as chairman of London

Transport in 1947, and died on 4 November 1948, which spared him the disappointment of having to watch the transport network in which he invested nearly forty years of his life deteriorate beyond recognition.

Harry Beck would be free from the day-to-day bureaucracy that would ultimately cripple the underground over the next thirty years. Despite leaving London Transport the previous year, his lecturing position did not stop his ongoing involvement with the Diagram. In some respects he was more under its spell than ever.

Beck's peak came with the 1949 Diagram. This was the version he considered to be his finest in terms of form and function, and it is easy to see why. He managed to achieve a balance in its composition which elevated its usability. This was helped in part by the fact that it was unencumbered by several of the features that had been foisted on Beck by other people – such as the duplication of station names, and the use of the colour green for both the District and Metropolitan lines. The ornamental border had also gone, having been dispensed with in 1947. Instead, the Diagram was furnished with an understated border depicting the roundel in a repeating pattern, which was better visually suited to the Diagram, as well as being more in keeping with London Transport's corporate brand.

It is testament to the clarity of this version that the following year it was used to create the first Braille Tube map by the Royal National Institute for the Blind. This tactile version of the Diagram was in a bound, hardback format and such was its importance, it is documented in a set of photographs by Walter A. Curtin, which can now be found in the London Transport Museum collection.

Beck's Diagram wasn't just capable of adapting to the evolution of the city – it was able to adapt to changing attitudes towards accessibility and the notion of the underground as an inclusive environment. This was one of the first services for passengers with additional needs and the following decades would see a more considered approach to planning and modernisation. Level access to trains, lifts where possible, wider thoroughfares and changes in the layout of concourses have all been implemented where the design and configuration of the station allows – although of course, there is still much progress to make. In the Tube of the twenty-first century, Beck's Diagram has been successfully adapted for step-free journeys, printed in both colour and large black-and-white print versions, as well as diagrams for those who wish to avoid stairs or

132 The History of the London Underground Map

tunnels. Beck could never have envisioned the versatility of his Diagram, but it is testament to its heritage – as the grandfather of 'information design' – that it has been used in so many ways and for so many different groups of people.

Beck's design changed little over the following decade, although the consequences of nationalisation meant that by 1951 the proposed Northern line extensions from Finsbury Park, Mill Hill East and Edgware, and the Bakerloo line extension from Elephant & Castle to Camberwell had all been omitted completely. In 1953, Beck widened the eastern end of the Circle line which allowed not only more space for station names, but for the District line stations east of Barking to be represented for the first time all the way to Upminster. In 1955 a grid was introduced as a permanent feature. This concept had been introduced on the poster versions of the Diagram in 1951 and 1952, but by 1955 the 176-square version was being used on both the poster and card folder. The grid's accompanying index of station coordinates had to be accommodated in a large box, which arguably, compromised the balance of the design.

Throughout Beck's twenty-seven-year tenure of the Diagram he would grapple with the fine balance between modern functionalism – the 'fitness for purpose' eulogised by Frank Pick – and his own sense of artistic perfection. Part of the Diagram's success lies in its status as both masterpiece of modern art and navigational tool. It is as much at home hanging on the wall of a modern art gallery as it is stuffed in the pocket of a London commuter. The fact it can occupy these dual positions simultaneously is part of its charm.

By the late 1950s, Beck was on the cusp of a new challenge. Planning for a new line – the first major cross-London Tube line since 1906 – was reaching the advanced stages and an updated version of the Diagram would be needed to accommodate it. The need for an underground rail link between the city and the north-eastern suburbs was pressing. As far back as 1894 the London, Walthamstow, and Epping Forest Railway was put forward for parliamentary approval, but no capital could be raised and the project was dropped. The idea was proposed again in 1952 and a vigorous campaign began to get the necessary approval but, as ever in the history of the underground, investment was once again the stumbling block.

By 1955, parliamentary authority was finally secured for the new line, which had the rather uninspired name of Route C. Fortunately, a much

better name was sourced by someone in the PR department and the route was renamed the Victoria line. Despite its quite obvious benefits, the BTC was still reluctant to fund the project, blaming the 'present economic situation'.[18] As Stephen Halliday points out in *Underground to Everywhere: London's Underground Railway in the Life of the Capital*:

> [the] 'present economic situation' consisted of a booming economy, with post-war rationing finally abolished; a general election recently won by the Conservatives under their new popular leader Anthony Eden; and a main line railway modernisation programme authorised the same year by the Minister of Transport. It is hard to imagine more favourable circumstances.[19]

Seven years later, in 1962, and with only a mile of experimental tunnelling to show for the Victoria line, the spectre of unemployment was once again hanging over the country. After much banging on tables, and probably a few heads as well, it was suggested that the Victoria line would not only boost employment in the capital, it would also provide a much needed boost to north-east England whose heavy industries would be providing the tunnel segments. The construction of the line was finally signed off on 20 August 1962, some sixty-eight years after the need for it was first identified.

In the meantime, back at London Transport, the publicity department was actively trying to dissuade passengers from using the underground. More people were using the network than ever before and therefore it was necessary to adapt the publicity messages and promotional output to prevent it from becoming overcrowded. 'Today our Traffic Department would actually be happier if people travelled less, especially during peak hours,'[20] announced Harold Hutchison in a staff magazine in 1947. He continued:

> The present function of our poster publicity, therefore, is different. It is to be London Transport's information window through which we tell the public what we do and what we hope to do; what we expect of our staff and what we appreciate from our public ... instead of the competitive simplicity of 'Go By Underground' we have the more difficult but more interesting theme of explaining

134 The History of the London Underground Map

the largest urban passenger transport system in the world to those who must use it.[21]

To achieve this, Hutchison aimed to encourage as much traffic as possible outside of peak hours, particularly on Sundays, and continue with the Pick tradition of furnishing its stations with posters that were both meaningful and able to communicate key corporate messages.

The resulting promotional output – the 'Know Your London' campaign – combined text that conveyed the functional aspects of the network alongside an artistic representation. Known as a 'pair poster' because one half was designated as a pictorial space for the designer and the other for commercial copywritten text, Hutchison displayed them at high footfall areas, such as at station entrances, for maximum exposure. Misha Black and John Barker's *London Transport at London's Service* (1947) showed a roundel as a three-dimensional planet beaming its light of hope over the war-battered city, while its other half cited key facts, such as 'London Transport provides passenger transport services over an area of 2000 square miles.'[22] The format proved popular with the public and critics alike, and also encouraged a more collaborative creative process between artist, copywriter and client.

The poster renaissance was to be brief however, and by the time discussions regarding the Victoria line were well underway in the mid-1950s, the campaign had begun to lose its impetus. This was despite some striking imagery, such as David Gentleman's *Visitor's London* (1956), Joan Beale's *London's Museums* (1955), which depicted a montage of artefacts from the South Kensington museums, and in a similar vein, Peter Roberson's *London's Museums and Galleries* (1956) which rather oddly suggested that passengers interested in culture contact 55 Broadway for a free leaflet that will tell them how to get to the nearest Velasquez or see a copy of the Magna Carta, rather than just pointing them down some steps to the closest underground station.

During this period, 'The Underground' as a separate brand began to get diluted by the overarching 'London Transport' message, and few posters were commissioned promoting the underground as a standalone service. Denys Nicholls's 1950 design for the Central line's Golden Jubilee was the last pictorial poster to refer directly to the underground for several years. Instead, passengers were encouraged to 'make the most

Life After Pick 135

of your public transport' by using 'London Transport trains and buses'. This broad-brush approach ensured the publicity office encompassed all the key services, although it was probably to the detriment of the Tube. Beck's Diagram did, however, make the cut on a select few posters and it was replicated on the quad royal (40 x 50 inches) series *Visitor's London* (1950, 1951 and 1956) by Peter Roberson, complete with grid and coordinates. The same poster warns travellers that 'You are asked to avoid the weekday rush hours... . During the rush hours London Transport must carry 2,500,000 passengers to and from their work.'

It was no doubt with much interest that Harry Beck watched these developments during the 1950s. Now free of the employer-employee relationship with London Transport, but still hovering on the fringes due to his ongoing involvement with the Diagram, his position was never more precarious. In the twenty-seven years that had elapsed since the Diagram's conception, the publicity office had seen several changes of leadership and consequently, commercial direction. Moreover, the organisation itself had seen immense change and several incarnations, as the UERL, LPTB and now under the BTC-controlled London Transport – as well as an ever-changing executive board. Arguably, the one fixture throughout was Beck's Diagram – a constant feature of the underground on which London could rely – albeit one that was able to adapt itself to the shifting corporate and cultural landscape.

The Diagram had become legend, but this did not necessarily render it untouchable.

Chapter 21

Harry's War

On Friday, 29 April 1960, the *Norwood News* made an important announcement on behalf of London Transport:

A NEW LOOK FOR TUBE MAP

London Transport's famous map of the Underground, familiar to Londoners and visitors for the last 30 years, has been given a complete 'new look'. The new-style map is now going up at London's 279 Underground stations. It is easier to read – only main interchange stations are shown in capital letters, and these specially marked to indicate interchange with British Railways or other Underground lines. It is more geographical in the layout of the seven lines and travel information for passengers to air terminals, London Airport and mainline stations is given for the first time. Stations which close on Sundays are also marked.[1]

Rather ominously, the announcement made no reference to who was responsible for the 'new look'. It was also news to Harry Beck who had the misfortune to be confronted with the Diagram's usurper at his local station. To add further insult to injury, it was a poor and amateurish imitation of his own design. But worse than that – the new diagram was signed 'Harold F. Hutchison'.

In one sweep, Beck's bevelled corners and exacting configuration were eradicated in favour of sharp angles and squares. The eastern central section around Liverpool Street had once again descended into the cluttered and chaotic tangle of the pre-Beck maps and – perhaps the biggest travesty of all – the slicing of 'Aldgate' in half, so that 'Ald' appears on one side of the route line and 'gate' on the other. The overall effect may have been 'more geographical', but it was at the expense of the clarity and ease of use that Beck had spent twenty-seven years advocating via his Diagram.

Harry's War 137

It is not difficult to imagine Beck's reaction, particularly as he appears to have been kept in the dark about the new design. His frustration would have centred around his belief that by assigning LPTB the copyright for the design in its earliest days, this entitled him and only him to make alterations to it.

The reason for the redesign was relatively spurious – after all, by London Transport's own admission the map was 'famous' and 'familiar to Londoners and visitors for the last 30 years'. So why change it?

Hutchison's understanding of the art and design world was not superficial, and neither were his capabilities as an 'advertising man'. Although he wasn't a designer, draughtsman or artist, he had built a successful career in the commercial sector prior to his appointment at London Transport, in roles that would have brought him into daily contact with creative experts. And he seemed to have a genuine affiliation and sensitivity towards the lot of an artist.

Hutchison's archive of correspondence, which now resides in the London Transport Museum collection contains numerous personal notes from the artists he commissioned stating how delighted they were to see the printed versions of their work on display. 'I am delighted that you persuaded me to go ahead with the design when I was beset by doubts,' wrote artist Dorrit Dekk on 1 May 1961. 'I think it looks quite gay and just right for the foreign invasion of tourists. It has been most beautifully printed. Do please thank the printers on my behalf. And what a clever headline! I hope it will be a successful poster.'[2]

In a post-Pick era, Hutchison was well aware of the importance of being 'on brand', declaring in 1950 that 'We hold to the Pick tradition and yet we move with the times.'[3] In spite of post-war austerity and a limited budget for promotional activity, the calibre of the artists he commissioned and the quality of their work was undiminished. Established artists such as William Roberts, Edward Bawden and Enid Marx were joined by new and emerging creatives, such as David Gentleman and Gaynor Chapman, and all were put through the 'fitness for purpose' test as equals. Tactfully managing the artistic temperament was an accepted part of Hutchison's role; rather than shy away from providing feedback to his cohort of artists, or delegating the job to one of his subordinates, he seems to have performed this duty admirably. His diplomacy in his dealings with artist John Nash is particularly telling. Hutchison gently informs him in November 1951:

138 The History of the London Underground Map

I had fully intended using your painting for an outdoor poster last summer ... and I was about to come and see you to discuss its 'pepping up' (if you will forgive the phrase) ... we had a sudden cut in budget expenditure, and I simply had to leave it with the thought that I could use it next year. And here we are planning next year, but again with an economy campaign (government inspired) to handicap us! But I am planning an open air series and would very much like to find a subject that would enthuse you more.[4]

He was also keen to further the careers of the artists he commissioned. In 1957–1958 he appears to have gone above and beyond his remit by writing several introductions and testimonials on behalf of artist Paul Millichip, sending them, along with samples of Millichip's work, to a handful of acquaintances. He states that Millichip's work 'proved to be one of the most successful posters we have produced of recent years.'[5] He continues:

His new poster which is now being lithographed will, I think, be even more successful than the first. Without in any way erasing or restricting his natural style he is able to produce work for reproduction in the specified time and to our complete satisfaction. We have found him to be very cooperative and full of understanding of our problems without ever relaxing the integrity of his work.

Hutchison's approach to his artists was free of the loftiness one might expect from a figure who has historically been cast as the villain. His 1960 portrait by Walter Bird – complete with mischievous smile and trademark cigar – belies a genuine appreciation for the artists whose work he valued.

Considering this, it seems remarkable that Hutchison would attempt to encroach on their domain, particularly in such amateur fashion, without good reason. As Claire Dobbin argues in her book *London Underground Maps: Art, Design and Cartography*, 'That he thought he could improve on Beck's design seems remarkably and uncharacteristically naïve.'[6]

To compound the issue, there was no written confirmation of the agreement between Beck and London Transport, which would have set the record straight. What followed in early 1961 was an increasingly fraught situation in which Beck continued to argue his case and London Transport attempted to put an end to the matter. Up to this point, Beck had no reason to believe London Transport would ever dispense with his

services. That London Transport would let anyone else near the hallowed Diagram was inconceivable to him – but due to his freelance status, he also operated in something of a creative bubble – sitting in a blind spot somewhere between 55 Broadway and complete obscurity.

Beck was no longer an employee so could not be sacked, but as he was a freelancer London Transport probably considered it normal – if slightly misguided in this case – practice to simply not commission him anymore. Given Beck's long association with London Transport, it seems highly insensitive that no one bothered to inform him of this decision. Instead, they had let him discover it for himself in the worst possible way. It was a conversation that no one wanted to have, and so matters were left to run their course – unfortunately at the expense of Beck's emotional wellbeing.

Another conversation that no one wanted to have was with Hutchison. The 'new look' Diagram that claimed to be 'easier to read' was turning out to be a bit of a misnomer. That it was replaced within four years points to its unpopularity, although there is nothing on record to suggest London Transport had an opinion on it, good or bad. But that was part of the problem. It appears that no one had the foresight to stop Hutchison attempting to redraw the Diagram. Or the courage to inform him that his version wasn't particularly good.

The beauty of Beck's Diagram is in its simplicity, but this simplicity belies the complexity of its execution. There is certainly a sense that Hutchison felt he could do justice to Beck's design. After all, it was *just a diagram*. In his eyes, it wasn't 'art' as he knew it – the type produced by John Nash and Dorrit Dekk et al. If a former electrical draughtsman could draw it, then surely Hutchison could improve it. But the success of the Diagram goes beyond mere artistry – Beck was also able to communicate the passenger journey. His rounded corners gave a sense of effortless movement – a visual representation of smooth efficiency and the continuous flow of a progressive network. Hutchison's sharp corners and jerky, stop-start angles reimagined it as a series of broken journeys and interrupted service.

That it lasted four years was an achievement in itself, but the inadequacies in Hutchison's design were eventually its undoing. Beck was still hopeful that London Transport would come to its senses, but it took until November 1963 for it to become clear that Hutchison's first (and mercifully only) design was on its way out. The Diagram had a new custodian, Assistant Secretary and New Works Officer Paul E. Garbutt.

Chapter 22

A Thermos Flask Reunites 'Ald' and 'Gate'

While Beck spent the early 1960s in a well of frustration, London Transport was in a similar situation – this time due to the continual delays to the start of the Victoria line construction programme. The stalled project had all the hallmarks of a publicly handled mid-twentieth-century investment project, documented by London Transport historians Barker and Robbins as 'general acceptance of the intention of desirable; delay for argument on constantly changing bases' and 'final approval under temporary pressures which were largely irrelevant to the arguments'.[1] Author Christian Wolmar adds two of his own to this list: 'constant rows over financing and cost overruns during construction'.[2]

The line was finally given the go-ahead in 1962. That it would take another seven years until the first section was opened demonstrates the complexity of the project, but for now there was much rejoicing. 'End Of Queues At New Oxford Circus Tube' announced the *Marylebone Mercury,* which was clearly looking forward to the 'new ticket hall' and 'nine new escalators' that would ensure passengers kept moving, even in rush hour. It continued:

> With the introduction of the Victoria Line and the improved facilities for the lines at present operating from Oxford Circus it is hoped that the present rush-hour congestion – with passengers spilling over on to the road while waiting to get into the station – will be eliminated ... passengers will be routed 'one-way' throughout the station to avoid congestion.[3]

The reporter goes on to explain how the new line will substantially reduce journey times, with Oxford Circus just four minutes away from Victoria, 'instead of 14 under the present system'[4] – a consideration that had proved key to securing government sign-off. The Victoria line was the first to be

built on the intangible benefits it was hoped it would bring – rather than a cash return on investment – such as time saved by passengers, better efficiency, less crowding on other lines, and a decrease in road congestion.

The needs of the humble motorist could not be ignored. Car ownership presented the single biggest threat to the railways in the mid-twentieth century. Economic recovery and an end to petrol rationing had seen exponential growth in the road transport network. While the underground network came out the other side of the 1960s relatively unscathed – the Metropolitan line had been gradually truncated from 1935 onwards, with Amersham becoming the end of the line by 1961 – the mainline railways would not fare so well. Just as Geddes had wielded his economy cutting axe in the 1920s, now Richard 'Dr' Beeching would do the same in the 1960s – only this time the victim was the railway network.

Beeching's engineering experience at Imperial Chemical Industries was sought at a time that the government was bringing in professionals from outside the railway industry to improve the finances of British Railways. His *Reshaping of Britain's Railways* report (1963), commonly referred to as the Beeching Report, was an attempt to slim down the national system and plug a haemorrhage of £300,000,[5] which was what the railways were losing daily. Out of 18,000 miles of railway, Beeching recommended that 6,000 miles of rural and industrial lines close, and those that only just survived the cut should continue as freight only. A mammoth 2,363 stations were earmarked for closure. Soon-to-be prime minister, Harold Wilson, would deliver his famous 'white heat' speech later the same year at the Labour Party Conference. Speaking in a period of significant social and technological change, Wilson argued that 'the Britain that is going to be forged in the white heat of this revolution will be no place for restrictive practices or for outdated measures on either side of industry.' In other words, trains were out, and cars were very much in.

Popular culture did little to help the plight of the railways either. Ealing comedy, *The Titfield Thunderbolt* (1953), which tells the story of a hapless group of villagers trying to preserve its branch line after British Railways closes it, promoted the idea that railways were a legacy of the past, only fit to be pickled in aspic along with other remnants of the country's industrial heritage.

Ten years after he penned his odes to Middlesex and Baker Street Station, and ten years before *Metro-land* was filmed by the BBC, John

142 The History of the London Underground Map

Betjeman found himself advocating another disappearing world as he became one of the founder members of the Railway Development Association – a protest movement that was formed to campaign against the Beeching proposals. But Beeching was undeterred and followed up his 1963 report with the publication of the second stage of his plan in 1965. *The Development of the Major Railway Trunk Routes* would curtail any further development or investment in all but 3,000 miles of trunk railways, out of a total of 7,500 miles. Despite the report promising that it was not 'a prelude to closures on a grand scale', many of the suggested closures were implemented by Harold Wilson's Labour Government with only a few lines granted a reprieve. The legacy of Beeching's reports in the early 1960s led to towns and villages, many in the most economically challenged areas of the country, being entirely cut off. The geographical divide between the country's cities and its smaller provincial towns grew ever wider – as did the financial divide, as the economy became even more Londoncentric.

In some respects, the loss of the railways marked a gain for the underground. Beeching's cuts were biased in favour of retaining north-south routes as opposed to east-west routes, especially in the Midlands and the north of England. This meant it became harder to make cross-country journeys without travelling into and across London, therefore pushing additional mainline passengers onto the capital's Tube network. Regardless of this small coup for London Transport, Beeching remains unpopular to this day, with most criticism being levelled at his disregard for the social benefits of a sprawling railway network. Perhaps if he'd employed the same cost-benefit analysis that was used to assess the viability of the Victoria line, he'd have upset fewer people. His 'short-sighted act of transport lunacy' still provokes strong feelings as a contributor to BBC. co.uk's 'On This Day' page points out:

> I'd love to stick him on just about any of our motorway overbridges on a typical Friday afternoon and show him just what he's responsible for... . Then I'd take him to any of our revitalised preserved lines on just about any weekend of the year and show him what initiative and endeavour can produce... . And finally, I'd read *Thomas the Tank Engine* to him until he began to cry with remorse.[6]

A Thermos Flask Reunites 'Ald' and 'Gate' 143

At the same time as Beeching was sharpening his axe, London Transport was celebrating a line that was very firmly rooted in history but going nowhere – except perhaps Amersham or Barking. The Metropolitan line turned 100 in 1963, marking the centenary as the world's first underground railway. To mark this momentous occasion, London Transport published two paperbacks at five shillings each: *The Story of London's Underground*, by John R. Day and *How the Underground Works*, by Paul E. Garbutt, he of imminent new Diagram fame. It was hoped these books would 'bring home the lesson that a great city should cherish its public transport services if it wishes to avoid the worst calamities of modern-day congestion.'[7] Although this sounded like a direct challenge to the motorist, it wasn't really Londoners, or motorists, who needed the lesson. Rather, it was a word of warning to the government.

Gaining approval for the Victoria line turned out to be London Transport's swan song. By 1963 the BTC, under which the various national transport systems had been organised, was abolished and separate boards were established for each network. The London Transport Executive would henceforth be known as the London Transport Board (LTB) – the crucial difference being that it reported directly to the Minister of Transport, the Rt. Hon. Ernest Marples, and had responsibility for its own budget. LTB may have been in control of its own destiny once again but there was still little money available for refurbishments and essential upgrade works. In 1963, a mere £1.1 million was made available for improving stations, track, signalling and depots due to the large amount of capital needed for the Victoria line preparations. The scant attention paid to the rest of the system, and chronic underinvestment in the existing infrastructure, saw the Tube slip into a gradual decline – the results of which were clear to everyone by the 1980s.

The centenary of 1963 was rightly a chance for celebration, but also a chance to reflect and consider what the future held for the underground. Chairman Alexander Valentine, who had retained his seat on the new LTB, wrote in *The Times*:

> if a centenary becomes merely an occasion for nostalgia, it loses most of its point. A centenary should help us to understand more clearly the nature of the problems that have been solved in the past … we should be better able to make the right decisions for the future.[8]

144 The History of the London Underground Map

LTB had the best of intentions, but it hadn't reckoned on car ownership in London quadrupling between 1950 and 1970. Nor had it considered the business interests of Transport Minister Marples.

During his controversial tenure, Marples would oversee significant road construction, as well as appointing Dr Richard 'the Axe' Beeching as Chairman of British Railways. As the 'motorway-age Minister',[9] this suited Marples. The closure of the railways encouraged car ownership, and more motorists meant more motorways. Valentine wrote in *The Times* about the severe congestion and parking issues caused by the growing dominance of the motorist in the capital, imploring not 'to destroy the character and efficiency of the city by motorways.'[10] Unfortunately, Marples had more than a bit of a vested interest in motorway construction. His ongoing involvement in the road construction business Marples Ridgeway – he was managing director and then an eighty per cent shareholder, until he offloaded the shares onto his wife to circumvent the House of Commons conflict of interest rules – was dubious at best. It was probably no coincidence that Marples Ridgeway won the tender to build both the Hammersmith Flyover and Chiswick Flyover. The company was also involved in the £4.1 million extension of the M1 into London. It was highly fortuitous that as Beeching was closing the railways, Marples Ridgeway was busy building motorways courtesy of government funding.

The *Daily Mirror* reported on the centenary celebrations at Moorgate Station in May 1963, which involved actors in Victorian garb and old rolling stock. The feature included a photograph of Marples kissing the hand of one of the female actors:

> An 1863 kiss – in Marples fashion… . The setting is Victorian. So are the dresses, and so is the old-world grace with which the lady's hand is being kissed. But the chap who's doing the kissing doesn't look very Victorian. No, he's a man of the motorway age. Marples by name.[11]

Marples' 'old-world grace' clearly didn't extend to his political and business dealings and his questionable conduct soon caught up with him. In 1975, by which time he had already angered motorists up and down the country by introducing yellow lines, parking meters and traffic wardens, he was forced to do a moonlight flit to Monaco, following claims he owed nearly

A Thermos Flask Reunites 'Ald' and 'Gate' 145

thirty years' worth of taxes. In an interview with the *Daily Mirror* in 1975, Marples, speaking from the balcony overlooking his 45 acre French vineyard, said:

> The revenue said I owed them all this money. The man was a socialist – I could tell. I thought the claim was preposterous and utterly unfair. In the end there was nothing I could do, so I said 'F***'em', if that's their attitude, I'm off.'[12]

Lawsuits followed; from a merchant bank, from the disgruntled tenants of a block of flats in Putney, of which he was landlord, and from a former employee. Marples concluded his interview with the *Mirror* with the details of his flight from Britain: 'My poor wife was crying but I told her we had to get out – and quick. If we had waited I would have been liable for another year's tax.'[13] Nevertheless, he wasn't too downcast by his plight; he was, in his own words, 'the best thief of ideas in the business'.[14]

* * *

Another thief of ideas – in Harry Beck's mind anyway – was Harold Hutchison, or more broadly, London Transport. But the Diagram was, mercifully, about to be rescued by Paul E. Garbutt. His photograph, kept in the London Transport Museum archive, shows a clean shaven, bespectacled man with an honest smile and trustworthy face. If the Diagram was to be safe in anyone's hands, it was Garbutt's. Born in 1919 in Westcliff-On-Sea, Essex, he left school in 1934 and worked first for the London Scotland and Midland Railway in the accounts office, rising to personal assistant and then vice president, before joining the Royal Engineers during the Second World War. His distinguished service in transport intelligence earned him an MBE in 1946. Following the war, Garbutt joined London Transport working on underground railway planning and the Railway Planning Working Party, which eventually led (many years later) to the construction of the Victoria line.

As noted, by 1962 it had become clear that Hutchison's map was universally disliked. Whether Hutchison himself was aware of this, the history books do not tell, but criticism of his misappropriation was sufficient for Garbutt to give up two days of his Christmas holiday

146 The History of the London Underground Map

in 1962 to attempt a redesign. Garbutt restored the curved corners, reinstated the white line connectors for interchange stations and redrew the Central line as a clean, horizontal line running across the centre of the Diagram. Many of Beck's original design principles were reapplied, but the most prominent departure from both Beck and Hutchison was Garbutt's treatment of the Circle line. Where Beck had settled on a rectangle with rounded corners from 1954 onwards, and Hutchison had employed the irregular polygon reminiscent of Beck's earlier diagrams, Garbutt incorporated his own shape – affectionately known within London Transport as the 'thermos flask'. 'Ald' and 'gate' were also reunited, putting an end to Hutchison's clumsy treatment of the area around Bank and Liverpool Street. However, London would have to live with Hutchison's design for a while longer – Garbutt's diagram wouldn't be published until 1964.

Meanwhile, Beck was attempting to demonstrate the provenance of the Diagram and his sole claim to ownership. His claims rested on his belief that the 45 and 90 degree angles he used were utterly original, but any hope that his design principles would be reinstated under his own hand was quickly extinguished. London Transport would refute these claims – refusing to accept that the map in circulation was influenced by, or bore any resemblance to, his original design.

It also had a legal department and enough money to see off potential lawsuits. Beck had only the strength of his own convictions and his own firm of solicitors. The balance of power was not on his side.

In May 1964, Garbutt's Diagram finally replaced Hutchison's across the underground network. The Garbutt design was clearly an improvement on Hutchison's efforts, but that was largely due to its resemblance to the Beck version. Yet Beck's name was absent. It was also an accomplished piece of design work which, unlike Hutchison's design, was worthy of its place in the station booking halls and on the platforms. The Diagram was back on track, but without Beck behind the wheel.

After almost four years of being stonewalled by London Transport, and the resultant stress and anxiety of the situation, it is remarkable that Beck retained the desire to return to his drawing board ... but he did. It says much about his character. Undoubtedly in his mind, to give up on the Diagram would be to give up on thirty years of work. The Diagram was more than just a design commission, it had defined Beck's life since

A Thermos Flask Reunites 'Ald' and 'Gate' 147

1933 and provided him with purpose, although he never sought fame, or indeed fortune (which was lucky given the pitiful amount he was paid for his design). In fact, he was thoroughly modest about his achievements. A former student of Beck's, Ian McLaren, who studied under him in the late 1950s at the London School of Printing and Graphic Arts recalled that, 'Despite persistent efforts we students could not wheedle out of him stories related to the London Underground diagram.'[15] The Diagram would go on to find itself on tea towels, cushions and even chopping boards, which would have surely raised Beck's eyebrows, but as McLaren points out:

> Given the sense of sheer fun which his design has engendered, and the degree of affection and international respect for it; I cannot believe that despite the vicissitudes of his relationship with London Transport he would today resent that his ideas have created the means to help preserve the design heritage of London.[16]

Beck's final attempt at reclaiming the Diagram as his own came in 1964, when he produced another amended version. Rather than ignore Garbutt's diagram, which was already in circulation, Beck gave it due credit and amalgamated elements of the Garbutt version into his own, such as the more geographically correct configuration and black dot interchange symbols – ostensibly because he recognised their value, but also perhaps to make his version a more attractive proposition to London Transport. He retained his idea for the proposed Victoria line – a simple lilac line (it wouldn't become blue until later) running on a 45 degree angle from Victoria, turning on the horizontal at Finsbury Park and ending at Walthamstow.

By this time the Diagram had become something of an unpaid lodger in the Beck household. It was a permanent work in progress and overly indulged by its host. The ability to improve and tinker with aspects of the design was a requisite part of being its custodian, a role that Beck fully embraced. As a concept, the 'diagram as map' was new and its aesthetic principles were untested, thus it needed to be nurtured to reach its full potential. The endless 'improvements' that were foisted on Beck by other London Transport employees, and the inevitable expansion of the network itself – neither of which was under Beck's control – were also a test of commitment. What Beck provided was a level of aesthetic consistency, which is only possible under one steadying hand.

148 The History of the London Underground Map

There is no record of whether Beck's 1964 version ever reached London Transport, but it is highly unlikely it would have formally commissioned the design. To do so would be to risk corporate pride. To reinstate Beck as the Diagram's designer would have been an admission of poor judgement. It would also have strengthened his claim to provenance over the 45 and 90 degree angle idea, which of course, was out of the question. London Transport's shabby approach to the situation was detrimental to all involved – but none more so than Harry Beck.

Chapter 23

Beyond Beck

By 1966 the storm whipped up by the Diagram had passed. Hutchison had retired from London Transport, leaving in charge his chief creative assistant Bryce Beaumont who had joined as a copywriter in the late 1930s. Beaumont had already put his stamp all over the London Transport publicity – as a copywriter he had helped to develop the tone of voice used on its visual content, employing a combination of erudite description and gentle persuasion to ensure Tube trains were full and bums were on the seats of buses and trams.

London was certainly swinging its way through the 1960s. With the new Post Office Tower dominating the skyline – its metal and glass gleaming like a beacon of optimism – alongside one of the first central London skyscrapers, Centre Point in Holborn, as well as Erno Goldfinger's high-rise council housing building, Balfron Tower in Tower Hamlets, the 'white heat' Harold Wilson alluded to in 1963 was writ large on the London landscape. These monuments of concrete and glass – 1960s Brutalism at its finest – were a fitting symbol to a society buoyed up by economic prosperity, low unemployment, and rising wages.

Superficially at least. But the cold, uncompromising structures that loomed over the city were prescient of the manifest anxieties of a highly unsettled society. That those same buildings would eventually come to symbolise the worst of urban decay was somehow inevitable given the spirit in which they were built.

From 1955 to 1964 the number of people employed in 'white-collar' jobs in London – commuting during the peak times of 8.00am and 6.00pm, Monday to Friday, and working in fields such as insurance, banking and finance – had grown by twenty-four per cent.[1] At the same time those employed in the manufacturing sector – in food, drink, tobacco and clothing – had shrunk by twenty-three per cent.[2] Trade was moving out of the city or closing down completely. The impact was most keenly felt at London's docks. The East India Dock ceased activity in

150 The History of the London Underground Map

1967 with St Katherine's Dock and London Dock following two years later – all deemed redundant because they were no longer large enough to accommodate the new container ships. The once busy banks of the Thames were now full of empty warehouses and rusting machinery.

It was a similar, if not so extreme, story underground. Outside of peak hours, a disturbingly large proportion of London Transport's rolling stock was languishing at the depot. The problem was exacerbated by rising car ownership and television – a form of entertainment that would have a lot to answer for over the coming decades. Where previously Frank Pick could have called on any number of expertly designed leisure travel posters to help fill the off-peak services, the draw of either travelling in the privacy of one's own car or staying at home to watch *Coronation Street* or *Z Cars*, was sufficient to keep trains in sidings and the network under considerable financial pressure.

Poster publicity also struggled to keep up with the times and London Transport entered something of a creative wasteland whereby the latest artistic trends were largely ignored. Pop Art, which incorporated imagery from popular culture such as comic books and advertising, often in the form of a collage, seemed to pass London Transport by completely. The only two examples from this time include Fred Millett's *London After Dark* (1968) and Hans Unger's *Art Today* (1966), which lent itself to the subject anyway since it advertised The Tate and Whitechapel Art Gallery. The latter also incorporated an adapted Tube Diagram to indicate new directions in modern art, such as Constructivism, Junk Art, and Neo-Dada. If Pop Art was too much for London Transport then Psychedelic art – and its partners in crime, namely drugs and rock and roll – was beyond the pale.

There was a glimmer of hope in the form of Harold Wilson's no-nonsense Minister of Transport, Barbara Castle. Castle managed to successfully negotiate the transfer of responsibility for London Transport to the Conservative-run Greater London Council (GLC). Leader of the GLC, Desmond Plummer, drove a hard bargain, insisting that the council would only agree if the £270 million legacy of debt – primarily from the 1930s New Works Programme – was written off by the government. A deal was struck and in 1970 London Transport was brought under local control. An immediate benefit was access to central government grants for capital expenditure, as it was hoped these would bring the

Beyond Beck 151

network back to a decent standard. However, much of these funds were eventually absorbed into various expansions: the Heathrow extension to the Piccadilly line, which opened in stages between 1975 and 1977, and the construction of the Jubilee line, which opened between Charing Cross and Baker Street in 1979.

Although the new relationship started promisingly, it wasn't long before problems arose. The GLC was often ruled by the party in opposition to the one in power at Westminster, and at almost every election changed hands. This lack of consistency in political control and constant shift in policy meant the GLC's fourteen years of tenure were volatile and unhelpful to a network looking to return to its role as the beating heart of the city.

Even the opening of the Victoria line in 1969 was an anti-climax, despite Her Majesty's first Tube ride in thirty years (her first being on the District line in 1939). Famously described by *The Observer* as 'extraordinarily bleak',[3] there was a sense of desolation to the Victoria line from the start. It is the only line, barring the Waterloo & City, that spends its entire 13.5 miles underground. There were no guards, no ticket staff, and no platform guards. Instead, the line boasted one-man-operated automatically driven trains, and automated tickets and ticket barriers.

'Features like this go towards making the new line the most up-to-date and best equipped of its type in the world,'[4] crowed the *Illustrated London News*. Unfortunately, the same features also removed all the character and charm from the route – the city's first in sixty years. The 'heat' of technology had left everything a little chilly and impersonal. An advert issued by London Transport and printed in *The Chelsea News and General Advertiser*, titled 'V-Day', eulogised the new line: 'make the most of it … it's all yours', describing it as the 'best Underground line in the world'.[5] The Victoria line promised 'a really comfortable ride',[6] loudspeakers that would 'save a lot of frustration'[7] and 'less traipsing'[8] between platforms. In an ironic turn of phrase, London Transport also declared that the line was 'designed to cut corners'.[9] It was a shame then that they had cut corners with its construction – narrower platforms and undecorated ceilings evidenced the severe budget restrictions under which the line was built.

The Victoria line opened between Walthamstow and Highbury on 1 September 1968. The Queen waited until the line had reached the more

152 The History of the London Underground Map

regally sounding Victoria before declaring the route officially open. Her Majesty arrived at 11.00am on 7 March 1969 and was met by London Transport chairman Maurice Holmes, before descending to the ticket hall where she was invited to purchase a ticket. Embarrassingly, her own money wouldn't work in the machine and an alternative coin had to be found for her to proceed through the automated ticket barriers. The Queen then proceeded to 'drive' the train (under heavy supervision, despite the only requirement to the role being the depression of a 'start' button) from Green Park to Oxford Circus, where she alighted and met the station master, Mr G. W. Grimes. After taking a ride up the escalator, she met other officials and contractors, before visiting the operations room and ticket office. From there she bade farewell and made the return journey to Victoria Station.

Her subjects had to wait a little longer to use the line. After spending two weeks watching 200 empty trains zip up and down the line while it was tested, at 3.00pm the same day, 7 March, passengers were finally allowed to board the 'Ghost Trains'[10] in time for the evening crush.

Despite all the testing and practice runs the new equipment was not failsafe. In its first year alone, it carried a third more passengers than had been anticipated. The pressure of daily use was evident from the word go and on the first day of operation a power failure put the automatic ticket machines out of use at Victoria. The resulting queue of passengers attempting to buy tickets from an actual human stretched from the booking office to the overground platforms. Having finally purchased a ticket, passengers then had to contend with the automatic barriers which would regularly trap them with their bags and luggage as they attempted to get through its snapping jaws. Like the early twentieth-century passengers on Yerkes' Tube, who had to learn to negotiate sliding carriage doors, a new etiquette had to be learnt – one that didn't include dithering. It was hoped the barriers would act as a deterrent to fare-dodgers rather than paying customers, but the ticketing system failed initially, and the gates were removed in 1972.

Not to be put off, the 'jaws of death' made another bid to relieve passengers of their luggage in the late 1980s. But Londoners have long memories and the new automated ticket barriers were greeted with little enthusiasm. 'I've seen huge scrums developing at the gate as people desperately try to avoid using the new technology,'[11] a reporter for the

Kensington Post wrote in 1989. 'So what is the secret of this spectacular non-starter? Could it perhaps be that the black and chrome barriers look like some kind of sci-fi torture apparatus, promising new levels of pain if you don't manage to get through in the statutory 0.07 seconds?'[12] Luckily, MP Sir Cyril Smith was on the case. At 28 stone, the politician joined a protest in June 1989 held by travellers who struggled to negotiate the barriers 'because of disabilities, shopping or size'.[13] He demonstrated the difficulties by trying to squeeze through the barriers. It is unclear whether he succeeded but he did comment that 'the gap to go through is very narrow. How humiliating it might be for a person to become wedged.'[14]

One gap was widening, however. The underground's annual running costs were not offset by its profits. It was the same old story, only this time it was compounded by a period of economic turmoil. If the 1960s were considered a time of 'innocence', as suggested by historian Peter Ackroyd, the 1970s were characterised by a sense of societal decay and dissent, as 'all the old problems of London reasserted themselves'.[15] The cost of oil was high, which had a direct effect on the costs of generating electricity as well as stoking the flames of inflation. Staff relations at London Transport were at an all-time low as wages failed to keep up with the cost of living. Deep cuts in public expenditure coupled with a freeze on fares and free travel for pensioners during off-peak hours (thanks to the policy makers at the Labour-lead GLC) meant that by 1975 London Transport announced an expected £113 million financial deficit in its 1976 budget.[16] In the same year, it was suggested that bus and underground fares were raised and brought more into line with the true costs of running the network. However, this ran contrary to the spirit of the Labour GLC's strategy to encourage Londoners to use public transport. 'Heavy fare increases would mean a severe loss of passengers,' stated Deputy Leader of the GLC Illtyd Harrington in February 1975. 'I fear that a return to a strictly commercial approach to fares would defeat our overall transport strategy.'[17]

Nevertheless by May, passengers were being warned to prepare themselves for 'massive fare increases'[18] of twenty-five per cent, coming into effect in November. A further twenty per cent rise was planned for the following summer, despite the grumblings of left-wing Labour stalwarts who believed it to be a betrayal of the party's election pledges.

154 The History of the London Underground Map

The only glimmer of hope was provided by a streak of silver running between Stanmore and Charing Cross. The underground's newest route, the 'Fleet line' wasn't that new at all since most of its initial distance was borrowed from the Bakerloo line. Originally conceived in 1948, it was authorised and christened the Fleet line in 1971 because its original route ran beneath Fleet Street and across the valley of the Fleet River (yes, *that* Fleet River). That the Conservatives would appropriate the word jubilee had, of course, nothing to do with currying the favour of voters, who in 1977 – the Queen's Jubilee year – were full of patriotic enthusiasm. It proved popular and the Conservatives returned to office at the GLC in the same year under the leadership of the flamboyant Horace Cutler and his collection of dapper suits.

The story of the Jubilee line would turn out to be a two-part serial. The funding secured in 1971 only covered the first phase of the project to Charing Cross, as the future of the now disused Docklands area was still undecided. Having appropriated an existing line – the Bakerloo – it was a bit of a backward step compared to its older, and more technologically proficient sibling, the Victoria line. There was no automatic train control, which meant two-driver operated trains as well as conventional signalling, and it was only half built. But the name change turned out to be fortuitous since the proposed next stage of the route under Fleet Street and the bothersome Fleet River valley was abandoned. The Jubilee line would have to wait twenty years to reach its conclusion when the rest of the line from Westminster to Stratford – which by now bore little resemblance to the original proposed route – was opened in 1999. This newer part of the line upstaged the older part by virtue of its polished metal and cavernous stations.

The first part of the line was formally inaugurated by Prince Charles in April 1979. The cynics were not convinced. Morning commuters who were used to a direct journey to Oxford Circus or Piccadilly now had to change onto the notoriously overcrowded trains at Baker Street to get into the city, while the empty Jubilee line trains carried on to their new destinations. The excuses for poor service given by London Transport were 'more than usually unconvincing', according to one angry letter writer in the *Harrow Observer*:

We are expected to believe that the unreliability of train services can reasonably be attributed to some crews being on holiday and others

being trained to operate the Jubilee Line... . Those with a long memory may realise that the Jubilee Line is three years late opening, so that the need for a last-minute panic programme of training is quite unbelievable.[19]

The writer went on to make three predictions: 'One, the train to be used for the opening ceremony by Prince Charles will definitely run. Two, fare paying passengers will subsequently encounter long frustrating waits. Three, the next excuse to appear in rotation will be "shortage of serviceable rolling stock".'[20]

London Transport's years under the Cutler-led GLC were far removed from the golden days of Ashfield and Pick. The network had become increasingly decrepit and the environment itself was no longer a force for cultural good, underpinned by social and civic values. Instead, it was strewn with rubbish and graffiti and became a hotspot for crime and antisocial behaviour. The legacy of the two giants of the underground had carried London Transport so far, but not far enough. It had guided the network through the Second World War and beyond, but while the brand established by Pick was still going strong, it obscured weaknesses in the network's management and a lack of clear objectives and consistent planning. London Transport's reliance on public subsidy meant having to satisfy social and commercial objectives while maintaining an efficient and profitable network which was being constantly reshaped by political circumstances that were out of its control. Fares were held down by successive governments who did not want to anger passengers or lose voters, and the revenue achieved by profitable services was ploughed back into subsidising less-profitable services, rather than much-needed long term investment in better facilities. The old dynamism was gone, not just on the underground network but from the city itself.

This dark period in the underground's history is usefully obscured by its diagrams. They remained clean and uncluttered by rubbish – the Tube as it should have been, rather than what it had become. Unless you travelled on the underground in this period, you weren't aware of the reality as the diagrams still boasted a model of efficiency and organisation. The London Transport brand was working hard to conquer a new market unfamiliar to the capital – tourists.

Capitalising on branded merchandise was not a recent phenomenon for London Transport. As early as the 1930s, the publicity office was

156 The History of the London Underground Map

receiving requests to use the Diagram on products – decades before it had reached the iconic status it enjoys today. Demand for its use grew in the post-war period, so much so that the publicity office was forced to review its commercial usage; reframing the Diagram in terms of its cultural value and benefit to the London Transport image. By the 1960s, the Diagram was making its debut on tablecloths, boardgames, scarves and even a brass powder compact case – all of which were sold in select West End stores.

In 1964, London Transport opened its own shop selling posters, postcards, prints and maps on Marylebone Road, but it wasn't until the mid-1970s that it began to recognise the value of the Diagram as a souvenir. One of the first products to be launched in 1977 was a T-shirt printed with the central portion of the Diagram, and accompanied by the slogan 'I'd be lost without it'. The timing was fortuitous, coinciding as it did with the Queen's Silver Jubilee celebrations and a patriotic demand for 'best of British'. The Diagram had transcended its original purpose, transforming from navigational aid to the recognised and accepted landscape of the capital. In a city made up of disparate neighbourhoods – a distinction that would become even more noticeable with the abolition of the GLC in 1986 – Beck's Diagram provides a snapshot of the city as a whole. It unifies. It is the glue that holds the city together.

Harry Beck would not live to see his Diagram's successors emblazoned on clothing and souvenirs. On his retirement, Harry and Nora moved to High Barnet, and then later The Eyrie in Fordingbridge, Hampshire – now a bed and breakfast which proudly states its connection to its former owner online. He died on 18 September 1974 at the Royal South Hampshire Hospital in Southampton from cancer of the bladder. He was 72.

Recognition was slow to come. It would take twenty years before Beck was publicly acknowledged by London Regional Transport (as it was then known), who only seemed to act following a request, via letter, from an acquaintance of the Becks. In 1994, a reproduction of the first printed version of the Diagram was displayed at his local station, Finchley Central, with some details of Beck's life under the inscription – 'A design classic – one man's vision'. Around the same time, the Beck Gallery was created at London Transport Museum in Covent Garden to provide a permanent home for his work and ensure his legacy was recognised more widely.

By 1997, London Regional Transport concluded that Beck ought to be formally recognised on future diagrams – now called 'Journey Planners' – and a line was added to every published version: 'This diagram is an evolution of the original design conceived in 1931 by Harry Beck.'

It had only taken sixty-six years.

Chapter 24

Fares Fair in Love and War

London Transport may have been working hard to attract tourists but even clever branding couldn't counteract the negative effects of the Moorgate disaster.

On 28 February 1975, at 8.39am, a Tube train carrying approximately 400 commuters left Drayton Park in North London. There was no indication that the journey would be any different to normal, as the train travelled its usual route on the Northern line through Highbury, Islington, Essex Road and Old Street. But just seven minutes after departing from Drayton Park the train 'burst through the buffers at Moorgate, plunging its passengers into a hell of dust, darkness and stinking hot air.'[1] Instead of braking, witnesses claimed that as the six-car train approached the Moorgate terminus it accelerated the last 100 yards, hurtling through the platform and into the 20 metre overrun tunnel. Despite the presence of numerous safety mechanisms, the train managed to plough through a sand drag (a pile of sand at the end of a platform intended to stop a train), destroy the buffers at the end of the line and hit the end wall of the 12 ft tunnel.

The first car buckled into a V shape, as the second car slid underneath it. The third car rode up over the second with its front jammed into the roof of the tunnel. Survivors from the rear three coaches managed to evacuate the train and stagger back to Moorgate Station to raise the alarm. The first rescue workers had to cut their way into the wreckage, lighting the area with arc lights. They were greeted with a scene of devastation. A doctor from St Bartholomew's Hospital who was one of the first medics on the scene said, 'I have never seen such grotesque carnage in all my life. One of the other doctors turned to me and said: "If there's a hell, I've lived to see it."'[2]

Forty-three people, including the driver, were killed at the scene – either from the impact of the crash or from suffocation under the wreckage. Seventy were injured. It took five days of rescue operations

Fares Fair in Love and War 159

in a dust-choked tunnel to retrieve all the bodies. 'In the airless tunnel, the operation rescue itself made conditions more difficult. Oxy-acetylene burners and arc lights raised the temperatures to such a level that rescue workers were given salt tablets because they quickly became soaked in sweat.'[3] The conditions were likened to that of a pit disaster. One rescuer said, 'It's awful down there. It's like a battlefield. We are having to cut our way through the damaged coaches inch by inch.'[4]

Naturally, the focus of the investigation fell on the driver, Leslie Newson. He was last seen standing upright, looking straight ahead with his hand on the controls. He was known to have a good record and was a conscientious worker. Suicide was suggested but refuted emphatically by his wife – an assertion that was lent further credibility by the discovery of £300 in Newson's pocket, which he was planning to use to buy his daughter a car after his shift. He'd also asked his colleagues to save him some sugar for a cup of tea on his return. Medical conditions and drunkenness were also ruled out, leaving the jury at the coroner's inquest with little option but to return a verdict of 'accidental death'. Inevitably, the Moorgate disaster left a plethora of questions and little in the way of answers. It has never been satisfactorily explained.

By 1982 the underground had hit rock bottom, with just 498 million annual passenger journeys compared to 720 million in 1948.[5] It was also in the middle of a political battleground. Labour had been re-elected to County Hall in 1981, with charismatic left-wing 'Red Ken' Livingstone at the helm. What followed would be a bitter war of words, mud-slinging and stand-offs as Livingstone's municipally focused GLC took on Thatcherism at its finest.

One of the lynchpin policies on which Labour had been elected was 'Fares Fair' – the idea that a drastic drop in the cost of fares would drive more Londoners onto public transport. The well-meaning but grandiose scheme would cost £123 million a year and be paid for by London's ratepayers – regardless of where they lived in the capital. This meant that people living in Greater London would pay as much as those living in the wealthier central area. The passengers set to benefit the most included students, young people, the unemployed and senior citizens, but also commuters and tourists – many of whom were travelling in from outside the ratepaying boundary. The policy, which came into effect in October 1981, also saw the introduction of travel 'zones'. The buses had four zones

160 The History of the London Underground Map

and the underground had two – the West End zone and the City zone. Journeys within either zone cost 20p and any journey across both zones cost just 30p.

The *Daily Mirror* likened the scheme to 'practically giving away a goldfish or a windmill on a stick with every ride'.[6] But behind the sardonic comments, concerns were also expressed about the legality of scheme. Leading the challenge was the Conservative borough of Bromley, whose councillors argued that since it had no underground station, its ratepayers were being unfairly penalised as they benefited less from the scheme than inner-city residents. The challenge made it to the House of Lords where, on 17 December 1981, it was unanimously ruled that the extra rates being levied were indeed illegal – as were the cut-price fares. Embarrassingly, the GLC was ordered to refund ratepayers – some to the tune of £100.

One of Livingstone's predecessors, Sir Horace Cutler, was quick to stick the knife in further. 'Mr Ken Livingstone and his supporters should resign in light of the Law Lords ruling … . They have no mandate to govern London,' he ranted. 'They must resign. No other course, honourable or otherwise, is open to them.'[7] Passengers were warned of 'chaos ahead'[8] as transport chiefs attempted to unscramble the cut-price policy and balance the books again. There would be more upset when, as a result of the ruling, fares swung disproportionately in the other direction. On 21 March 1982, a ninety-six per cent fare increase was announced. The underground braced itself for passenger dissent and even assaults on staff, but as the press reported, 'British people like a good moan, but they aren't going to break the law.'[9] A planned protest flopped, with only a few hundred travellers across the network refusing to pay the newly inflated fares. Londoners were clearly too jaded by this point to care, so, they coughed up and got on with their journeys.

There were, however, some benefits to the fares debacle. We have the legacy of 'Fares Fair' to thank for the principle of fare zones, which despite growing and changing shape over the years, remain a strong feature of the underground's pricing strategy. The policy also allowed for the introduction of the Travelcard ('Capitalcard' before 1989) – which was popular with commuters travelling in from outside of London who needed to use a combination of overground, underground and bus travel – and eventually the Oyster card, a contactless value-loaded smart card which was introduced in 2003. By 2012, over 43 million Oyster cards

Fares Fair in Love and War 161

had been issued and more than eighty per cent of all journeys on public transport in London were made using the card. Incredibly, the idea of the Travelcard and its offspring the Oyster, have their roots in Charles Yerkes's turn-of-the-century Tube – although the technology needed to make the idea an efficient and speedy reality would take many decades to catch up. Economically, the proposal seemed to make no business sense to successive cash-strapped London Transport managements, yet once implemented, the increase in overall usage over time was significant, meaning the network was eventually able to dig itself out of a hole.

The new fare zones also meant new maps and diagrams, and the first to appear was used on the doomed 'Fares Fair' promotional material in 1981. The panel poster includes the network Diagram and the two proposed zones – the West End zone shaded in yellow, and the City zone in blue. It also includes the strapline 'Going places'. Sadly, the only place 'Fares Fair' was going was the law courts, but at least it introduced the idea of zones to London's travelling public – something they would need to get used to if they were to successfully decipher London Transport's diagrams from 1981 onwards.

Initially, the diagrams of the early 1980s – which were still credited to Paul Garbutt, despite his retirement in 1978 – included the zonal areas in a separate box out. This either appeared alongside the Diagram on the 1983 quad royal version, or on the reverse of the pocket map, which was published the same year. With only two zones to accommodate, this was a straightforward approach and meant the grid lines and accompanying index of stations could be retained. However, over the years, the introduction of a further four fare zones and a mass of competing information made the Diagram redolent of the District and Metropolitan information-laden maps from 100 years earlier. Then the excuse had been a game of cartographic one upmanship, but this time the only people London Transport needed to impress were its passengers, and in terms of its maps, it wasn't doing a particularly good job.

Alongside the long-serving Garbutt, some new(er) faces, or rather names, were beginning to surface on the Diagram. Tim Demuth joined the London Transport publicity office in 1971 and on Garbutt's retirement became responsible for maps, timetables and posters – producing a new central area Diagram in 1979 for display inside the trains. The same Diagram was used for a board game called *The London*

162 The History of the London Underground Map

Game, which promised a 'train load of fun', according to a magazine advertisement. The game's creators must have been familiar with the underground's history as one of the aims of the game was to deliberately block the progress of others, which seems entirely in the spirit of the early clashes between the Metropolitan and District railways. Demuth was also responsible for the maps that featured inside the *London Connections* leaflet, which detailed rail, underground and bus travel around London, and accompanied Capitalcard tickets which were first used in 1985. In the same year, information design agency FWT, under Doug Rose, was brought in to redesign the Diagram – which by now included both the Jubilee line and the Heathrow extension to the Piccadilly line, which opened in 1977 – the world's first direct link between a major airport and a capital city centre.

By the mid-1980s the GLC's days were numbered. Having spent several years wrangling over fares, investment in the long-term infrastructure needs of the network had yet again been overlooked. However, it had managed to bring about a new line, a new extension, and a new ticket. The fares fiasco was eventually ironed out by the 'balanced plan' – a pricing policy put forward by the GLC in late 1982 in order to strike a compromise between the needs of the travelling public and the ratepayers who would be subsidising them. A twenty-five per cent reduction in fares was implemented by London Transport in May 1983, meaning the fares had now come full circle and were back at the same rates as two years earlier when Livingstone had become leader.

Watching all of this with exasperation from her Westminster eyrie was Prime Minister Margaret Thatcher, who took a particularly dim view of proceedings across the Thames. Thatcher had fought and won the 1983 General Election on the basis that the GLC would be disbanded to cut bureaucracy and increase efficiency – along with six other Labour-led metropolitan county councils. It was controversial, but Maggie got her wish and at midnight on 31 March 1986 the GLC ceased to exist. In its final hours, the GLC festooned its offices at County Hall with a banner claiming 'We'll meet again', which was mirrored on the badges of the 250,000 people who gathered on London's South Bank to bid the council farewell. Ken Livingstone declared defiantly, 'This is an interruption till normal services are restored after the next General Election.'[10] He waited fourteen long years but eventually fulfilled his own

Fares Fair in Love and War 163

prediction – becoming Mayor of London in 2000 and leading the new Greater London Authority, which was established as a devolved body in the same year.

The cessation of the GLC in 1986 meant its constituent parts were distributed across an assortment of obscure non-departmental bodies and the underground, along with the buses, became the responsibility of London Regional Transport. This didn't solve its financial issues, however. Chronic under-investment and the distracting influence of political wrangling was to have grave consequences the following year.

* * *

On the evening of 18 November 1987, a lit match was dropped by a passenger on one of the wooden escalators at King's Cross Underground Station. The resulting fireball shot up the escalator shaft and engulfed the ticket hall within fifteen minutes of the alarm being raised. 'Black smoke poured through the tunnels as panicking crowds, screaming in terror, hammered on trains which rushed past platforms without stopping,'[11] reported the *Daily Mirror*. 'Some tried in vain to pick their way to the surface through choking fumes. Others tried to seal themselves from the furnace-like heat and smoke in the underground rooms, praying for a miracle rescue. Many prayed in vain and perished in the black hell.'[12] Witnesses described the event as 'horrific ... the worst thing I have ever seen in my life.'[13]

Thirty-one people were killed and more than sixty were injured. Less than twenty-four hours after the disaster, a journalist from the *Newcastle Journal* who had been travelling through King's Cross at the time the fire started, returned to the scene:

> Little of the roof remained, most of it brought down by the heat and firefighting efforts. Large amounts of asbestos had been dislodged and confusion persisted yesterday as to whether the area was contaminated or not. Some wore protective face masks, others did not. Makeshift lighting hung from the remains of the roof. The automatic ticket machines were just about the only recognisable fittings. Personal belongings abandoned in the panic and confusion were in plastic bags in one corner.[14]

164 The History of the London Underground Map

London Fire Brigade and the Metropolitan Police spoke of a 'blowtorch effect', which had paralysed the concourse area, incinerating everything in its path.

Questions were raised within hours. There were concerns over the activation of the sprinkler system – which was apparently operated by hand, rather than automatically – and a row over the correct procedures in the event of a fire. Following a major fire at Goodge Street Station in 1981, which killed one passenger and injured sixteen, smoking had finally been banned in 1984 – but even then it was for an experimental period of twelve months rather than permanently. The decision to make the ban permanent was taken out of London Regional Transport's hands when fate intervened in November 1984. A fire at Oxford Circus, which started in a store cupboard, spread to the northbound Victoria line station tunnel. Fortunately, there were no fatalities or major casualties, but 700 passengers had to be escorted from stopped trains in smoke-filled tunnels and £2.5 million of damage was caused, meaning the closure of the Victoria line platforms for three weeks. This resulted in a permanent ban on smoking below ground and a ban on smoking on trains was extended indefinitely. Chairman of London Regional Transport Sir Keith Bright and Managing Director of the Underground Tony Ridley came under intense media scrutiny following the fire and both resigned shortly before the results of the public inquiry were published in November 1988.

The King's Cross fire was the culmination of twenty years of neglect and, according to Christian Wolmar, illustrative of 'everything that had gone wrong with the system in the previous forty years since nationalisation.'[15] The same view was shared by Mr Desmond Fennell QC, chairman of the King's Cross inquiry, whose report contained 'scathing criticism of the Tube's management and 157 recommendations for improving safety'.[16] Much of Fennell's criticism was directed at Ridley and Bright, who were said to have given more attention to economy and efficiency than passenger safety – operating in a 'blind spot'[17] when it came to fire safety, and regarding blazes at stations as inevitable 'smoulderings'[18] that were merely an occupational hazard. This in turn led to staff complacency and a false sense of security regarding the management of fires: 'their overall response may be characterised as uncoordinated, haphazard and untrained',[19] leading to 'a general failure to appreciate the severity of the disaster.'[20] Senior management was accused of suffering from a

'dangerous, blinkered, self-sufficiency'[21] but the whole organisation came under scrutiny. The lit match was only a small part of a bigger catalogue of reasons as to why the fire spread uncontrollably: a build-up of flammable rubbish – including clothes fluff, hair, bits of paper and matches – had been allowed to accumulate under the escalator; understaffed concourses were left unattended for long periods; staff were poorly trained; networks of communication were bad; and there had been a total failure to recognise the gravity of the situation. As the Fennell report summarised with depressing clarity: 'Between 19:30 and 19:45 not one single drop of water had been applied to the fire which erupted into the tube lines ticket hall causing horrendous injuries and killing 31 people.'[22]

The King's Cross fire forced major changes to the managerial structure of London Underground. During the inquiry, Ridley himself pointed to a culture of engineering 'baronies' which meant the underground was run, as it had been since the earliest days of operation, 'by the engineers who had built, developed and maintained it.'[23] The 'barons' sat above an operating department 'seen as being staffed by worthy but less accomplished people'.[24] There was also a lack of departmental collaboration, and even at the highest level, one director was unlikely to trespass on the territory of another.

The shake-up, when it came in late 1988, arrived courtesy of new managing director Denis Tunnicliffe, on whose shoulders sat the responsibility for effecting cultural change. As an outsider coming into the organisation, he was able to make an objective assessment of the legacy he was inheriting. And he was horrified enough by what he found to do something about it. With a background in aviation – specifically British Airways, where he'd worked in the management team – he brought a similar model of customer-led services, inspirational leadership, and teamwork to London Underground.

The fifty-year-old vision of a thoroughly modern network – one that enhanced the city and its inhabitants, rather than undermined them – just needed to be re-imagined. And it would do so in a way that would have been wholly approved of by Frank Pick.

Chapter 25

Out of the Ashes

'Modern art is alive and well – in the London Underground.' Such words wouldn't have sounded out of place in the 1930s London of Pick and Ashfield. Yet these were penned in the red-top *Daily Mirror* in September 1990. The occasion was the promotion of 'Art on the Underground', a pet project of London Underground's marketing director, Texan Dr Henry Fitzhugh.

'Partly they are to fill our empty advertising space,' he told the newspaper. 'But they're also to brighten up the Tube by fine painting. I believe that the originals of these posters will have lasting value. They will still be appreciated in 50 or 100 years' time.'[1] The new approach was straight out of the Frank Pick School of civic harmony, but with one crucial difference – these were not artworks that had to earn their keep by publicising the network. Instead, they were commissioned to be admired and appreciated – although the themes were loosely linked to destinations or leisure activities reached by the underground to give the scheme some consistency. The artworks were also reproduced as posters which could be purchased from London Transport Museum, providing an additional revenue stream.

With the shift in focus from publicity to artistic designs that would improve the passenger environment, the commissioned artists were free from the constraints usually imposed by the marketing department, such as communicating a specific message or 'call to action'. This meant a breadth of work was produced – some easier to interpret than others. Fitzhugh planned for six commissions a year: two 'easy' subjects, two avant-garde, and two somewhere in the middle that would perhaps provoke some thought and engagement. Works such as the languid *Days on the Water* (1989) by Sandra Fisher were self-explanatory, but others were a little more challenging. John Bellany's *Chinatown* (1988) was one of the more controversial pieces and the average traveller would probably have been hard pushed to decipher the cultural references and

Out of the Ashes 167

East versus West power struggle motif it depicts. There is something menacing about the painting, which was originally in oils, and its prescience of a doomed future – portrayed through the fortune teller and her cards.

Overall, the images that endured were those that tapped into a sense of fun. *Tate Gallery by Tube* (1987) by David Booth of agency Fine White Line, was one of the first to be commissioned yet remains to this day one of the best-selling prints of all time. Like the Diagram it is based on, it has become an iconic image in its own right – a network drawn in paint being squeezed, quite literally, from a tube (labelled Pimlico – the nearest station to the Tate Gallery). The three-dimensional work was modelled in plastic and given a glossy finish to create the appearance of freshly squeezed paint before being mounted onto canvas and photographed, thus making it a one-dimensional poster. Unusually for the Art on the Underground programme, it was produced by graphic designers through an agency rather than by a commissioned artist.

Tate Gallery by Tube wasn't the last work to draw inspiration from the Diagram. In the early 1990s, aspiring artist Simon Patterson used the Diagram as the basis for *The Great Bear* (1992), which was an almost identical reproduction of the 1991 map, but with station names substituted for the names of well-known people from the worlds of sport, philosophy, film and theatre, science and Chinese scholars, among others. The resulting artwork encourages the viewer to look for connections among names that range from the obscure (Zog I and Henry the Navigator) to familiar (Audrey Hepburn and Pelé). Associations are created at intersecting points, where two divergent categories collide – so Gary Lineker finds himself among the great and the good – quite literally as he sits on an interchange of elite Italian artists Raphael and Titian, and Saint Francis and Saint Peter. Pythagoras very aptly appears at the triangular intersection of three lines. *The Great Bear* turns the original ethos of the Diagram on its head and subverts our understanding of it as a reliable source of information. Of his own work, Patterson said:

There is no code to be cracked in any of my work. Meanings may not be obvious, you may not get a joke, but nothing is really cryptic – I'm not interested in mystification. I like disrupting something people take as read. I am not simply pulling the rug out from people. I am

168 The History of the London Underground Map

not nihilistic. What interests me is juxtaposing different paths of knowledge to form more than the sum of their parts.[2]

Patterson forces us to look again and question what we see – and what we see, despite the incongruous station names, is Beck's Diagram. It is the quintessential embodiment of a large collection of 'parts' that together form something much greater. *The Great Bear* now resides in the Tate – the storehouse of another impressive collection.

Patterson's decision to use the Diagram as a basis for his work draws on the idea that the urban landscape exists in our minds as a series of intersecting lines and dots. For Patterson, the Diagram

moved on from being an underground map ... as a fixed logical thing, to a meaning that, like music, is in the mind. I started with a map that is to some extent an abstraction of the urban landscape ... the tube stops ... can be seen as stars in a constellation, where you imagine the lines to connect the dots.[3]

The flexibility of the Diagram, and its capacity to grow and adapt along with the city it represents, has inspired numerous interpretations of what it means to traverse the metropolis. Tube maps have hosted their own range of artworks – since 2004 the covers of pocket Tube maps have provided the perfect miniature platform for public art across the network. The programme has seen the network imagined as lines on the palm of a hand (*All My Lines in the Palm of Your Hand* – Michael Landy), a magic carpet (*Fragment of a Magic Carpet, c.1213* – Pae White) and a bird on a branch (*The Central Line* – Tracey Emin).

The Platform for Art programme, of which the Tube map covers are a part, is just one of the ways the underground has restored some of its former reputation as a patron of the arts. Another opportunity, in the best tradition of Frank Pick, came in the 1990s. Following on from the 1980s station renewal programme, which saw individual themed decoration on selected stations (the most notable perhaps being Eduardo Paolozzi's mosaic panels at Tottenham Court Road, Baker Street's Sherlock Holmes profiles and David Gentleman's medieval scenes at Charing Cross), the Jubilee line extension stations became some of the most architecturally impressive developments in the city. 'A return to the

Out of the Ashes 169

heyday of Pick and Ashfield in terms of the grandeur of the stations and the "no expense spared" feel of the scheme,[4] writes Christian Wolmar. Or as Andrew Martin puts it, 'like a man who wears a scruffy tweed jacket, but with expensive trousers and shoes by Armani',[5] recalling the line's older section and its glitzier other half. Stations such as Canary Wharf, Canada Water and North Greenwich are cathedral-like, and take full advantage of the space that was available for the build, which came courtesy of the Docklands regeneration scheme. Once an area of industry and international trade, the wholesale gentrification of the area has seen the creation of a new financial business district for East London.

The Jubilee line extension project also had a hard stop deadline. The creation of a new venue – a sort of exhibition space/entertainment showcase/Festival of Britain-type project which was intended to be a celebration of the new millennium in 2000 was part of the regeneration plan. Conceived by John Major's Conservative Government but completed by Tony Blair's Labour Government, there was always some confusion over the exact function of the Millennium Dome. Described by the *Illustrated London News* as a 'spiny, upturned fruit bowl',[6] the project was controversial from the outset, with most criticism levied at the cost of constructing a building that was widely acknowledged to have a shelf life of only twenty-five years.

'What more cynical monument can there be for this totalitarian cocksure fragile age than a vast temporary plastic bowl, erected from the aggregate contribution of the poor through the National Lottery?'[7] railed MP for Medway Bob Marshall-Andrews in 1998. The general public were not particularly enamoured either. 'I am writing to complain about the Millennium Dome,' wrote one angry reader of the *Hayes & Harlington Gazette*. 'It does not appeal to everyone … . Forty nine per-cent of the people of Britain said they did not want the Dome… . Our education system is seriously underfunded, our national health service a shambles, but we can offer a Millennium Dome costing billions.'[8]

In order for all the disgruntled dome-protesters to make their way to the building that no one seemed to want, it was critical that the Jubilee line extension came in ahead of schedule, or at the very least *on schedule* at the end of 1999.

It made it – just. On 22 December 1999, the extension opened along its entire length at a cost of £3.5 billion – making it £2 billion over budget, a

170 The History of the London Underground Map

financial situation exacerbated by the effort involved in meeting the New Year's Eve deadline. The inflated cost of the project would have further implications for the running of London Underground, as it proved to the government that the network wasn't fit to manage and undertake its own refurbishment programme. To this end, a frankly bizarre and enormously complicated funding scheme was concocted whereby the underground would be part privatised. Responsibility for the infrastructure (track, trains, and signalling) was separated from the day-to-day operational side of the network. The Public Private Partnership (PPP) saw two consortia of engineers, or 'infracos' – Metronet and Tube Lines – contracted to maintain the infrastructure of the underground over thirty years. They would bring with them a long-hoped-for private sector cash injection, and London Underground would retain its status as public sector 'operator'.

The idea should have been sound. Indeed, it looked that way on paper – after all, some parts of the network were approaching their 150th birthday. But its implementation was anything but. In the three years of contractual wrangling (between 2000 and 2003) that it took the government to iron out the details, many of the PPP's aims had been lost. Too much power lay on the side of the infracos to determine how money would be spent; and they were vast sums – £1 billion a year under a thirty-year contract.[9] Despite spending an estimated £500 million[10] on lawyers and consultants, the 2,800-page contract drawn up for the PPP lacked basic information such as how to establish the condition of the existing assets and exactly what improvements were required. Inevitably, this meant more lawyers and more cost to the taxpayer. The former editor of *The Times*, Simon Jenkins, found it 'absurd to have to argue the virtue of public-sector values with a Labour government. I am an enthusiast for most forms of privatisation but this one makes no sense. Further fragmenting ownership and investment in mass transit is stupid.'[11]

Opposition began to emerge, most notably from Labour's Ken Livingstone. Using the political leverage of the PPP lost Livingstone his Labour nomination, but it won him the support of London, and the rebel contender became the first directly elected mayor of London, presiding over the Greater London Authority. It was a spectacular own goal for Labour, since the London mayoralty was Tony Blair's idea – although he didn't expect his nemesis, Livingstone, to be voted in. For Blair, it was a political and personal disaster. 'Three years after he coasted to

Out of the Ashes 171

Downing Street on a chorus of *Things Can Only Get Better*,' wrote the *Sunday Tribune*, 'things could hardly be worse'.[12] Quite.

Livingstone promptly installed American ex-CIA officer Bob Kiley as transport commissioner. It was an unlikely partnership – the old-fashioned socialist and the man from Minneapolis – but together they carved out a new transport executive, Transport for London (TfL) which included just about every mode of transport available in London, including cycling and walking. Then commenced yet more scrapping and bickering, as the government butted heads with TfL. On the day John 'Two Jags' Prescott, Secretary of State for the Environment, Transport and the Regions announced the delivery of the PPP timetable in April 2001, TfL won consent from the High Court for a judicial review of the scheme.

Livingstone's argument was that the PPP would prevent him from running a safe network and would result in an underground that was 'fragmented, inefficient, uneconomic and ... unsafe'.[13] He said that he would be left to 'carry the can' for a system he was responsible for but had no real control over. But this fell flat and three months later Livingstone lost his High Court bid to block the government's plans when Mr Justice Sullivan rejected his application for a judicial review, with a *fait accompli* – that it was for the government, not the mayor, 'to have the last word'.[14]

All this nonsense was to have an end date but not before Metronet went bust in 2007, having failed to meet its spending obligations. A report commissioned in 2009–10 by the Department of Transport into the failure of Metronet, concluded that 'The Department for Transport's oversight and management of the risk on the Metronet contracts were inadequate, especially given that it provided a £1 billion a year grant, was ultimately responsible for delivery and carried the majority of the risk of failure.'[15] But it was the taxpayer who paid the biggest price: 'The loss to the taxpayer arising from Metronet's poor financial control and inadequate corporate governance is some £170 million to £410 million.'[16] The other infraco – Tube Lines – was moderately more successful but once Metronet had gone, its days were numbered. The end came with the signalling project on the Jubilee line. Tube Lines wanted more money to fulfil the project, but the PPP arbiter refused saying it had had more than enough. It probably didn't help the cause when Tube Lines released a statement claiming the amount it was to be granted was not 'conducive

172 The History of the London Underground Map

to private sector involvement'[17] and that London Underground was a 'difficult' client.

'One of the great scandals of the decade is about to come to an end,'[18] announced Christian Wolmar in *The Guardian* in 2009, 'but because of its complexity and arcane nature, it has passed almost unnoticed – even though the man largely responsible for it occupies No 10 Downing Street.'[19] Wolmar was referring to Gordon Brown, the former chancellor of the exchequer and now prime minister following Blair's resignation in 2007. Wolmar's scathing attack of the 'fanciful' scheme is quite clear at whose door the blame should be laid, but 'since no one understands the PPP and its failings, those who devised the scheme – consultants, lawyers, long-gone Underground executives and politicians – will never be brought to account.'[20]

The era of PPP and its many failings was perhaps only overshadowed by the events of 7 July 2005. As London woke up that morning, it was in the knowledge that it was to host the 2012 Olympic Games – the first time the games had been held in Britain since 1948. The previous day, a crowd had amassed in Trafalgar Square to hear the news. Strangers hugged each other and shed genuine tears of joy, as Lord [Sebastian] Coe declared it to be 'a most fantastic opportunity to do everything we ever dreamed of in British sport.'[21] For Blair it was 'a momentous day … it is the greatest capital city in the world and the Olympics will help keep it that way.'[22] The future looked bright for London and the city swelled with a sense of pride, optimism and self-confidence.

All that was to change in the space of fifty seconds. At 8.49am on Thursday 7 July, three bombs were detonated by British Muslim terrorists on the Circle line between Aldgate and Liverpool Street, Edgware Road and Paddington, and on a Piccadilly line train which had just left King's Cross for Russell Square. A fourth bomb was planned to detonate on the Northern line, but the attempt failed, and the suicide bomber left the underground and sought out a bus instead, where he eventually succeeded in exploding his bomb in Tavistock Square at 9.47am.

Reports initially suggested a major power outage, but once injured passengers began to struggle onto platforms the full, horrific details began to emerge. A Metropolitan Police officer who was one of the first on the scene at Edgware Road described how walking down the undamaged part of the train was like

Out of the Ashes 173

walking through an empty train which starts off by being exactly as it was when it left the station that morning… . Then by the time you stop walking you are looking through a window at the end which is black. It is almost like the world (and) the whole train ended at that point. Beyond that was the blast and everybody who had been seriously injured.[23]

A train operator travelling in the opposite direction said the bomb going off was 'like a dull, orange bubble expanding'[24] although he didn't realise what had caused the extraordinary sight: 'It suddenly became completely dark and the train seemed to accelerate away,' he recalled. 'I heard lots of screaming, but I couldn't see a thing. Everything was just black … I could hear someone calling out "help me, help me", and passengers started knocking on my door.'

He knew there had been a serious incident when a colleague banged on his window shouting that people were dead and others were dying. The air was thick with smoke, dust and detritus and the train operators found themselves in charge of the situation; trying to work out what had happened, evacuate their trains as safely as possible, assist injured passengers and raise the alarm for the emergency services.

As part of a set of well-rehearsed emergency plans, all underground services were immediately suspended as well as the Zone 1 bus network, and motorists on all major roads into London, including the M25, were warned to 'Avoid London, Area Closed'. Those who were able to walk with their injuries emerged at Aldgate, Edgware Road, Russell Square and King's Cross stations, where platforms and ticket halls were hastily converted into casualty clearing stations. The seriously injured were carried out by staff and police, with some reports suggesting that urgent medical operations had taken place on the Liverpool Street concourse.[25]

The Piccadilly line explosion was the most devastating. The train was already overcrowded from earlier delays and the confined space of the deep-level Tube tunnel reflected the blast force, concentrating its effect. This also hampered rescue work and the removal of bodies, even several days following the attack: 'The pace was slow and the approach delicate because the bodies of as many as 20 victims of the Piccadilly Line bomb were still trapped in the wreckage.'[26] It was also delayed by stifling heat, the risk of asbestos and fears over the structural condition

174 The History of the London Underground Map

of the tunnel roof. Most fatalities occurred on the Piccadilly line where twenty-six passengers lost their lives, including the suicide bomber. Six died at Edgware Road and seven at Aldgate. A further thirteen lives were lost above ground when the fourth bomb exploded in Tavistock Square. Fifty-two passengers were killed and over 700 were wounded in what became the worst day in the history of London Underground.

What also emerged were stories of courage, resilience in the face of adversity, and a community spirit that refused to be dimmed by an act of terrorism. What struck many of those involved in the incident was the unexpected kindness of other people. Churches, community buildings and nearby offices threw open their doors to provide shelter and safety to those in shock. Tea rooms were cobbled together by strangers to provide refreshments to victims and rescue workers. Food outlets and supermarkets provided free sandwiches and drinks. Those who couldn't provide practical assistance showed their solidarity in more creative ways. One Londoner decided the best way to defy any further passing terrorists was a simple message printed on a Union Jack towel, draped over a wall opposite Liverpool Street Station. It read: 'Burning with fear? My arse.'[27]

But most importantly for London Underground, the subsequent inquest into the 7 July bombings demonstrated just how far it had come since the devastation of the King's Cross fire in 1987. The ethos of safety first had created a sense of ownership and responsibility. Staff knew what they needed to do and how to manage the situation effectively, despite facing scenes of utter carnage. Alongside the medics, emergency services and passengers, London Underground staff were commended at the coroner's inquest, which reported in May 2011. Lady Justice Hallett remarked that each organisation should be proud of its employees who 'when presented with an uncertain, complex and traumatic set of circumstances did all that they could to ensure that lives were saved.'[28] Peter Hendy, the transport commissioner at the time of the inquest, echoed Lady Justice Hallett's praise:

I want to pay tribute to the TfL staff who were on duty that terrible day, as well to the staff of the emergency services and other transport operators. Their actions were often nothing short of heroic - going above and beyond the call of duty to help and comfort those affected. TfL staff also responded in the best possible way, by

Out of the Ashes 175

getting our transport networks up and running as soon as possible, to demonstrate that Londoners will never be cowed by such attacks, and that the freedoms and tolerance that are such important features of this great city are preserved.[29]

It is perhaps unsurprising that the full, and then part, suspension of Tube services in the days following the attacks led to gridlock in London. The city came to a standstill – not just in shock, but because its very heart had been ripped out. A new respect for London Underground was formed in the aftermath of the bombings, and a long-overdue acknowledgement of its importance in the life of the city – not just as a transport network but of its heritage and character. Six weeks after the bombings, passenger numbers had recovered to their normal levels, and by 2007 the underground recorded one billion passengers in a year for the first time.

The political attitude towards the underground also shifted, with successive governments recognising both the economic and social value of London's transport infrastructure. An unprecedented level of investment has brought about major changes in a short period. The birth of London Overground, from a hodgepodge of suburban lines and the underused East London line, has seen something of a renaissance for large parts of East London, which has had better accessibility and enhanced opportunities for travel since the section opened in 2010. The overground network, which operates an orbital route around the capital, took over the North London Railway routes from Silverlink Metro; the West London line between Willesden Junction and Clapham Junction; and the South London line from Surrey Quays to Clapham Junction. It isn't actually possible to travel the entire loop without changing trains, but the overground allows outer London to be fully connected by using existing railways – the first new 'circular' route since the Circle line opened in 1884. In 2015, the Greater Anglia services that ran between Liverpool Street and Enfield, Chingford and Cheshunt were incorporated, as well as the services operating between Romford and Upminster.

Thameslink has also been revitalised, using the old city widened lines. The route originated as long ago as 1866 with the opening of the London, Chatham & Dover Railway's extension over the River Thames. The route was largely underused but was brought back to life in the late 1980s, until it reached capacity over the following two decades, prompting a programme

176 The History of the London Underground Map

of works to improve the service, starting in late 2007. It is fitting that part of the programme involved upgrade works to one of the oldest stations on the underground network – and ancestral seat of the Metropolitan Railway – Farringdon. The station currently occupies a unique position as it is the only one where the city's two biggest improvement schemes of this millennium will meet. Due to be launched imminently, the east-west route of Crossrail (now known as the Elizabeth line) will run services through Farringdon, with connections to Thameslink, as well as direct connections to three major airports – Heathrow, Gatwick and Luton. The station will also be a hub for cross-London travel, being the only station providing a north-south service via Thameslink and an east-west service through the Elizabeth line. In theory, a passenger could travel in every direction from this original vestige of Charles Pearson's dream – south to Brighton, north to Bedford and Peterborough, west to Reading and east to Shenfield. Since Pearson lobbied hard for a central station at Farringdon, it is safe to assume that he would have wholly approved of the new scheme. Edward Watkin may not have been so enamoured, however. His arch-rival James Staats Forbes was chairman of the London, Chatham & Dover Railway at the height of their long-standing feud, and this is one of the lines that became Thameslink. Would Watkin have allowed a Thameslink interchange at Farringdon? Perhaps not given his previous form, but he would certainly have approved of the ambition of the Elizabeth line, stretching out into the Berkshire and Essex commuter belts. Trial running began on the Elizabeth line in 2021, with full service on the line predicted for spring 2023.

There is one further person who would have approved of the Elizabeth line – well, of its route colour anyway – and that is Harry Beck. The shade of purple he chose for the Victoria line on his final draft of the Diagram may not have passed muster in 1964, despite its royal connotations, but it was deemed entirely appropriate for the newest addition to the capital's transport network – and thoroughly befitting of a line named in honour of Victoria's great-great granddaughter. Her Majesty even wore the same shade of purple for the unveiling of the new name in 2016 – so it obviously had royal approval. Being a thoroughly modern monarch, she may even have had an Oyster card stashed in that ubiquitous black handbag of hers.

Chapter 26

Breaking Beck's Rules

Would Beck have approved of TfL's current Journey Planner? Maxwell Roberts, map designer extraordinaire and expert on all things cartographic doesn't think so. 'I believe that aspects of the design of the current underground map leave a lot to be desired,' he says. The devil, it seems, is in the detail, as he continues:

> Humans have limited cognitive capacity. The more information they are given, the more likely they will make a mistake making use of it. Even if the information is of peripheral importance to the task in hand, it can still get in the way and distract from it. Any given task has a cognitive load associated with it. The higher the cognitive load, the more cognitive capacity required to cope adequately.[1]

You only have to look at TfL's current Tube map to understand and appreciate Roberts's point. He blames it on the psychology:

> Our problem is that there is a creeping malaise in the bureaucracy business, on the one hand a belief that if one piece of information is helpful, ten pieces of information will be ten times as helpful, and on the other hand a fear that if people are not told everything that might possibly be relevant no matter how peripheral to the task, then something terrible might happen.[2]

Roberts calls this 'information pollution' – a creeping up of cartographic features making the map appear overloaded, and therefore much harder to use. The issue lies in the fact that while one feature is helpful to one set of people, it may not be of use to others. A culture of accessibility means the map needs to be all things to all people – so how do designers determine what makes a good map?

178 The History of the London Underground Map

Surprisingly, the answer is not to copy Beck's Diagram. 'There seems to be an assumption made by many people that all a designer has to do is create a map using the same sorts of rules that Henry Beck did seventy-five years ago, and a design masterpiece will magically appear,' Roberts explains.

He is of course referring to Beck's 45 degree horizontal and vertical rules, which the map experts call 'octilinear'. But any mapping rules – be they octilinear (à la Beck's original Diagram), curvilinear (all curves), or horizontal lines with 60 degree diagonals (hexalinear) – will impact on the overall appearance of the design. The topographical landscape also plays a part. Roberts suggests that because different cities are different shapes, one set of design rules may suit one city, but not another. He says:

> Chicago is primarily a rectangular grid, but Cologne almost perfectly fits a concentric circles and spokes design. London is more chaotic but is perhaps more hexalinear than octilinear … the purpose of schematisation is not to use a magic set of design rules, it is about simplifying reality by taking complex twists and turns and streamlining them so that the lines are easier to follow and the user can see how they fit together.[3]

But his advice comes with a word of warning: 'Get the design rules wrong and the entire design process will be a fight and the result disappointing.'[4] And that's not all, because even if the geometry of the map is impeccable, 'serious usability damage will result if excessive poor-quality information is added.'[5] The key is in understanding the user – something Beck did instinctively. Arguably, for a map labelled Journey Planner any information that hinders that process is superfluous.

Roberts understands the challenges faced by any potential London Underground map designer – after all, he speaks from the experience of creating his own designs. From a map depicting the network as concentric circles with spokes and tangents – which subsequently went viral on the internet, despite Roberts intending it as a cartographic joke – to a multi-angle map which eliminates unnecessary corners and comprises eighteen different angles ('not for the fainthearted,' he says). He has dedicated a career to exploring schematic maps and the interface between map and user. For Roberts, his curvy map best represents what might be possible if

we set aside Beck's rules. For would-be transit map designers, his advice is simple: 'The goal is simplicity,' he writes in his book, *Underground Maps Unravelled*. 'A well-designed schematic will maximise this.'[6]

It all sounds straightforward – but is it? Roberts says that the complex nature of London the city is its biggest stumbling block – and as the network grows, so too does the complexity. Beck only had a fraction of the routes, stations, and passenger information to consider. There were no ticketing zones, Docklands Light Railway or Jubilee line, and no step-free access or anything remotely resembling an accessibility symbol. The underground map designers of today are grappling with almost 200 additional stations, all of which need to be crammed into the same paper dimensions that Beck worked with in 1933. Thus, the task of creating clear, usable, and aesthetically pleasing maps has become more difficult.

The solutions so far have radically transformed the look of the Diagram – although Beck is still in there somewhere, he's just been buried under a plethora of information. As Roberts points out: 'With each addition to the map, the designers have stuck with the 2001 version and just added and added to it, rather than drawing it again from scratch. The current version is unbalanced, has complex line trajectories and strange geographical distortions. The map fails by every serious metric of effectiveness.'[7]

The Tube map may be iconic, but that accolade may not extend to recent incarnations, or to those to come. 'Future developments will tax the ingenuity of designers further,' says Roberts, 'but initial attempts to incorporate them lack the simplicity and elegance of Beck's early work. Is this inevitable? Should designers pay more attention to optimising their maps, or should they be looking for fresh approaches?'[8]

Born-and-bred Londoner and expert design consultant Mark Noad took up the 'fresh-approach' gauntlet in 2011. He agrees with Roberts regarding the most recent versions of the Tube map. 'The current version still looks similar to his [Beck's] original work but, although it follows the same principles, these have not been applied with any great care,'[9] he says. 'If Harry Beck saw the current Diagram, I don't think he would be happy to put his name to it. Newer lines have been shoehorned in with stations pushed and pulled around in what seems more of a space-filling exercise than an attempt to communicate clearly and effectively.'[10]

Noad's response was to create a map that reflected the geographic relationships of the stations to each other, and to London as a whole, but

180 The History of the London Underground Map

remained mindful of usability and ease of interpretation. His approach took the principles of map creation all the way back to the early examples of the Metropolitan and District railways. 'To plot the position of the stations, I used a combination of true geographic representations of the system found online, Google maps, and a battered old copy of the *London A-to-Z* street atlas,' he says.[11] It sounds simple, but as many a would-be cartographer has discovered, that simplicity often belies a geographic complexity that is, at times, impossible to capture legibly on paper or screen.

Noad then established the angles and created a grid, using the central area as a starting point. The map uses sinuous 60 and 30 degree lines, as well as the familiar vertical and horizontal lines – just one more angle than Beck's Diagram. But like Beck's geographical distortions, Noad has obscured the truth to some extent: 'The lines do not follow all the actual twists and turns,' he says. 'These have been drawn to make navigating between the stations as simple as possible.'[12] From his initial sketches, it took just under a year to launch the new 'Tubemap' online.

The response was mixed, with some users welcoming the new geographical approach and some firmly in the 'don't mess with a design classic' camp. In fact, it was the catalyst for an entirely new debate over semantics. Respected typographer and art historian Erik Spiekermann pointed to the 'common misunderstanding' over what makes a diagram a map and vice versa. Spiekermann's design credentials extend to the Berlin U and S-Bahn transit systems – which he says 'owe a lot to Beck'[13] – so it's clear whose side he is on. As far as Spiekermann is concerned, mixing the two concepts of geographical accuracy and network connections is a cardinal sin.

Claire Dobbin, author of *London Underground Maps: Art, Design and Cartography* is pragmatic when it comes to this linguistic sidestep. 'It's a diagrammatic map,' she says. 'It functions as a map – London's travelling public uses it to plan and execute journeys from A to B. It just uses a diagrammatic form of representation.'[14] Noad's response to the debate was succinct and, arguably, spot on: 'The semantic debate is a bit of a distraction.'[15]

Distraction it may be, but it does raise an important point. The Diagram only needs to be fundamentally useful to one set of users – the passengers. And what do the passengers overwhelmingly refer to the Diagram as?

The Tube map. They use it to make a journey, therefore in their minds, it is a map. Even TfL refers to it as the Tube map, because it's more user friendly. The argument about what we call it is, really, a meaningless one.

What is clear is the strength of the 'Tube map' subculture. There's a whole gamut of designers throwing their hat into the redesign ring – some have attempted to do it themselves for the purposes of experimentation, others confess to being transit map obsessives. All are repeating the same refrain – that the current map is distinctly average. Paris-based architect Jug Cerovic moonlights as a mapmaker. He also feels that the current Tube map isn't fit for purpose:

> The London underground map used to be an outstanding artwork, an iconic 20th century design that has set the standard for schematic mapping worldwide. Unfortunately, numerous additions and tweaks to the map over the years have altered its original neatness and consistency and downgraded it to the status of an average diagram.[16]

His proposal is ambitious. Not content with tackling just the London map, Cerovic is aiming to standardise transit maps around the globe, based on his belief that his design nomenclature could be applied to most, if not all, the world's mass transit systems. 'They are meant to be useful first of all,' Cerovic has said. It is no coincidence then that he hopes to develop a smart phone app, so travellers can access them at the touch of a button. But he also sees their artistic value, adding, 'since they are also visually pleasant you can also hang them on a wall or send them as a postcard.'[17]

There has been one sticking point for Cerovic in the design process – something Beck would empathise with – and that is recognition. City governments were slow to adopt his map as the 'official' version of their network. The Belgrade-born Cerovic blames bureaucratic red tape and the cult of the 'sacred cow', which allows administrative bodies to monopolise a design and, in many cases, spoil its integrity, without considering alternatives. Happily, Cerovic's hard work has now been recognised and several cities and institutions are now using his maps as 'official' versions, including Luxembourg, Utrecht, Belgrade, Seoul-Naver and most recently, Riyadh.

Unofficial – but no less professional – versions of the Tube map are rife. A passenger must only look online or on a smartphone app store to

182 The History of the London Underground Map

see the numerous alternatives that are now available. These 'unofficial' versions operate underground – no pun intended – with no affiliation or approval from TfL. Copyright of the official Journey Planner – sorry *Tube map* – is closely guarded and to infringe on it would be tantamount to throwing oneself under the proverbial (Routemaster) bus. Nevertheless many alternatives exist. Some have even been hailed as an improvement. This sacrilegious compliment was directed at a mystery designer from Hong Kong who goes by the name of 'SameBoat'. The anonymous designer's efforts were hailed by urban geography website *CityMetric* as 'far better than the real thing',[18] and by the *Independent* as 'more useful than the official one'.[19]

In addition to the redesigns are the artistic re-imaginings. Part of the appeal of the original Beck Diagram is its aesthetics. As well as being a navigational tool, it is one of the greatest visual designs of the twentieth century – an image that is so strong, it resides not only in the public's imagination, but in museums and art galleries too. Beck's original 1931 notebook sketch is on display at the Victoria and Albert Museum in South Kensington, and he also has a gallery named after him in the London Transport Museum in Covent Garden, which is also the custodian of just about every version of the underground's various maps from 1863, to Beck and beyond.

That it inspires new works of art is unsurprising. From abstract pieces, such as those by photographer Nick Saltmarsh, who takes a minute section of the Diagram and magnifies it to obscure its context (although he himself readily admits, 'I'm not sure how successful this has been – of course, once you know the context, it's almost impossible not to see it'),[20] to Anna Burles's *Storylines* (2013), which transforms the Diagram into a journey through literature, with individual routes posing as genres. Under Burles's hand, the Northern line becomes, somewhat aptly, the Horror line, and the Bakerloo becomes the Crime and Mystery line – any other genre would have been, frankly, a travesty. Burles wasn't the only artist to use the 'hook' of the Tube's 150th birthday celebrations in 2013 to adapt the Diagram. Duncan Titmarsh, the UK's only certified LEGO professional, was responsible for creating five different 'maps' from the Tube's 150-year history, including Beck's, in LEGO, as part of the anniversary events. No doubt it was as painstaking a task constructing the Diagram in tiny bricks as it was for Beck drawing it in 1931. It was

all in the name of fun, however, with *Londonist*'s Matt Brown describing it as a 'geek dream made real',[21] and *BuzzFeed*'s Sam Parker announcing, 'Small plastic bricks used in latest attempt to make London commute less harrowing.'[22]

There is perhaps a universal truth in Parker's words – after all Beck's Diagram brought coherence to a system that was both complex and baffling to many of its users. That he managed to print it onto the minds of millions is testament to its enduring appeal. Passengers may use the underground to navigate the city, but the Diagram is used to make sense of it – even though that reality is borne out of geographical inaccuracy. And if the mental sat-nav fails, there's a 'Tube map' app in our pocket to show us the nearest station.

Concorde may have beaten Beck's Diagram as the nation's favourite design in the BBC's Great British Design Quest in 2006, but which is the real winner? The defunct supersonic jet or the free Diagram that's still getting us to where we want to be more than ninety years later?

My money's on the Diagram.

Notes

Introduction
1. TfL (2021) *Keeping London Moving Safely: Annual Report and Statement of Accounts.* Available at https://tfl.gov.uk/corporate/publications-and-reports/annual-report [Accessed 6 December 2021]
2. Correct as of February 2022, Source: TfL https://tfl.gov.uk/corporate/about-tfl/what-we-do#on-this-page-1

Chapter 1
1. *The Clerkenwell News,* 4 December 1861
2. *Ibid*
3. *The Daily News,* 1 December 1862
4. Hawthorne, N. 'Up The Thames', *The Atlantic,* May 1863
5. *Ibid*
6. Bobrick, Benson (1981), cited in Pike, David, 'The Greatest Wonder of the World: Brunel's Tunnel and the Meanings of Underground London,' *Victorian Literature and Culture,* Vol 33, No. 2, (2005)
7. *The Clerkenwell News,* 4 December 1861
8. *Ibid*
9. Madox Ford, F. (1905), *The Soul of London: A Survey of a Modern City,* Alston Rivers, London
10. Ackroyd, P. (2001), *London: The Biography,* Vintage Books, London
11. Flanders, J. (2012), *The Victorian City: Everyday Life in Dickens' London,* Atlantic Books, London
12. Dickens, C. (1903), *Sketches by Boz: Illustrative of Every-Day Life and Every-Day People (1836),* Chapman and Hall, London
13. *Ibid*

Chapter 2
1. Robins, M. (2004), *Pearson, Charles – Oxford Dictionary of National Biography*
2. Wolmar, C. (2005), *The Subterranean Railway: How the London Underground was Built and How it Changed the City Forever,* Atlantic Books, London
3. *Ibid*
4. *Ibid*
5. Commons Select Committee on Metropolitan Communications, 1854–5, question 1345. Cited in Wolmar
6. *Ibid*
7. Martin, A. (2012), *Underground, Overground: A Passenger's History of the Tube.* Profile Books, London

Notes 185

8. *House of Lords Record Office, I. K. Brunel's Evidence*, 30 May 1854. Cited in Halliday, S. (2004), *Underground to Everywhere: London's Underground Railway in the Life of the Capital*, Sutton Publishing, Gloucestershire
9. *Ibid*
10. *Report from Select Committee on Metropolitan Communications*, 23 July 1855. Cited in Halliday
11. *Ibid*
12. *Ibid*

Chapter 3
1. Pedroche, B. (2013), *Working the London Underground From 1863 to 2013*, The History Press, Gloucestershire
2. Hollingshead, J. (1862), *Underground London*. Groombridge & Son, London
3. The *Illustrated London News*, 13 September 1862
4. *Ibid*
5. *Ibid*
6. *Ibid*
7. *London Daily News*, 1 September 1862
8. *Ibid*
9. *Ibid*
10. *Ibid*
11. *Ibid*
12. *London Evening Standard*, 4 August 1862
13. *The Clerkenwell News*, 13 August 1862
14. *Ibid*
15. *Bedfordshire Mercury*, 20 December 1862
16. The *Illustrated London News*, 17 January 1863
17. *Ibid*
18. *The Times*, 30 November 1861
19. *The Times*, 10 January 1863
20. Green, O. (2019), *London's Underground: The Story of the Tube*, White Lion Publishing, London
21. Mayhew, H. (1865), *The Shops and Companies of London and the Trades and Manufactories of Great Britain*, London
22. Williams, Watkin (1863), *The Underground Railway*. B Williams, London

Chapter 4
1. *The Times*, 7 October 1884.
2. Parliamentary Papers, 1898, vol 45. Cited in in Halliday
3. Parliamentary Papers, 1863, vol 8, p.iv
4. *Morning Advertiser*, 3 July 1871
5. *Ibid*

Chapter 5
1. *London Evening Standard*, 28 February 1888
2. Hornsey, R. (2012), 'Listening to the Tube Map: Rhythm and the Historiography of Urban Map Use', *Environment and Planning D: Society and Space*. Vol 30, Issue 4, pp 675-693

186 The History of the London Underground Map

3. Ackroyd
4. Madox Ford

Chapter 6
1. *The Irish Times*, 31 May 1887
2. *Ibid*
3. *Bath Chronicle and Weekly Gazette*, 12 May 1887

Chapter 7
1. Zola, E. (2008), *The Ladies' Paradise*, Oxford World Classics, Oxford
2. Jane, F. T. (1892), 'Round the Underground on an Engine', *The English Illustrated Magazine*, 1892–1893: Vol 10, pp 787-792
3. *Ibid*
4. *Ibid*
5. *Ibid*
6. *Birmingham Daily Post*, 30 October 1890
7. *Ibid*
8. *Ibid*
9. *Ibid*
10. *Ibid*
11. *Punch*, Vol 80, 30 April 1881
12. *Punch*, Vol 88, 17 January 1885

Chapter 8
1. *Tamworth Herald*, 13 August 1898
2. *Shoreditch Observer*, 23 August 1900
3. Heffer, S. (2018), *The Age of Decadence: Britain 1880 to 1914*, Windmill Books, London
4. *Daily Mail*, 30 July 1900
5. *The Globe*, 9 August 1900
6. *Ibid*
7. *Shoreditch Observer*, 23 August 1900
8. *Dundee Evening Telegraph*, 18 August 1900
9. Hattersley, R. (2004), *The Edwardians: Biography of the Edwardian Age*, Little, Brown, London
10. *The Times*, 7 June 1901

Chapter 9
1. 'Concerning Mr. C. T. Yerkes', *The Bystander*, 31 May 1905
2. *Weekly Journal*, 6 March 1903
3. *Bath Chronicle and Weekly Gazette*, 28 January 1904
4. *Ibid*
5. *Ibid*
6. *Ibid*
7. *Ibid*
8. *Ibid*
9. *Ibid*
10. *Ibid*

Notes 187

11. *London Daily Telegraph and Courier,* 29 January 1904
12. *Ibid*
13. *Illustrated London News,* 30 January 1904
14. *Saturday Review* Vol 97, 30 January 1904
15. *New York Times,* 27 January 1904

Chapter 10

1. *Berkshire Chronicle,* 21 January 1905
2. *Ibid*
3. *Ibid*
4. *Railway Times,* 28 October 1905. Cited in Bownes, D., Green, O., and Mullins, S. (2012) *Underground: How the Tube Shaped London,* Allen Lane, London
5. Frosterus, S. (1903), *London Rhapsody.* Cited in Allen, R. (ed) (1998), *The Moving Pageant: A Literary Sourcebook on London Street-Life, 1700–1914,* Routledge, London
6. Green, *London's Underground*

Chapter 11

1. *Hampshire Advertiser,* 17 March 1917
2. Relative value, calculated via Measuring Worth (www.measuringworth.com)
3. Pevsner, N. (1968), *Art, Architecture and Design: Victorian and After,* Walker & Company
4. Kellet, J. (1969), *The Impact of Railways on Victorian Cities.* Routledge, London
5. *The Times,* 10 November 1941
6. Edwards, D. and Pigram, R. (1986), *London's Underground Suburbs,* Baton Transport p 12
7. Bownes, Green, Mullins
8. *The Globe,* 28 May 1910

Chapter 12

1. *The Globe,* 26 March 1914
2. Walker, C. (2014), *Gill, Leslie MacDonald (Max) - Oxford Dictionary of National Biography.* [Viewed: 2 December 2020] https://doi.org/10.1093/ref:odnb/107133
3. *Daily Sketch,* 21 March 1914
4. Underground Poster; France, A. (1911), *Underground – The Way For All*
5. Underground Poster; unknown artist (1913), *The Popular Service Suits All Taste.*
6. Underground Poster; Brangwyn, F. (1914), *War – To Arms Citizens of the Empire*
7. Underground Poster; Warbis Brothers (1915), *Why Bother About the Germans Invading the Country?*

Chapter 13

1. *Metro-land Guidebook* (1924), Published by the Metropolitan Railway.
2. Owen, W. (1917), *Anthem for Doomed Youth,* in Ferguson, M., Salter, M. J. and Stallworthy, J. (eds) *The Norton Anthology of Poetry* (1996), New York, W. W. Norton
3. The National Archives. *Deaths in the First and Second World Wars.* [Online]. [Accessed 11 December 2020] Available from: https://www.nationalarchives.gov. uk/help-with-your-research/research-guides/deaths-first-and-second-world-wars/
4. Laurie, L. (1959), *Cider with Rosie,* Penguin, London
5. *Ibid*

188 The History of the London Underground Map

6. Halliday, *Underground to Everywhere*
7. *Marylebone Mercury,* 29 May 1915
8. *Ibid*
9. *Ibid*
10. *Pall Mall Gazette,* 3 September 1919
11. *Ibid*
12. *Ibid*
13. *Metro-land Guidebook*
14. *Ibid*
15. Ruislip House Advertisement, 1935
16. *The Times,* 6 January 2007
17. Betjeman, J. (1989), *Summoned by Bells,* John Murray, London
18. Wilson, A. N. (2006), *After the Victorians,* Arrow Books, London
19. Rowley, T. (2006), *The English Landscape in the Twentieth Century.* Hambledon Continuum, London
20. *Uxbridge and West Drayton Gazette,* 6 November 1925
21. *Ibid*
22. Worsley, G. (2002), *England's Lost Houses: From the Archives of Country Life,* Aurum Press, London

Chapter 14
1. Bownes, Green, Mullins
2. Rasmussen, S. E. (1934), *London: The Unique City,* Jonathan Cape, London
3. *The Sphere,* 15 December 1928
4. *Illustrated London News,* 15 December 1928
5. *Ibid*
6. *Westminster Gazette,* 26 July 1922
7. Graves, R., and Hodge, A. (1940), *The Long Week-End.* Faber and Faber, London
8. *Architectural Review,* 1929
9. *Westminster & Pimlico News,* 24 September 1926
10. *Ibid*
11. *Ibid*
12. Edwards, Pigram
13. Willoughby, H. R. (1923), 'Art and Advertising: London Underground Railways' Publicity Service', *The American Magazine of Art,* Vol 14, No 8 pp 441-447
14. *Ibid*
15. Green, O. (1990), *Underground Art,* Studio Vista, London
16. *Ibid*
17. Ackroyd
18. Leadbeater, C. (2009), *Who Stole the River Thames From the London Tube Map?* [Viewed: 28 January 2021] travelblog.dailymail.co.uk/2009/09/who-stole-the-river-thames-from-the-london-tube-map.html
19. Mail Online (2009), *Boris Johnson puts Thames back on London Underground map after outrage over redesign.* [Viewed: 28 January 2021] www.dailymail.co.uk/news/article-1213932/Boris-Johnson-puts-Thames-London-Underground-map-outrage-redesign.html

Notes 189

Chapter 15

1. *2LO London,* 'Mr Gerald Barry: A Review of the Year', 31 December 1929
2. *Ibid*
3. *Ibid*
4. Carrington, N. (1930), 'Need Our Cities be Ugly?' *Listener,* 22 January 1930. Cited in Welsh, D. (2010), *Underground Writing: The London Tube from George Gissing to Virginia Woolf,* Liverpool University Press, Liverpool
5. *Daily Mirror,* 29 March 1929
6. *Belfast News-letter,* 17 January 1929
7. *Sheffield Independent,* 2 July 1929
8. *Dundee Courier,* 28 May 1929
9. *Ibid*
10. *Sheffield Independent,* 2 July 1929
11. *Westminster Gazette,* 20 October 1925
12. *The Courier,* 20 October 1925
13. *Ibid*
14. *The Lancashire Daily Post,* 14 November 1925
15. *Ibid*
16. Cook, W. (2017), *The Endless Influence of the Bauhaus,* [Viewed: 5 February 2021] www.bbc.com/culture/article/20171109-the-endless-influence-of-the-bauhaus
17. Ovenden, M. (2013), *London Underground by Design,* Penguin, London
18. Huxley, A. (1932), *Brave New World,* Vintage Books, London
19. Howell, D. (2011), *Morrison, Herbert Stanley, Baron Morrison of Lambeth – Oxford Dictionary of National Biography.* [Viewed 8 February 2021] https://doi.org/10.1093/ref:odnb/35121
20. *Ibid*
21. Wolmar, *Subterranean*
22. *The Yorkshire Post,* 1 July 1933
23. *The Lancashire Daily Post,* 1 July 1933
24. *Ibid*
25. *The Yorkshire Post,* 1 July 1933

Chapter 16

1. Woolf, V. (2000), *The Waves,* Wordsworth Editions, Hertfordshire
2. *Ibid*
3. Baigent, E. (2007), *Beck, Henry Charles [Harry] – Oxford Dictionary of National Biography.* [Viewed 10 February 2021] https://doi.org/10.1093/ref:odnb/52164
4. Glancey, J. (2015), *The London Underground map: The Design that Shaped a City – BBC Culture.* [Viewed 11 February 2021] https://www.bbc.com/culture/article/20150720-the-london-underground-map-the-design-that-shaped-a-city
5. Gießmann, S. (2013), 'Henry Charles Beck, Material Culture and the London Tube Map of 1933', *Amodern 2: Network Archaeology,* October 2013
6. *Ibid*
7. Vertesi, J. (2008), 'Mind the Gap: The London Underground Map and Users' Representations of Urban Space', *Social Studies of Science.* Vol 38, Issue 1 pp 7-33
8. Gaiman, N. (1996), *Neverwhere,* BBC Books, London
9. Beanland, C. (2011), *Rethinking the Tube Map: A Design For Strife – The Independent.* [Viewed 11 June 2020] https://www.independent.co.uk/news/uk/this-britain/rethinking-tube-map-design-strife-2337609.html

190 The History of the London Underground Map

10. *London Tubemap*, Mark Noad Design. [Viewed 16 February 2021] http://www.therightidea.co.uk/london-tubemap.html
11. Hadlaw, J. (2003), 'The London Underground Map: Imagining Modern Time and Space', *Design Issues*, Vol 19, No 1, pp 25-35
12. Pike, D. (2002), 'Modernist Space and the Transformation of the London Underground,' in Gilbert, P. K. (eds) (2002), *Imagined Londons*, State University of New York Press, Albany, pp 101-119
13. *Ibid*
14. Martin, *Underground, Overground.*
15. Hadlaw

Chapter 17
1. Pick, F. (1926), 'Design in Cities,' in Gloag, J. (eds) *Design in Everyday Life and Things. The Yearbook of the Design & Industries Association 1925–7*, London, pp 47-8
2. Frank Pick 'The Organisation of Transport,' *Journal of the Royal Society of Arts*. Vol LXXXIV, 3 January 1936, pp 207-21. Cited in Bownes, D. and Green, O. (eds) (2008), *London Transport Posters: A Century of Art and Design*, Lund Humphries, Aldershot
3. Green, O. (2013), *Frank Pick's London: Art, Design and the Modern City*, V&A, London
4. Hadlaw
5. *Ibid*
6. Overy, R. (2009), *The Morbid Age: Britain and the Crisis of Civilisation, 1919–1939*, Allen Lane, London
7. *Ibid*
8. Orwell, G. (1939), *Coming Up for Air*, Penguin, London
9. Priestley, J. B. (2012), *English Journey: Special Anniversary Edition*, Ilkley, Great Northern Books
10. Barman, C. (1979), *The Man Who Built London Transport: A Biography of Frank Pick,* David & Charles, Newton Abbot
11. Jackson, A. and Croome, D. (1993), *Rails Through the Clay: A History of London's Tube Railways*, Capital Transport, Middlesex. Cited in Gießmann
12. *Ibid*
13. Bownes and Green, *London Transport Posters*
14. *Ibid*
15. *Ibid*
16. Rye, J. (2006), 'The brilliant and the damned.' *The Spectator*, 21 January 2006
17. *The Sphere*, 16 April 1949
18. Green, O. (2001), *Underground Art: London Transport Posters 1908 to the Present*, Laurence King Publishing, London
19. *Ibid*
20. Barman
21. *Ibid*

Chapter 18
1. London Transport. *Christian Barman 1898–1980.* [Viewed 6 March 2021] https://www.ltmuseum.co.uk/collections/collections-online/people/item/2001-9599
2. David McKenna, 'Obituary – Mr. Christian Barman', *Journal of the Royal Society of Arts*. Vol. 129, No. 5293, December 1980, pp 72-75

Notes 191

3. *Ibid*
4. *Ibid*
5. Ovenden
6. *Ibid*
7. *Ibid*
8. *Ibid*

Chapter 19

1. *The Scotsman*, 28 September 1938
2. *Ibid*
3. *Middlesex County Times*, 2 September 1939
4. *Daily Mirror*, 2 September 1939
5. War Emergency Poster (1939), London Transport
6. *Belfast News-letter*, 9 September 1940
7. *Ibid*
8. *Ibid*
9. *Dundee Courier*, 9 September 1940
10. War Emergency Poster (1940), London Transport
11. Ministry of Information, Home Intelligence Weekly Report, No. 32 7–14 May 1941
12. *South London Press*, 1 October 1940
13. *Belfast News-Letter*, 27 September 1940
14. *Shields Daily News*, 19 September 1940
15. *Ibid*
16. Ministry of Information, Home Intelligence Weekly Report, No. 32. 7-14, May 1941
17. *BBC Radio*, 'The Lively Arts: Henry Moore on his wartime shelter drawings', 9 October 1966
18. *Daily Mirror*, 13 January 1941
19. *The Bradford Observer*, 6 April 1946
20. Barman
21. *Ibid*
22. *Ibid*
23. *Ibid*
24. Green, O, *Frank Pick's London*
25. Rasmussen

Chapter 20

1. Baigent
2. *Illustrated London News*, 5 October 1940
3. *Daily Herald*, I November 1940
4. London Transport Poser; Artist Unknown (1943), *A Word to Women Employees*
5. London Transport Poster; Taylor, F. (1945), *Rehabilitation: It Takes Time*
6. *Liverpool Echo*, 4 February 1947
7. *Ibid*
8. *The Scotsman*, 18 May 1946
9. *Ibid*
10. *The Bradford Observer*, 9 August 1946
11. *Ibid*

192 The History of the London Underground Map

12. *Yorkshire Post and Leeds Mercury,* 16 November 1946
13. *Ibid*
14. Dobbin, C. (2012), *London Underground Maps: Art, Design and Cartography,* Lund Humphries, Farnham
15. *Belfast Telegraph,* 1 January 1948
16. Ibid
17. *The Bradford Observer,* 2 January 1948
18. British Transport Commission Report, *London Transport in 1955.* Cited in Halliday
19. Halliday
20. H. F. Hutchison, 'The policy behind our posters', *London Transport Magazine,* Vol. 1, No. 8, 1947. Cited in Green, O, *London Transport Posters*
21. *Ibid*
22. *London Transport at London's Service* (1947), London Transport

Chapter 21
1. *Norwood News,* 29 April 1960
2. Letter from Dorrit Dekk to Harold Hutchison, 1 May 1961. London Transport Museum Archive, Ref. 2007/1070
3. Dobbin
4. Letter from Harold Hutchison to John Nash, 30 November 1951. London Transport Museum Archive, Ref. 2007/5727
5. Letter from Harold Hutchison to Paul Millichip, 15 April 1958. London Transport Museum Archive, Ref. 2007/5501
6. Dobbin

Chapter 22
1. Barker, T. C. and Robbins, M. (1974), *A History of London Transport: Vol. 2 – The Twentieth Century to 1970,* George Allen & Unwin, London
2. Wolmar
3. *Marylebone Mercury,* 24 August 1962
4. *Ibid*
5. 'British Transport Commission' HC Deb 21 March 1961 vol 637 cc223-343. [Online] [Accessed 13 April 2021] http://hansard.millbanksystems.com/commons/1961/mar/21/british-transport-commission-chairman
6. BBC 'On This Day', *1963: The End of the Line.* [Online] [Accessed 13 April 2021] http://news.bbc.co.uk/onthisday/hi/witness/march/27/newsid_4339000/4339761.stm
7. *The Sphere,* 29 June 1963
8. *The Times Supplement,* on the Centenary of the London Underground, 2 May 1963
9. *Daily Mirror,* 25 May 1963
10. *The Times Supplement,* Centenary, 2 May 1963
11. *Daily Mirror,* 25 May 1963
12. *Ibid,* 2 July 1975
13. *Ibid*
14. *Ibid*
15. McLaren, I. (2016), *Design for Visual Communication 2016.* London College of Communication, London
16. McLaren, I. (1996), 'Harry Beck Would Have Been Amused,' *Baseline: International Typographics Journal,* No. 21

Notes 193

Chapter 23
1. Halliday
2. *Ibid*
3. *Observer,* 9 March 1969
4. *Illustrated London News,* 15 March 1969
5. *Chelsea News and General Advertiser,* 7 March 1969
6. *Ibid*
7. *Ibid*
8. *Ibid*
9. *Ibid*
10. *Daily Mirror,* 4 March 1969
11. *Kensington Post,* 16 March 1989
12. *Ibid*
13. *Aberdeen Press and Journal,* 15 June 1989
14. *Sandwell Evening Mail,* 14 June 1989
15. Ackroyd
16. *Harrow Observer,* 28 October 1975
17. Ibid, 7 February 1975
18. *Daily Mirror,* 13 May 1975
19. *Harrow Observer,* 4 May 1979
20. *Ibid*

Chapter 24
1. *Daily Mirror,* 1 March 1975
2. *Ibid*
3. *Ibid*
4. *Ibid*
5. Bownes, Green, Mullins
6. *Daily Mirror,* 15 October 1981
7. *Liverpool Echo,* 17 December 1981
8. *Daily Mirror,* 18 December 1981
9. *Sunday Mirror,* 28 March 1982
10. *The Guardian,* 1 April 1986
11. *Daily Mirror,* 19 November 1987
12. *Ibid*
13. *Ibid*
14. *Newcastle Journal,* 19 November 1987
15. Wolmar
16. *Dundee Courier,* 11 November 1988
17. Desmond Fennell OBE QC, *Investigation in the King's Cross Underground Fire* (1988), HMSO, London. P 116
18. *Ibid* p 235
19. *Ibid* p 125
20. *Ibid* p 71
21. *Ibid* p 31
22. *Ibid* p 17
23. *Ibid* p 29
24. *Ibid*

194 The History of the London Underground Map

Chapter 25

1. *Daily Mirror,* 20 September 1990
2. Greenberg, S. (1994), 'The Word According to Simon Patterson', *Tate: The Art Magazine,* Issue 4, Winter, p 47
3. *Ibid*
4. Wolmar
5. Martin
6. *Illustrated London News,* 1 December 1999
7. *Sunday Times,* 1 February 1998
8. *Hayes and Harlington Gazette,* 12 May 1999
9. London Assembly (2007) 'A Tale of Two Infracos: The Transport Committee's Review of the PPP', Greater London Authority, London
10. *Ibid*
11. *Evening Standard,* 28 September 2000
12. *The Sunday Tribune,* 30 April 2000
13. *The Guardian,* 30 July 2001
14. *Ibid*
15. *Department for Transport: The failure of Metronet,* Fourteenth Report of Session 2009–10, 22 February 2010, House of Commons Committee of Public Accounts
16. *Ibid*
17. *The Guardian,* 18 December 2009
18. *Ibid*
19. *Ibid*
20. *Ibid*
21. BBC Sport 'London beats Paris to 2012 Olympic Games'. [Online] [Accessed 18 May 2021] http://news.bbc.co.uk/sport1/hi/front_page/4655555.stm
22. *Ibid*
23. Helen William, '7/7 bombings: Met Police officer recalls the horrific scene after the Edgware Road explosion'. *The Independent,* 7 July 2015. [Online] [Accessed 18 May 2021] https://www.independent.co.uk/news/uk/home-news/7-7-bombings-anniversary-london-live-met-police-officer-recalls-horrific-scene-after-edgware-road-explosion-10369935.html
24. '7/7 bombings: Tube driver recalls the moment a bomb exploded yards from his train at Edgware Road'. *The Independent,* 7 July 2015. [Online] [Accessed 18 May 2021] https://www.independent.co.uk/news/uk/home-news/7-7-bombings-london-anniversary-live-tube-driver-recalls-moment-bomb-exploded-yards-his-train-10369731.html
25. *Evening Herald,* 7 July 2005
26. *Irish Independent,* 9 July 2005
27. *Ibid*
28. *Coroners Inquests into the London Bombings of 7 July 2005: Government response to the Report under Rule 43 of the Coroner's Rules 1984* (2011), HM Government
29. Transport for London Press Release, *Transport for London responds to 7/7 Inquest findings.* 6 May 2011 [Online] [Accessed 19 May 2021] https://tfl.gov.uk/info-for/media/press-releases/2011/may/transport-for-london-responds-to-77-inquest-findings

Freepost Plus RTKE-RGRJ-KTTX
Pen & Sword Books Ltd
47 Church Street
BARNSLEY
S70 2AS

✂ DISCOVER MORE ABOUT PEN & SWORD BOOKS

Pen & Sword Books have over 4000 books currently available, our imprints include; Aviation, Naval, Military, Archaeology, Transport, Frontline, Seaforth and the Battleground series, and we cover all periods of history on land, sea and air.

Can we stay in touch? From time to time we'd like to send you our latest catalogues, promotions and special offers by post. If you would prefer not to receive these, please tick this box. ☐

We also think you'd enjoy some of the latest products and offers by post from our trusted partners: companies operating in the clothing, collectables, food & wine, gardening, gadgets & entertainment, health & beauty, household goods, and home interiors categories. If you would like to receive these by post, please tick this box. ☐

We respect your privacy. We use personal information you provide us with to send you information about our products, maintain records and for marketing purposes. For more information explaining how we use your information please see our privacy policy at www.pen-and-sword.co.uk/privacy. You can opt out of our mailing list at any time via our website or by calling 01226 734222.

Mr/Mrs/Ms ..

Address..

Postcode Email address.................................

Website: www.pen-and-sword.co.uk Email: enquiries@pen-and-sword.co.uk
Telephone: 01226 734555 Fax: 01226 734438
Stay in touch: facebook.com/penandswordbooks or follow us on Twitter @penswordbooks

Notes 195

Chapter 26

1. Maxwell Roberts, 'Information Pollution on the Underground Map.' [Online] [Accessed 20 May 2021] http://tubemapcentral.com/writing/webarticles/infopol/infopol.html
2. *Ibid*
3. Personal correspondence with the author, 5 August 2021
4. *Ibid*
5. *Ibid*
6. Roberts, M. (2012), *Underground Maps Unravelled: Explorations in Information Design.* Maxwell J. Roberts, Essex
7. Personal correspondence with the author, 5 August 2021
8. *Ibid*
9. Mark Noad, 'London Tubemap.' [Online] [Accessed 24 May 2021] http://www.therightidea.co.uk/london-tubemap.html
10. *Ibid*
11. *Ibid*
12. *Ibid*
13. Beanland
14. *Ibid*
15. *Ibid*
16. Jug Cerovic, 'Apples To Apples: London Underground Map Update.' [Online] [Accessed 24 May 2021] http://www.inat.fr/map/london-underground-map-update/
17. Hohenadel, K. (2014), One Designer's Ambitious Quest to Standardize the World's Subway Maps – Slate. Viewed 24 May 2021 <https://slate.com/human-interest/2014/04/designer-jug-cerovics-ambitious-quest-to-standardize-the-worlds-subway-maps.html>
18. 'This amateur London Tube map someone posted on Wikipedia is far better than the real thing.' [Online] [Accessed 25 May 2021] https://citymonitor.ai/transport/amateur-london-tube-map-someone-posted-wikipedia-far-better-real-thing-1090
19. Brooks-Pollock, T. (2015), A Tube map of the London Underground that's far more useful than the 'official' one – The Independent. Viewed 25 May 2021 <https://www.independent.co.uk/news/uk/tube-map-london-underground-s-far-more-useful-official-one-10289941.html>
20. Nick Saltmarsh, 'Abstracts underground.' [Online] [Accessed 25 May 2021] https://www.flickr.com/photos/nsalt/albums/72157609547452776
21. Brown, M. (2013), See a Tube map made from LEGO – Londonist. [Viewed 25 May 2021] https://londonist.com/2013/06/see-a-tube-map-made-from-lego
22. Parker, S. (2013), Lego Tube Map Is Delightfully Geeky – BuzzFeed. [Viewed 25 May 2021] https://www.buzzfeed.com/samjparker/lego-tube-map-is-delightfully-geeky

Bibliography

Books

Ackroyd, P. (2001), *London: The Biography*, Vintage Books, London

Allen, R. (ed) (1998), *The Moving Pageant: A Literary Sourcebook on London Street-Life, 1700–1914*, Routledge, London

Barker, T. C., Robbins, M. (1974), *A History of London Transport: Vol. 2 – The Twentieth Century to 1970*, George Allen & Unwin, London

Barman, C. (1979), *The Man Who Built London Transport: A Biography of Frank Pick*, David & Charles, Newton Abbot

Betjeman, J. (1954), *A Few Late Chrysanthemums*, John Murray, London

Betjeman, J. (1989), *Summoned by Bells*, John Murray, London

Bownes, D., Green, O. (eds) (2008), *London Transport Posters: A Century of Art and Design*, Lund Humphries, Aldershot

Bownes, D., Green, O., Mullins, S. (2012), *Underground: How the Tube Shaped London*, Allen Lane, London

Cerovic, J. (2016), *One Metro World*

Dickens, C. (1903), *Sketches by Boz: Illustrative of Every-Day Life and Every-Day People (1836)*, Chapman and Hall, London

Dobbin, C. (2012), *London Underground Maps: Art, Design and Cartography*, Lund Humphries, Farnham

Edwards, D., Pigram, R. (1989), *London's Underground Suburbs*, Bloomsbury, London

Emmerson, A. (2013), *The London Underground*, Shire Publications, Oxford

Engels, F. (1845), *The Condition of the Working Class in 1844*, Otto Wigand, Leipzig

Ferguson, M., Salter, M. J., Stallworthy, J. (eds) (1996), *The Norton Anthology of Poetry*, New York, W. W. Norton

Flanders, J. (2012), *The Victorian City: Everyday Life in Dickens' London*, Atlantic Books, London

Ford Madox Ford. (1905), *The Soul of London: A Survey of a Modern City*, Alston Rivers, London

Gaiman, N. (2005), *Neverwhere*, Headline Review, London

Gilbert, P. K. (ed) (2002), *Imagined Londons*, State University of New York Press, Albany

Gloag, J. (ed) (1927), *Design in Everyday Life and Things. The Yearbook of the Design & Industries Association 1925–7*, London

Graves, R., Hodge, A. (1940), *The Long Week-End*. Faber and Faber, London

Green, O. (1990), *Underground Art: London Transport Posters, 1908 to the Present*, Studio Vista, London

Green, O. (2013), *Frank Pick's London: Art, Design and the Modern City*. V&A, London

Green, O. (2019), *London's Underground: The Story of the Tube*, White Lion Publishing, London

Bibliography 197

Halliday, S. (2004), *Underground to Everywhere: London's Underground Railway in the Life of the Capital*, Sutton Publishing Limited, Gloucestershire

Hattersley, R. (2004), *The Edwardians: Biography of the Edwardian Age*. Little, Brown, London

Heffer, S. (2017), *The Age of Decadence: Britain 1880 to 1914*, Random House, London

Hollingshead, J. (1862), *Underground London*, Groombridge & Son, London

Huxley, A. (1932), *Brave New World*, Vintage Books, London

Jackson, A., Croome, D. (1993), *Rails Through the Clay: A History of London's Tube Railways*, Capital Transport, Middlesex

Kellet, J. (1969), *The Impact of Railways on Victorian Cities*, Routledge, London

Laurie, L. (1959), *Cider with Rosie*, Penguin, London

Martin, A. (2012), *Underground, Overground: A Passenger's History of the Tube*, Profile Books, London

McLaren, I. (2016), *Design for Visual Communication 2016*, London College of Communication, London

Mayhew, H. (1865), *The Shops and Companies of London and the Trades and Manufactories of Great Britain*, London

Metro-land Guidebook (1920), the Metropolitan Railway

Orwell, G. (1939), *Coming Up for Air*, Penguin, London

Ovenden, M. (2013), *London Underground by Design*, Penguin, London

Overy, R. (2009), *The Morbid Age: Britain and the Crisis of Civilisation, 1919–1939*, Allen Lane, London

Pedroche, B. (2013), *Working the London Underground From 1863 to 2013*, The History Press, Gloucestershire

Pevsner, N. (1968), *Art, Architecture and Design: Victorian and After*, Walker & Company

Pick, F. (1941), *Paths to Peace: Two Essays in Aims and Methods*, Frank Routledge, Oxfordshire

Priestley, J. B. (2012), *English Journey: Special Anniversary Edition*, Ilkley, Great Northern Books

Pugh, M. (2009), *We Danced All Night: A Social History of Britain Between the Wars*, Vintage Books, London

Rasmussen, S. E. (1934), *London: The Unique City*, Jonathan Cape, London

Roberts, M. (2012), *Underground Maps Unravelled: Explorations in Information Design*, Maxwell Roberts, Essex

Smith, S. (2004), *Underground London: Travels Beneath the City Streets*, Little, Brown, London

Welsh, D. (2010), *Underground Writing: The London Tube from George Gissing to Virginia Woolf*, Liverpool University Press, Liverpool

Wolmar, C. (2005), *The Subterranean Railway: How the London Underground was Built and How it Changed the City Forever*, Atlantic Books, London

Woolf, V. (2000), *The Waves*, Wordsworth Editions, Hertfordshire

Worsley, G. (2002), *England's Lost Houses: From the Archives of Country Life*, Aurum Press, London

Zola, E. (2008), *The Ladies' Paradise*, Oxford World Classics, Oxford

198 The History of the London Underground Map

Journals

Gießmann, S. (2013), 'Henry Charles Beck, Material Culture and the London Tube Map of 1933', *Amodern 2: Network Archaeology*, October

Greenberg, S. (1994), 'The Word According to Simon Patterson', *Tate: The Art Magazine*, Issue 4, Winter, p 47

Hadlaw, J. (2003), 'The London Underground Map: Imagining Modern Time and Space', *Design Issues*, Vol 19, No 1, pp 25-35

Hawthorne, N. (1863) 'Up The Thames', *The Atlantic*, May

Hornsey, R. (2012), 'Listening to the Tube Map: Rhythm and the Historiography of Urban Map Use', *Environment and Planning D: Society and Space*, Vol 30, Issue 4, pp 675-693

Jane, F. T. (1892), 'Round the Underground on an Engine', *The English Illustrated Magazine*, 1892–1893: Vol 10

McKenna, D. (1980), 'Obituary – Mr. Christian Barman', *Journal of the Royal Society of Arts*, Vol 129, No 5293, pp 72-75

McLaren, I. (1996), 'Harry Beck Would Have Been Amused', *Baseline: International Typographics Journal*, No 21

Pick, F. (1936), 'The Organisation of Transport', *Journal of the Royal Society of Arts*, Vol LXXXIV, pp 207-21

Pike, D. (2005), 'The Greatest Wonder of the World: Brunel's Tunnel and the Meanings of Underground London', *Victorian Literature and Culture*, Vol 33, No 2

Vertesi, J. (2008), 'Mind the Gap: The London Underground Map and Users' Representations of Urban Space', *Social Studies of Science*, Vol 38, Issue 1, pp. 7-33

Willoughby, H. R. (1923), 'Art and Advertising: London Underground Railways' Publicity Service', *The American Magazine of Art*, Vol 14, No 8, pp 441-447

Newspapers and Magazines

Aberdeen Press and Journal
American Magazine of Art, The
Architectural Review, The
Bath Chronicle and Weekly Gazette, The
Bedfordshire Mercury
Belfast News-Letter, The
Belfast Telegraph
Berkshire Chronicle
Birmingham Daily Post, The
Bradford Observer, The
Bystander, The
Chelsea News and General Advertiser, The
Clerkenwell News, The
Courier, The
Daily Herald
Daily Mail
Daily Mirror
Daily News, The
Daily Sketch
Dundee Evening Telegraph
English Illustrated Magazine, The

Bibliography 199

Evening Herald
Globe, The
Guardian, The
Hampshire Advertiser
Harrow Observer
Hayes & Harlington Gazette
Illustrated London News
Irish Independent
Irish Times, The
Kensington Post
Lancashire Daily Post, The
Leeds Mercury, The
Liverpool Echo
London Daily News
London Daily Telegraph and Courier
London Evening Standard
Manchester Guardian, The
Marylebone Mercury
Middlesex County Times
Morning Advertiser
Newcastle Journal
New York Times, The
Norwood News
Observer, The
Pall Mall Gazette, The
Press Association
Punch
Sandwell Evening Mail
Saturday Review, The
Scotsman, The
Sheffield Independent
Shields Daily News, The
Shoreditch Observer
Spectator, The
Sphere, The
South London Press
Sunday Mirror
Sunday Tribune
Tamworth Herald
Times, The
Train, Omnibus and Tram Staff Magazine
Uxbridge and West Drayton Gazette
Weekly Journal
Westminster Gazette, The
Westminster & Pimlico News
Yorkshire Post, The
Yorkshire Post and Leeds Mercury, The

200 The History of the London Underground Map

Websites
BBC.co.uk
Buzzfeed
Londonist

Archives

For social context, the British Newspaper Archive (accessed online at www.britishnewspaperarchive.co.uk) provides a wealth of material relating to the development of London Underground and its wider impact on society and culture.

For parliamentary questions and debates relating to the underground, the reading of various bills and sittings, full transcripts can be accessed at Hansard online (hansard.parliament.uk)

London Transport maps, including Harry Beck's 1933 Diagram, are held in the archives of the London Transport Museum. This archive also contains historical records, corporate documents, photographs, posters, and other publicity material, as well as ephemera such as letters, guidebooks, leaflets, tickets and timetables. Much of the collection can be viewed online at www.ltmuseum.co.uk/collections or in person by appointment only at the Acton depot.

Index

55 Broadway, 73, 81, 134, 139
7/7 bombings, 172-75

Aldgate station, 22, 69, 172-74
Aldwych station, 118
Amersham station, 141, 143
Architecture:
 Bauhaus, 84
 lead domes, 32
 neo-Classicism, 32, 69
 station design, 32, 48, 69, 73, 81, 84,
 131
Arnos Grove station, 85
Art on the Underground, 166-68
Attlee, Clement, 101
Aylesbury station, 56

Baker Street station, 15, 19, 49, 56, 64,
 141, 151, 154, 168
Baker Street and Waterloo Railway, 42,
 44, 49
Bakerloo line, 25, 44, 48-9, 72, 85, 90,
 99, 109, 132, 154, 182
Balham station, 73, 116
Bank station, 35, 117, 146
Barking station, 132, 143
Barman, Christian, 98, 105-107, 118-19,
 125-26
Beck diagram:
 1931, 89, 91-2, 182
 1933, 92-4
 1937, 105
 1940, 122
 1941, 122, 126
 1946, 125-26
 1949, 131
 1953, 132
 1955, 132
 1959, 123

 1964 final diagram (unpublished),
 147-48
 as electrical circuit, 90
 as mental map, 90
 early drafts, 90
 Hans 'Zero' Schleger 1938 version, 105
 iconic status of diagram, 93-4, 156,
 167, 179, 181
 in Braille, 131
 on souvenirs and merchandise, 156
 ownership of, 104, 146
 public reaction to, 93
 restoration of 'Beck rules', 146
 use on Sperry route indicator, 128
 versatility, 132
 with Charles Shepherd border, 126
Beck, Harry (Henry Charles):
 'agreement' with LT, 105, 126, 138
 background and early life, 89
 copyright of diagram, 137
 cultural influence, 91, 94, 156, 167,
 182
 death, 156
 legacy, 156-57
 obsession with diagram, 93, 105
 reaction to alterations by other parties,
 105, 136
 rejection, 146
 teaching career, 129
Beeching cuts, 141-44
Bethnal Green station, 113, 117
Blackfriars station, 20
Bond Street station, 29
Bounds Green station, 116
Bradshaw, George, 23-4
Branding. *See* Design.
British Transport Commission, 130, 133,
 135
Brunel, Isambard Kingdom, 8

202 The History of the London Underground Map

Brunel, Marc Isambard, 2, 22
 Tunnelling shield, 31

Camberwell station, 132
Camden Town station, 72
Canada Water station, 169
Canary Wharf station, 169
Canons Park station, 85
Capitalism, 38, 101
Carriages, 4, 6, 13-14, 17, 32, 48
Central line, 25, 35-6, 48, 84, 91, 109,
 118, 128, 134, 146, 168
Central London Railway, 36-40, 51-2
Cerovic, Jug:
 international standardisation of transit
 maps, 181
 thoughts on the Tube map, 181
Charing Cross, Euston and Hampstead
 Railway, 44, 48, 55, 72
Charing Cross station, 34, 61, 85, 100,
 108, 154, 168
Chesham station, 26
Circle line, 19, 23, 30, 47, 132, 146, 172,
 175
City and South London Railway, 30-33,
 35, 52, 72, 113
Clapham South station, 73
Clark, Charles W., 69, 85
Colliers Wood station, 73
Covent Garden station, 97
Crossrail, 176
Croxley Green station, 68-69
CSLR. *See* City and South London
 Railway.

Demuth, Tim:
 1979 central area diagram, 161
 London Connections maps, 162
Design:
 Abstraction, 76, 168
 Art Deco, 68, 70
 Arts and Crafts, 32, 96, 100, 129
 branding, 52-53, 96, 158
 Carr-Edwards report, 106, 128
 iconography, 88
 information design, 129, 162
 informational graphics, 37, 40
 marketing, 25, 37-38, 56, 60, 65, 166

Modernism, 68-70, 98, 101
moquette, 36
posters, 23, 37-9, 46, 52-5, 58-9, 61,
 71, 74-6, 81, 95-103, 123, 128, 133-
 35, 137-38, 150, 161, 166-67
 Wartime, 109, 111, 113, 124-126
publicity, 24, 38-40, 54, 62, 74, 102,
 111, 125, 128, 133, 135, 149-150,
 155-56, 166
 roundel, 53, 57, 100, 104, 121, 131,
 134
 signage, 23, 49, 53, 106, 121, 128
Surrealism, 100
typefaces, 73,77
UndergrounD wordmark, 53, 55
Vorticism, 76
Dickens, Charles, 4
District line, 83-84, 132, 151
District Railway:
 accidents, 34
 amalgamation into LPTB, 87
 completion of Circle, 20
 disputes with the Metropolitan
 Railway, 16, 23, 35
 District Railway Map of London, 5th
 edition 1892, 32-3
 District Railway Miniature Map of
 London, 1897, 27, 33
 early maps, 24, 27, 161, 180
 electrification, 40-1
 extensions, 22, 27, 83-4
 finances, 44, 50
 in wartime, 64, 110
 leisure travel, 27
 opening of, 1868, 19-20
 timetables, 24
 topographical maps 1880s and 1890s, 28
 under Yerkes, 40, 44-5, 47, 50
Docklands Light Railway, 179
Down Street station, 118-19
Drayton Park station, 158

Ealing Broadway station, 109
Earl's Court station, 27, 34, 37
East London line, 175
East London Railway, 2, 22, 78
Edgware Road station, 13, 15, 34, 49, 69,
 72, 172-74

Index 203

Elephant & Castle station, 49, 107, 132
Elizabeth line. *See* Crossrail.
Embankment station, 72
Enfield West station, 110
Engineering:
 cut and cover, 1, 11
 Greathead Shield, 31
 tunnelling, 2, 5, 29-31, 35-6, 133
Essex Road station, 158
Euston station, 6, 72

Fares, 7, 14, 23, 28, 51, 100, 153, 155,
 162
 'Balanced Plan', 162
 Capitalcard, 162
 fare zones, 159-61
 'Fares Fair', 159-62
 Oyster card, 160-61, 176
 Travelcard, 160-61
Farringdon station, 5, 8, 12, 14-15, 57,
 176
Fenchurch Street station, 4, 6
Finchley Central station, 156
Finchley Road station, 19, 56
Finsbury Park station, 44, 49, 82-3, 132,
 147
First World War, 40, 57-8, 61, 63, 72,
 96, 108, 124
Fleet sewer, 12-13
Fowler, John, 8, 11, 19, 36

Garbutt, Paul E.:
 1964 diagram, 146
 1983 quad royal diagram, 161
 background and early life, 145
 initial redesign of diagram 1962, 146
Geddes, Sir Eric:
 Geddes Axe, 71-2, 89, 141
Gill, MacDonald, 59-62, 76-8, 126
Gladstone, William, 20
Gloucester Road station, 19-20
GNR. *See* Great Northern Railway.
Golders Green station, 55
Goodge Street station, 164
Gower Street station, 13, 15, 34
Great Depression, 83
 influence on the Underground, 80-1
Great Northern Railway, 6-8, 10, 18, 44

Great Northern, Picaddilly and
 Brompton Railway, 49
Great Portland Street station, 18, 69
Great War. *See* First World War.
Great Western Railway, 8, 10, 15-17, 19,
 26, 71, 86, 109
Greater London Authority, 163, 170
Greater London Council, 150
 politics and policy, 150-51, 153-56,
 159-163
Green, Leslie W., 48
Green Park station, 152
Greenford station, 128
GWR. *See* Great Western Railway.

Hainault station, 105
Hammersmith & City line, 19
Hammersmith station, 19, 44, 49
Hampstead Tube, 49, 72, 74
Harrow station, 56
Highbury station, 151, 158
Hillingdon station, 97
Holborn station, 84
Holden, Charles, 69-70, 73, 81, 84-5, 98
Hounslow station, 27, 84
Hutchison, Harold:
 background and early life, 126-27
 management of artists, 137-38
 redesign of Beck diagram, 136, 139,
 145-46
 role as publicity officer for LT, 127,
 133-34

Islington station, 158

Johnston, Edward, 59,
 Typeface, 73, 77, 121
 Roundel, 100, 121
Jubilee line, 151, 154-55, 162, 168-69,
 171, 179

Kennington station, 72
Kilburn station, 26
King William Street station, 31, 113
King's Cross station, 6-8, 12, 15, 17, 34,
 163-65, 172-74
 fire, 163-65, 174
Kingsbury station, 85

204　The History of the London Underground Map

Lambeth North station, 42, 44
Leicester Square station, 97, 100, 109, 129
Liverpool Street station, 22, 113, 128, 136, 146, 172-74
Lloyd George, David, 63-4, 71
London & Globe Finance Corporation, 42
　bankruptcy, 44
London and North Eastern Railway, 71, 83, 86
London and South Western, 52
London Bridge station, 4, 6
London Chatham and Dover Railway, 21, 175-76
London County Council, 86
London County Council Tramways, 71
London General Omnibus Company, 30, 52, 60, 86
London Midland and Scottish Railway, 71, 86
London Overground, 175
London Passenger Transport Board. See *London Transport.*
London Regional Transport, 156-57, 163-64
London Transport:
　as a patron of the arts, 95, 101-102
　beginnings, 87-8, 92, 96-7
　corporate brand, 95-6, 131, 155-56
　dispute with Harry Beck, 138, 146-47
　New Works Programme, 104
　public relations, 125, 133, 135, 149, 151, 154
　relationship with Harry Beck, 93, 105, 126, 135, 137
　Second World War, 103, 109-19
　staff relations, 124, 153
London Transport Board, 143
London, Midland and Scottish Railway, 86
London, Walthamstow and Epping Forest Railway, 132
Lord Ashfield:
　death, 130-31
　early life and career, 51, 53
　First World War, 64
　legacy, 169

relationship with Frank Pick, 54, 71, 87, 119
Lots Road Power Station, 46-7, 125

MacDonald, Ramsey, 81, 86
Mansion House station, 20, 22, 107
Maps:
　accessibility, 177, 179
　as art, 90, 167-68, 182
　decorative, 59-62, 76-7
　diagrammatic. *See* Beck diagram.
　early route diagram, 38, 40, 49
　in Braille, 131
　inclusion in posters, 38, 76, 123, 128
　inclusion of fare zones, 161
　Journey Planner, 90, 177
　Metro-land, 66
　navigational excess, 24
　pocket maps, 33, 55-6, 77, 105, 161, 168
　pre-Beck maps, 24, 26-8, 32-3, 39, 77-8, 96, 136
　printing of, 77, 122
　removal of River Thames, 77-78
　schematics, 40, 97, 178, 181
　Stingemore map, 78, 91
　topography, 23, 39, 90-1
　UERL maps, 49, 76
　visual communication, 23, 129
　way-finding, 24, 84
　zonal maps, 105
Marylebone station, 49
Met. *See* Metropolitan Railway.
Metroland:
　architecture, 67-9
　criticism of, 68
　development of, 19, 27, 39, 57, 62-3
　estates, 65-6
　marketing, 65-6, 76
　Sir John Betjeman, 67-8, 141-42
Metropolitan Country Estates Ltd, 57, 64
Metropolitan District Electric Traction Company, 44
Metropolitan District Railway. *See* District Railway.
Metropolitan line, 141, 143
Metropolitan Railway:

amalgamation with LPTB, 85-6, 88
architecture, 15, 69
beginnings, 8-10
branding, 57
construction accidents, 12
disputes with other operators, 16-17, 20, 23, 35, 45
early financial issues, 19-20
electrification, 47, 56
expansion, 18, 22, 26, 85
impact of construction, 1-3, 12
in popular culture, 15, 162
in the First World War, 57, 62, 64-5
maps, 23-24, 26, 28, 33, 66, 161
opening of, 13-14
relationship with UERL, 79
use of steam, 17-18, 30, 34, 36
Midland Railway, 6, 145
Mill Hill East station, 132
Ministry of Transport, 71, 74, 120
Moor Park station, 68
Moorgate station, 144
disaster, 158-59
Morden station, 72-5, 78
Motor cars:
development of road network, 141
increase in car ownership, 141, 144
motorists, 141, 143-44

Navvies, 11, 13, 31
Newbury Park station, 128
New Works Programme 1935-1940, 104, 106, 119, 122, 130, 150
New York City Subway, 107
Noad, Mark:
opinion on Tube map, 179-180
Tubemap 2.0, 91-2
North Greenwich station, 169
North London Railway, 175
Northern line, 25, 44, 49, 72-3, 78, 108, 132, 158, 172, 182
Northwood Hills station, 69
Notting Hill station, 69

Old Street station, 158
Omnibuses, 4, 6-7, 23, 88
Ongar station, 105
Overcrowding, 6, 11, 54, 70-1, 82, 127

Oxford Circus station, 35, 140, 152, 154, 164

Paddington station, 6, 7-8, 13, 15, 33, 49, 172
Paris Métro, 53
Parliamentary Select Committee, 8
Passengers:
accessibility, 131
affect of disputes on, 23
artistic depictions of, 15, 33, 38, 70, 74
early trips on the Metropolitan, 12, 14
experiences in wartime, 61, 109, 112, 114, 123-24
importance of maps to, 23-5, 90, 106, 123, 161, 180, 183
involved in major incidents, 124, 158, 163-64, 172-74
passenger class, 14
passenger complaints, 54, 82, 127
passenger experience, 12, 15, 18, 23, 30-3, 48-9, 59, 98-9, 127, 152
passenger flow, 31-2, 48-49, 53, 73, 84, 98-100, 140-41
passenger numbers, 6, 14, 17, 35, 38, 49-50, 55, 58, 70-71, 83, 88, 135, 159, 175
reactions to the early Metropolitan, 16, 18
use of workman's tickets, 18-19
Pearson, Charles, 4-10, 14, 18, 61, 85, 176
Pinner station, 26
Piccadilly Circus station, 70-1, 81, 98-9, 118, 121, 154
Piccadilly line, 44, 48, 83-4, 90, 92, 110, 151, 162, 172-74
Pick, Frank:
artistic ethos, 84, 96, 97, 100-103
as a patron, 53-4, 84, 100-102
background and early life, 54
branding and design ethos, 73, 75, 92, 95, 105, 132
civic role, 53-4, 84, 95-97, 166
commercial activities, 55
commissioning of maps, 58-9, 93
death, 103, 121
final years, 119-120

206 The History of the London Underground Map

First World War, 64
joins UERL, 54
legacy, 121
memorials, 121
reaction to Beck diagram, 93
relationship with Lord Ashfield, 54, 119
Second World War, 103, 110, 118-120
Popular culture:
board games, 38, 161-62
cartoons, 33
film, 141
literature, 66-7, 85, 91, 97, 182
music hall, 15, 38
theatre, 15
toys, 38
Portland Road station, 15
Public Private Partnership (PPP), 170-72
Putney station, 22, 27, 32

Queensbury station, 85
Queensway station, 107

Railway mania, 8
Rickmansworth station, 26
Roberts, Maxwell:
cognitive load, 177
Concentric Circles Underground Map (2013), 178
Multilinear Underground Map (2012), 178
opinion on Beck diagram, 177
Russell Square station, 172-73

Selbie, Robert Hope, 56, 64, 66, 74, 86
Shepherd's Bush station, 35
Silverlink Metro, 175
Sloane Square station, 124
South Harrow station, 76
South Kensington station, 19
South Wimbledon station, 73
Southgate station, 85
Staats Forbes, James, 20-1, 26, 40, 44, 176
Stanley, Albert. See Lord Ashfield.
Stanmore station, 68-9, 85, 154
Stingemore, Fred, 77-8, 91
St James's Park station, 53, 73

St John's Wood station, 69
Stockwell station, 31
St Pancras station, 6
Stratford station, 128, 154
Suburbs:
criticisms of, 80, 97
mapping of, 32, 60, 76, 97
expansion of, 26-27, 29, 40, 55, 66, 74, 98
extensions to, 26, 55, 128, 132
suburban life, 66, 77
suburban traffic, 52
travelling to, 39, 56, 97
Sudbury Town station, 84
Swiss Cottage station, 26, 69

Thames Tunnel, 2, 22
Thameslink, 175-76
Thatcher, Margaret, 162
Tooting Bec station, 73
Tooting Broadway station, 73
Tottenham Court Road station, 168
Tourists:
marketing to, 155
Tower Hill station, 19, 22
Transport for London, 171, 174, 177, 181-82
Tube:
construction, 31-2
early days of, 29
etiquette, 48, 77, 127, 152
in the Blitz, 108, 113, 116-18, 123
influence on suburban expansion, 55, 74
Two-penny tube, 38-9
wartime art and propaganda, 116
Yerkes' Tube, 41, 46, 48-9

Underground Electric Railways
Company of London:
absorption into LPTB, 92
acquisitions, 47, 51-2, 60
American influence, 47-8, 54
Beck's first role, 89
Combine, 52
early influence of Albert Stanley, 51
early influence of Frank Pick, 53-5
expansion, 49, 72, 83

Index 207

finances, 44, 50-1
in the First World War, 64
Piccadilly Circus reconstruction, 70
public perception of, 54
reaction to Beck diagram (1931), 91
suburban development, 71-2, 74
Upminster station, 175
Uxbridge station, 84, 87, 97

Verney Junction, 26
Victoria station, 34, 60, 140, 147, 152
Victoria line, 93, 133-34, 140, 142-43,
145, 147, 151, 154, 164, 176

Walthamstow station, 147, 151
Warwick Avenue station, 61
Waterloo station, 35, 44, 72, 110
Waterloo and City line, 35, 52, 71, 151
Watford station, 68-9
Watkin, Sir Edward, 21, 26, 36, 56, 64,
66, 74, 176
Wembley Park station, 68, 85
Westbourne Park station, 60

West End, 29, 39, 48, 52, 55, 61, 156,
160-61
Westminster station, 20, 154
West Ruislip station, 128
Whitechapel station, 22, 91
Willesden Green station, 26, 69
Willesden Junction, 175
Wimbledon station, 22, 27, 110
Women:
absence of, 38
on posters, 38-9, 124
roles on the underground, 38, 114, 124
using the underground, 38
Woodford station, 128
World War I. *See* Great War.
Wright, Whitaker:
trial and death, 42-3

Yerkes, Charles Tyson:
arrival in Britain, 41
early life, 41
financial affairs, 42, 44-5, 49-50
financial syndicate, 44-5